Bearing
Witness

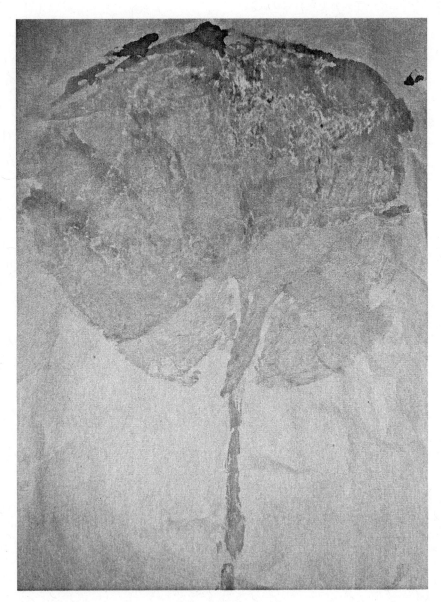

Placenta Print

Bearing Witness

Childbirth Stories Told by Doulas

Edited by Dr Lisa Doran, ND,
and Lisa Caron, CD & PCD (DONA)

FOX
WOMEN'S
BOOKS

Dedication

This book is for my mother. A woman who reached into the core of her being, when I am so very sure it felt like she could not go on, and found the strength to raise her three spirited daughters alone in the wilderness into strong, loving women. Mom, you taught me how powerful a community of women could be, how sacred tradition and family are, and how very important it is to live your dream. –Lisa Doran

I dedicate this book with love and gratitude to my delightful daughter, Lindsay Benjamin, whose incredible strength inspires me and everyone she touches. –Lisa Caron

Cataloguing in publication data is available.
ISBN-10: 1-894997-16-6 ISBN-13: 978-1894997-16-4
Edited by Fina Scroppo.
Designed and typeset by Sari Naworynski.
Cover art by Catherine Tammaro,
inspired by the frontispiece placenta print by Sofie Weber.
Printed and bound in Canada.
Published by Fox Women's Books,
a division of Quarry Press Inc., PO Box 1061, Kingston, Ontario
K7M 2L5 Canada www.quarrypress.com

Birth is not only about making babies.

Birth is also about making mothers – strong, competent,

capable mothers who trust themselves

and know their inner strength.

–Barbara Katz Rothman

Contents

Introduction

Being pregnant and giving birth are like crossing a narrow
bridge. People can accompany you to the bridge. They can greet
you on the other side, but you must walk that bridge alone.
–African proverb

THERE IS WISDOM IN THESE PAGES.
I am humbled by the volume of experiences shared, the voices we
hear, the stories that are told. As a doula and as a woman who
attends birth, the stories, and the openness of the authors, are all
so familiar to me. The stories are wonderfully real, they are emo-
tional, they reflect how we so often have the opportunity to expe-
rience the joy of something divine and the awe of a woman giving
birth. By the same token, birth can be a difficult journey for some
women and a few of these stories may uncover raw feelings; some
authors may experience frustration as a witness to modern birth
practices applied to a deeply intimate event. These stories from the
heart are presented to you with courage and truth by the women
who support women giving birth powerfully.

Many of these women are not writers and I salute their courage
for baring all their feelings, taking a risk when putting pen to
paper, and sharing a part of their lives with us so effectively. Some
of these women are brilliant authors and storytellers and I thank
them all from my heart for their eloquence and vision. These sto-
ries come to you as poems, as observations, as interviews or as

recordings from story circles. What this collective project has become is a vehicle for women to express what it has been like for them to be a part of a very unique community. We bear witness in a very literal way to something that is always joyful, sometimes heartbreaking, sometimes appalling and, mostly, kept very secret. Our calling is a way of life. It is not an easy road. We see and hear things in the course of our work that are difficult. We have a need to bear witness to these events, to tell our stories, but in doing so, we have carefully protected the confidentiality of everyone involved. Doulas are governed by codes of conduct established by their certification boards that require them to respect the privacy of their clients and colleagues.

I came to doula work in an interesting political climate in Ontario. It was 1992 and midwives were working very hard to obtain legislation that would regulate and legalize midwifery in Ontario under the Regulated Health Professionals Act. The natural birth movement had peaked and we were seeing fear-based choices beginning to seep back into birthing practices. Women afraid of the unknown during birth and wishing for the illusion of control during the event consented to the decisions that led to a surprising and concerning rise in elective Cesarean sections, as well as huge increases in the use of epidural anesthesia, especially at some of the larger urban hospitals. We saw modern obstetrical practices also tighten their clinical control of birth with augmentation of labor using very controversial medication, aggressive Group B streptococcus treatments, strict post-dates policies and strong resistance to support persons attending a woman in labor other than her partner. It was a time of true activism in Ontario. Anyone interested in home birth or natural birth was encouraged to speak out, to act, to support the midwives in their push for legislation, which came soon after in 1994. I was trained as a midwifery assistant in 1992 by Informed Homebirth and Parenting, now the Association of Labor Assistants and Childbirth Educators (A.L.A.C.E). I was barely 22 years old and my heart was on fire with the activist atmosphere, the empowering post-feminist conversation, and my interest and calling to natural medicine.

Doula, birth companion, labor coach, labor support worker, birth worker, midwife assistant – doulas are known by many names. We are lay women experienced in attending labor and birth as nonclinical support providers. In 1986, Kennell and Klaus published "Effects of Social Support During Parturition on Maternal and Infant Morbidity" in the *British Medical Journal* showing how the presence of a nonclinical support person who attended labor to provide emotional and physical support during labor actually lessened the length of labor, the perception of pain in labor, and decreased the interventions required during labor. The birth of the modern doula occurred and the role grew rapidly in popularity with birthing moms. Today, the word "doula" is as common as "childbirth educator."

But one thing should be clear: doulas are not midwives. Although we were born from the philosophies central to midwifery and most doulas will claim the midwifery model as the root of their own personal philosophies around birth, doulas are not trained like midwives with the same advanced clinical skills. Midwives are primary care providers at a birth and have much responsibility clinically. Some would say that as midwives became more clinical in their practice and developed their skills and expertise in this arena, the art of supporting a woman through labor has been taken up by the doula. Doulas fill a gap in maternity care that simply cannot be filled by someone with responsibilities for clinical charting, checking vital signs, etc., because each role requires a very different way of thinking and attention during birth. Stepping outside of the responsibilities modern midwives have and providing the intense supportive care that women need during labor is very difficult. Doulas are present to provide physical and emotional support and encouragement. In this way, doulas complement the birth team by providing physical and emotional support.

The doula community is a unique community of sisterhood and we share a distinct camaraderie. My growth as a doula was largely influenced by a circle of women who worked together in the Durham Region of Ontario in the late 1990s to provide choice-based prenatal classes and doula services that were accessible by

all women, regardless of their ability to pay for our services. Our group of 10-plus women worked together to back each other up, share stories, support each other, and maintain statistics and a volume of information about the obstetrical care being provided in our region. On a personal level, I leaned on these women for child care in the middle of the night, creative problem-solving, and for support (we ate chocolate cake together when we had a rough birth). We were not only a very powerful voice in our community, but also important facilitators in providing care to many women and their families. It was when I began seeing many members of this community move away from the field and I, subsequently, lost the therapeutic outlet that they provided that the idea for this book came to me. The value of such a group of birth workers meeting and hearing each other's stories and adding their sisters' experiences to their collective consciousness and knowledge as it pertains to birth cannot be underestimated. The positive effect of this 'debriefing' or 'doula circle,' for anyone who works with or witnesses an intense experience (positive or negative) needs to be more highly valued. Talking about what we've seen and sharing it helps us not only to work through events and process them on a primary level, but also I'm convinced that it helps us process these incredible heaven-sent, universe-glimpsing experiences on the much higher level of the soul. It lightens our load, keeps us healthy in mind and body, and ensures we foster fresh perspectives. I miss that circle of women!

Doulas are lay childbirth support workers who work with and for birthing families. We support laboring women as well as her partner. Usually doulas are neither employed by the hospital nor part of the institutionalized medical system (although some hospitals employ doulas while others offer volunteer doulas). We are employed by or volunteer for the families we work with and this puts us in the position of witnessing events within a hospital environment that have never been spoken about in the past.

Doulas also assist at home births. We arrive at a client's home when she feels she needs us and we remain there with the midwife until the babe is born or until it is time to travel to the hospi-

tal. In a hospital environment, we arrive with birthing families and support them during the entire birth experience. In both cases, we often follow up with families in their postpartum period, providing hands-on support, encouragement, and continuity of care. Doulas have the unique opportunity of providing a type of care that is just not available to women who access modern obstetrical care. We see and understand that women's experiences during labor and birth, along with the high rate of unnecessary interventions, can often affect their emotional health and physical recovery, their ability to mother their babies, and their ability to have a healthy relationship postpartum with their partner because of long recoveries. We see clearly that women who have perceived their birth as a positive experience heal faster, bond with their babies easier, and are more emotionally healthy. They perceive themselves as better, stronger mothers. Women who most often perceive their birth as positive are those women who have had very few interventions and medications during their labor and birth.

No matter where their work takes them, doulas really do live and work in the gray area between institutionalized and private health care. Most doulas are driven by a passion for birth and a desire to support women in their community. Doulas see their work as a way of life and not necessarily as a career. Working as a doula rarely pays the rent, so most doulas work part time and have other jobs or professions, delicately balancing the work-life-passion spectrum. Doulas are generally underpaid based on hours worked and time on call. We never know when we may need to walk away from our work, family, our beds, Christmas dinner. Sometimes it causes doulas to burn out early – the low pay, the long hours, and the difficult experiences as they navigate through modern obstetrical care can take a toll.

Today, the decisions women are making around childbirth is bringing with them a welcome transformation. Many things have changed since I first began my journey as a birth worker. We've made leaps from the very early days of medicalized childbirth when twilight sleep was used, our mothers and grandmothers were rendered unconscious "for their own good," and fathers were

forbidden in a delivery room. Birth activists fought hard to change things and then in the 1970s and '80s, we saw the evolution of the natural childbirth movement and we had prenatal classes, gentle birth, and the important re-emergence of North American midwifery care. Now we are at the peak of 15 years of the new medicalization of childbirth with chemical induction, high epidural use and an all-time high Cesarean rate. Something is happening again in child-birth. A trend toward something different and explosive in much the same way the natural childbirth movement took us out of obstetrical standards of the 1950s. Birth is more transparent – more eyes are watching it happen and consumers are demanding it be different. In fact, the demand is so high that midwifery practices are full and doulas must turn away some clients. As parents demand changes in birth, it is prompting other modifications, such as baby rearing, breastfeeding advocacy, co-sleeping, and cloth diapering. Underground movements like unassisted birth and wet nurses are also growing. And with the Internet, parents have become informed consumers with their own opinions about their care rather than simply patients in need of delivery. Consumers know they have choices and they are not afraid to make them.

The contributors to *Bearing Witness* are all women who have made a lifestyle out of rising from their warm beds in the middle of the night to answer their pagers and sometimes not returning to their home for days. We do this because, in most cases, we want to bring change to the birthing process. We want birth to become more humane, to reclaim its natural primacy. We want to educate and support mothers so that they understand their choices and have a positive birth experience based on their own informed choices. Being an effective doula and advocating for women's informed choices contributes to moms who feel strong and confi-dent about themselves and will mother their babies in a healthy way. Peace on earth does indeed begin with birth.

Lisa Doran

Bookends

Shawn Gallagher

SHE LOOKED DIRECTLY INTO MY EYES
and I was hooked.

It was 1986 and I was a doula-in-training, a volunteer to single mothers. It was my first birth. She was 16 and single. It was her first birth, too.

"This is my midwife," she proudly announced as the nurse walked into the room early in the birth. The nurse turned to me, deeply impressed. I backpedalled, feeling awkward. "Just a doula," I murmured.

When I was 16, many years earlier, I was visited by an epiphany tucked deep into the pages of *Glamour* magazine. It wasn't an article about make-up, skin care, or fashion, although Lord knows, I sucked up these articles like a monthly IV.

It was an article about midwives. Nurse midwives, in fact. And it was then, sitting in the shadows of a summer day on the front porch of my family home, that I knew, absolutely knew beyond a shadow of a doubt, that I would become a midwife. First, I would have to become a nurse (according to this article), and then one day, I would become a midwife. However that might happen.

So now, many years later in my late 20s, I had been granted a chance to see if this romantic idea of mine could actually hold water. I had no training and I honestly had no idea what I was doing. The birthing mother, her obstetrician, the labor and delivery nurse, an anesthetist and I were all squeezed into an operating room. She had the operating table to herself. It couldn't have been comfortable. She was flat on her back, her legs in stirrups. This is how they did things in those days.

I stood on her left near her head. The anesthetist was on her right. "Sit," he said to me, pointing to the stool. I looked down at it. *But if I sat*, I thought, *I wouldn't see anything. I'd completely miss the birth, and I was here to see the birth. Didn't he know that?*

I scanned his face and softened, realizing that he was actually worried that he'd been saddled with a fainter. *I'm not so sure I can stay conscious*, I thought to myself, and I mulled whether sitting was actually the best idea, given the circumstances.

But I resisted him. We pulled and tugged at each other and, eventually, he let me remain standing.

Of course, I was completely useless to her – she was lost in her birth, pushing like the dickens. I just stood there gaping.

And as her daughter's head emerged, I saw a baby's face turning, turning, turning to scan the ceiling as if there might be something of importance to notice high up in the rafters, if an operating room were to have rafters.

And then she stopped turning, her face taking in all of us. And she looked directly into my eyes. We locked eyes. All I could see were two round black invitations, darker than the night sky, and in an instant, I was hurtling through the universe, passing galaxies, completely free, totally enveloped by a warm, soft blanket of peace, of love.

He was right. I didn't remain conscious. But I didn't faint, either. In those few seconds, time stopped at eternal, and I was hooked.

I didn't know then how unusual a birth it was. It would be hundreds of births before I would see a persistent posterior delivery again in a first-time mom.

I attended more births as a doula, trained as a midwife, first in

Texas and then returning to Toronto to do an internship with a well-established midwifery practice.

In Ontario, in the old days, midwives were not recognized legally or medically. Those of us who considered ourselves midwives had only a rare handful of times when we actually delivered a baby. Mostly we were midwives in the woman's home and doulas in the hospital. Sometimes the transition in hospital birth units was graceful; mostly it wasn't. Then in 1994, the law changed and we were granted hospital privileges, delivered babies as primary-care providers in home and hospital and had a workload that would floor an elephant.

It didn't take long for exhaustion to settle in and, by 1999, I was attending my last birth. I thought at the time that it would be a short sabbatical. *A little time off and I would be raring to go again*, I told myself. But deep down, if I was really honest with myself, I knew that this would be the last baby I would deliver as a midwife.

It was January and I received a call in the dark hours of the late afternoon. I stepped outside into a blizzard. The snow was thick and fluttery as I trudged through knee-high snowbanks hoping to keep some of it out of my boots. *Nothing more miserable than cold wet feet*. The working city had left early and the rush-hour roads were clear for a change. Drivers were slow and cautious – danger could leap out at you at any moment in this kind of weather.

It was her second birth and this time, a planned home birth. Her partner opened the door, a pause for him from chasing a frantic toddler. He motioned to the second floor. I hauled my luggage up the stairs with heavy oxygen tanks, sterile equipment, necessary medications, important papers, and stuff I didn't know I even had. *Packing economically has its virtues*. At five foot and change, I'm not a bodybuilder and I've never relished swinging bags half my weight.

She was in her bedroom and clearly in active labor. You learn to move quickly in these situations, unpacking, calling the second midwife, charting, checking her, making sure everything is in its place. Only then can you relax. With a large mug of strong hot black tea, I rested my gaze at the fury happening outside her window.

Calm. Peaceful. People across the city were sitting down at dinner and at this moment it doesn't even look as though the sun had ever shown its face today. People are winding down, running hot baths, getting ready for bed. And downstairs, an agile screaming toddler was outrunning her father over and over again. I was ready. *Baby, anytime you want to be born, I'm ready for you.*

She went into the bathroom to use the toilet. I followed. I don't ask in these situations because you never know, especially with multips (a woman who has given birth before). Sure enough, she was on the toilet and pushing. "Let's get you to the bed," I gestured. She looked at me with one hundred percent certainty that she was completely and totally incapable of walking. "I'll help you," I said. She grunted. Another push. "Let's go now," I said firmer. *Where is that backup midwife? Stuck in the snow? Even EMS vehicles will never make it in time, not in this weather.*

But, I had a feeling it would all work out. Nothing based on any evidence, per se. Just a feeling. And back on the bed, pillows behind her, semi-sitting, she pushed. I sat beside her, checking the fetal heart rate – strong and steady. Good. I looked to see what might be emerging and what emerged wasn't a baby.

Not a baby. It was a balloon. Small at first, stretching bigger and bigger with each push. I was on her right side, gloved up, ready to go. The bigger the balloon got, the more transfixed I became. *Time is slowing.*

I remembered the first time I saw the bag of waters emerging before the baby. I was a student in Texas, desperately missing Canada. I could see little white bits – vernix – floating, drifting, looking at the world like a snow globe, the kind that comes out of storage at Christmas where a shake creates an instant winter wonderland.

And then, his head emerged in the bag. I could see black hair. I could see it was the back of his head. Good. I could see him pausing, then stretching, head and neck arcing forward into his bag of waters, turning, turning. And as he turned, a face coming into view, pausing.

He looked directly at me.

Eye-lock. Again.

Time is stretching now. Time is standing still. How can it do this?
He had a curious look, like "Who *is* this? Do I know you?" Melting,
I looked deep into his eyes, escaping once more into the silent vel-
vet of the universe, flying, free one more time. I silently blessed
him, her, the universe.

And then I broke the bag and he scooted out and howled and
was held by his mum and all was well.

These are my bookends: first and last births with a deep, visceral
soaring of my soul. Some of the births after the first and before the
last were hard-slogging, some were long sleepless events, some
were exercises in frustrated powerlessness, some were births of
grief, some even brought moments of almost heart-stopping fear,
but most were births of elation, of joy.

And none of them matched the feeling at the first one of being
hooked into a wave – riding it, caught on a wave that built over
time, became stronger, more insistent, a bit like a contraction press-
ing on me, pressing harder and harder with each birth, each new
season, each year that passed.

None of them matched the feeling at the last birth, either. The
realization that all along I was never alone, all along I was being
watched, and guided by a silent, dark universe – one with sprin-
kles of stars like snow falling on the blackest canvas of the deep-
est softest silence. Because now my universe and I were back
together again. I was riding it once more, through his eyes.

Lady in Waiting

Lisa Caron

I SIT QUIETLY ON THE SIDE OF THE bathtub, as I have dozens of times before. I'm a lady in waiting.

Waiting for the next contraction, waiting to anticipate the laboring woman's needs, waiting to hand her a drink, rub her back, look in her eyes, and tell her she can do this. Waiting to catch her partner's eyes to convey all is well, and acknowledge the valuable role of their supportive presence.

Waiting to touch her shoulder, brush her hair from her face, to be silent during a contraction in respect of the powerful work she is doing. Waiting for the nurse to acknowledge the strength in their patient.

Waiting to see if she speaks of an epidural, because she doesn't know if she can do this, waiting for her to realize she is already doing it. Waiting to see if she will surrender to the wisdom of her body, or fight and tense up, thinking and doubting her innate ability, instead of flowing with her body's commands as other women are doing with her all over the world. Waiting to hear that familiar sound deep in the laboring mother's throat, to hear her say, "The baby is coming."

Waiting for the moment of birth. Waiting to see who will shed a tear, who will weep uncontrollably, who will stand in amazement, or in relief, who will hide all emotion.

Waiting for the moment of connection between mother and baby as her newborn instinctually searches for his mother's eyes and drinks her in.

As a doula, I am honoured to be a lady in waiting, occasionally shedding a tear of awe and reverence for the miracle of birth, new life, and the strength deep inside women.

♀ Living Earth Mama

Lara Stewart-Panko

living earth mama
interdependent weaving
playful air laughter blood be
destructive creative balanced
beautiful bold brown bouncing
sweet supportive multiplicity
essentially rhythmic mystery
learned patient striving
strong curving water
body
sage
land
kind
beat
home
nourish intuition moving everywhere wisdom
light presence choose grace sacred honor all
tears
love
heal
care
with
soul
flow
well

A Glimpse of the Beyond
Julei Busch

AS A DOULA AND A SPIRITUAL WITNESS, every birth is unique to me, each with its own journey. Yet certain moments are so collective, so universal, that everyone present comments on them after. I have been patiently gestating a way to articulate how one of those moments impacts us. It was after the third birth for a lovely family, now dear friends, that this poem was also birthed. Mom is a trained singer so her breath and vocalizations and the music she chose made the birth room all the more transcendent.

A Glimpse of the Beyond

A babe is sung into mom's pelvis
like a dolphin diving deep

Called down by the trust and love
vocalized by a goddess
across her birth-gate
into the here and now

A babe slides
between thighs trembling with power
as we, mere guests, tremble with awe

A babe takes its first breath
and we lose ours

Glistening tears of joy go unnoticed
but for the rainbow flares across eyes

gifted a glimpse into the unknowable beyond
With one breath
a single tiny breath
all illusions burn away
and our souls fill with the fire of the divine

♀ *Aurora*

Tara MacLean-Grand

full moon
full mom
baby taking her time
to be harvested
leaves exploding
red and orange...
orange juice and castor oil
and in an hour mom is
moaning and howling

the moon hears
mother wolf
I hold her hand and
reassure

Dad is nervous
shot of whiskey and he settles
but where are the midwives?
On Nelson time
thinking they have space to gather
their things slowly
but the baby is crowning and I am there

my dear friend
of 16 years
is pushing her baby toward me
and asking where the midwives are
It doesn't matter
I assured her in my

most confident, power voice
we can do this!
What haven't we done.
I was there when her young heart broke
I was there in Europe
stoned teenagers immersed in Van Gogh
I was there when her first child
was brought violently into the world
at the hands of a doctor she had never seen sliced
and cut and stitched and betrayed

And now I am here
and now the midwives are coming through the door
and they hustle to take my place at the gates of life
and the room becomes a sacred space
filled with a strange light and
I hold her head in my hands and look into her eyes
and she screams as the baby comes
sailing through her into this world of form
another girl and my friend has torn
but she is laughing and cooing
and they called her Aurora
I was there
witness to the healing of the home birth.

Union

Crescence Krueger

THE AFTERNOON LIGHT FILLS THE house and me. I am translucent. I am aglow. In the last 27 hours I've attended two births. At the first, I spent 20 hours amid drugs and IVs, monitors, and machines. In the end, a child was born and she is loved. I walked home, exhaling fluorescence and inhaling the moist air of the night. Asleep as dawn broke, the phone rang an hour and a half later. Another birth!

Shivering from my disorientation in time, I ran over to my client's house. Her husband gave me a hug and a mug of tea and then she and I entered her bedroom. The walls and sheets were white and the morning sun made everything whiter still. Outside the window, budding branches filled the view. A contraction came. She kneeled on the bed and I sat beside her. We wove our breath together. She led. I followed. Another contraction came and another series of breaths unravelled like one silk thread. In time, the thread turned unraveled into a hum. We were one.

Her daughter came into the room and leapt into the fluff of the duvet. I had been at her birth 4 years ago, in the same room, in a different spring. As she left again, looking for more interesting

things to do, our hum turned into a long, low sound resonating through our bodies and shimmering the air around us. Soft with fatigue and receptivity, I was grateful to be with her in this way. Her trust was total, our intimacy effortless.

In the quiet space between one contraction and another, a piano began to play. It took me a few minutes to realize it was her husband playing in the next room. For about 45 minutes his music and our sound was all that could be heard as the morning grew. Then the midwife arrived and silently set up her things. No words were needed.

Contractions came long and strong as the mother got into the birthing pool. Her daughter had stripped naked in the process of filling the tub and she stayed that way. I put my arms into the water and pressed the mother's sacrum as we continued to sound. It wasn't long before I felt the baby's head pressing into her tailbone. "The baby's coming," I said to the midwife. A few more contractions and the head was born, then the body. The midwife lifted the baby out of the water and put her into her mother's arms. A little girl inhaled for the first time and life began anew.

I stayed for a couple of hours after the birth. The family and I ate together on the bed as the baby nursed. She had been born in such grace, in such love. I will never forget this beauty. It is rare. I gave birth to my daughter within the same beauty and began my work out of the impulse to pass it on. But fear fills our society. In 2006, 30% of women in Toronto gave birth through major abdominal surgery, according to the *National Post* (Jun. 26, 2008). One in three women has her baby cut out of her. I see this. There are times when I come home from the hospital in such despair. What I see is hard to bear.

"Man's heaven has created a hell out of this abundant paradise." Spiritual advisor Mark Whitwell said spiritual teacher U.G. Krishnamurti used to repeat this, over and over (Mark Whitwell, "Home," *Heart of Yoga,* Jan. 10, 2009). U.G. was recognized as a living Buddha, despite the fact that he himself rejected the idea of enlightenment. He knew that trying to reach an idealized state separates us from the reality of where we are, perfect in our wholeness.

The thing we're longing for is what we already are. When birth is not interfered with, a woman's integration with her baby and all of life becomes clear to her. She is in a profoundly tangible state of unity. To be one with life is yoga, *sahaj samadhi*, natural union. What happens so frequently today is that the psychology of our society and the structure and tools of the medical system separate a woman from life. Feeling alone and afraid, she tries to avoid the uncertainty and pain in giving birth and further alienates herself from her own experience. Out of touch with reality, integration is impossible. The flow of life doesn't have a chance.

When we let ourselves feel, the power and intelligence of life moves. Simply bringing your attention to the sensation and sound of your breath brings you deeper into labor. Your body functions to the best of its ability. Scientists call the hormones that are integral to the birth process the "hormones of love." The wonder of this world is that love is the force of life. It is what we are. The deepest understanding of yoga recognizes this fact and offers ways to nurture love. The key is relationship. In *Yoga of Heart* (New York: Lantern Books, 2004, p. 15), Whitwell says, "Relationship moves the life force, nothing else."

I came into deep intimacy with the mother this morning and she with me. One of the ancient texts, Patanjali's Yoga Sutras, defines yoga as "a merging with the chosen direction or experience (1.2)," Mark Whitewell writes. Certainly the mother and I were in a state of yoga. She was me. I was her. In this union, the peace and power of life moved.

Relationship is only possible when we are able to receive: ourselves and each other. Receptivity is the feminine principle. In South Asia, this principle is called Shakti, the Mother or Source. In the West, she is the White Lady, the White Goddess, Muse, or the Mother of All Living, as Robert Graves notes in *The White Goddess* (New York: The Noonday Press, 1948, p. 24). She is repressed all over the world and this repression impacts how we respond to and experience birth.

The feminine is absent from the medical paradigm, of course, and as midwifery integrates more deeply into this paradigm, she is

increasingly absent from it, too. The very structures in which women give birth deny the means to do so. Can we heal these structures? Can we bring *her* back so that living and birthing is felt to be a gift rather than something we and our children are traumatized by? I think so. She is me. She is you. In receiving each other, we can enter heaven here.

We Stand in the Gap

Marcie Macari

I STAND IN THE MIDDLE OF A CLEARING in the woods. Arms outstretched, I feel the air, hear wind rustling in the trees, feel the strength of the earth in which I am solidly grounded. I feel magical. I look down and see my belly swollen and profound, and I smile. I feel ready. Ready to become a vessel to immortality, to face my deepest fears, to welcome my little one to my breast and to begin our journey together. I smile.

Suddenly, someone flips a switch, and I'm surrounded by masked men and women wielding scalpels and force-feeding me oxygen. I try to flee, but find I'm no longer in my lovely unspoiled woods. Instead, I'm on an operating table, strapped down and naked. I awake in a cold sweat.

I always have the same dream. It never gets easier, and the fear in that scenario is just as real now as it was when I first had this dream. It's not a personal flashback, because though I have experienced some physical violation during birth, I'm thankful for being spared the worst of these scenarios. But it *is* a never-ending metaphor for my work as a birth advocate and spiritual midwife.

While I'm not a doula in the traditional sense, I "midwife" women through the nonphysical aspects of birth.

In my work, I see women's lives changed by their birth experience, for the better and the worse. It's difficult to watch so many women having no one to help them prepare for the profundity of the passage through birth, or for the aftereffects of the journey-waltz through their "childbirth preparation" classes and believe wholeheartedly that they are ready. The great percentage is not. I also see all too often women, young and easily complicit, taking their walk down the hallways of hospitals toward an "easy" birth, the birth their doctors have said will be better. Better for the baby, better for them.

Doctors base these decisions on physical, tangible outcomes. The goal is always to have a living mother and baby that fit the healthy "profile." But there is so much more to birth than the physical statistics collected in "studies" or in perceived outcomes, and many more ways a person can be healthy or injured! There is so much more going on in birth than the tangibles, and "numericals" – 6 centimeters, 7:01, 2 minutes apart, 120/80, +1 station, breathe 1,2,3,4,5,6,7,8,9,10, breathe! Is this what birth is? Is this what we've let it become?

Birth is the foundation of everything. Because of its spiritual, emotional, psychological and intellectual magnitude and investment, it touches every aspect of life, and shapes each woman's perspective.

I spend most of my time walking the line between two different, but deeply interconnected, groups of women: On one side are the women who are approaching their birth passage, who hire me to help prepare them for the nonphysical aspects of childbirth. This also often involves reconnecting to their feminine divine. There is nothing more exciting to me than when these concepts suddenly "click" for a woman. She starts to see her life and her birth passage in new ways, and the positive effects are both awe-inspiring and far-reaching.

On the other side, however, my work is more and more with women who find themselves at the end of their birth passage, feeling devastated or violated. The emotional, psychological, and

spiritual impacts of unwanted birth experiences, regardless of the types of intervention, are also far-reaching. All too often, these women are simply told to be happy they have a healthy baby, and to go home and stop thinking about it, or to take antidepressants. These mothers need tending to! I stand in the gap for these women, so that their parenting can come from a strong place – the babies have already been affected by their births. But further damage can be prevented if women are encouraged to trust (again) in their instincts.

These women are often well-versed in "how it was supposed to go," but completely new to the nonphysical concepts I focus upon. Healing for these women is a long and involved process, but eventually it does come. Their ah-ha moments are often threaded with a rage that can't be described or contained. This rage is the same rage that our forerunners had when denied access to voting, and then when arrested for protesting, were beaten and starved for their 'insolence.' It's the same rage that echoes back from women who endured legally permissible "moderate chastisement" at the hands of their husbands, and is found in the eyes of the Burmese women who endure all manner of torture and emotional pain. It's a rage that needs a voice. It must be welcomed, released, and then channelled into positive movements toward justice.

One of the most telling ways that women are frustrated about the current birth model is not what I observe during birth, but rather the questions I get asked the most by expectant women. I don't often hear: "How do I cope with pain or overcome my fear?" or even "Where should I give birth?"

They aren't questions about how or where but rather why. "Why did this happen to my niece?" "Why can't I have a VBAC?" "Why did they do this without my consent?" "Why can't I just wait to go into labor on my own?" This is a reflection of what is at the heart of a woman's perspective and experience in birth, and it expresses the foundational need to return to a women-centered, female-empowered birth model.

I have a "why" of my own:

WHY do we wait for what we *know* to be documented before we believe it! Did you know that the female orgasm has only

existed since the 1940s? Before this "discovery" was documented, I can only imagine how many women were told that their "hysterical tension" was not important, not healthy, or not their right to protect and make choices over. Does that mean it really did not exist? Of course not! Women have been having orgasms since the beginning of time! But in this situation, science had started to mislead women, and because doctors were a trusted entity, women were being masturbated by them with steam-powered vibrators in order to 'relieve their tension.' We look back at that now and wonder how they could've been so misled that they allowed themselves to be molested in such a manner. In our day now, a doctor would lose his license over that type of conduct, but in those days, the husband would take his 'hysterical' wife to the doctor to be 'cured.' Does this sound at all similar to what's happening in birth now?

I wonder how many generations behind us will feel the same about what we're buying into about birth. How many women will read our accounts online or in some futuristic version of books, mouths agape over the atrocities and violations we willingly submit to today?

Women know. It's a glorious part of being female to have innate, undocumented birth wisdom. No medical study, no obstetrical theory or thesis could ever touch the mystery we hold in our womb. It just isn't made for pure logic – it's an act of intelligent faith.

We know. We instinctively understand that there is so much more to birth than bringing a baby into the world. We recognize that the passage through birth and the one a woman takes into motherhood are distinctly separate, though often intertwined. We know that giving birth means we are literally giving birth (as a gift) to our children. And we know it is a life-changing event, not just in terms of status, but in ways that can only be fathomed and experienced by the women who walk it.

And as they walk, we stand in the gap.

Divine Tapestry

Melissa Cowl

BIRTH AS A SUBJECT HAS FASCINATED
me since the day I was born.

I was adopted in the 1960s. I always knew that I was a special
baby, a chosen baby, and the storybooks read to me about being
adopted fostered an early passion for pregnancy and birth. I was
overjoyed when at the age of 12, I was finally able to babysit for
the Orthodox Jewish women in my community; it seemed that at
different times one of them was always pregnant, which intrigued
me, possibly more than caring for their children.

Toward the end of high school, while my friends were planning
their careers, I was planning my pregnancies and naming my chil-
dren. I didn't have my first child until I was 23, but my focus was
always on pregnancy and children over pursuing a career.

When I was 17, two things happened: my grandfather died of
lung cancer and my father developed cancer. I found myself very
comfortable in the role of caregiver to both of these special men. I
realized I could nurture and encourage them, feed them, bathe and
massage them, and talk with the medical staff to encourage dia-
logue between them and their patients. In addition, I provided

information to the other members of my family in order to help make more informed decisions regarding their care. This all came very naturally. Five years later, I had my first child.

Each of my own pregnancies and subsequent births of my six children was an education in itself. From Cesarean to home birth, breech and posterior presentations, obstetricians, family doctors, midwives, and doulas, I learned about myself, my partner, birth, parenting, and partnership in general. 'Birth as a learning experience' became my motto.

Just after the birth of my fourth child, I became a volunteer in our local hospital's Maternal – Child program. It was the first time I had heard the term "doula," and when her function was described to me, I knew it would be my calling. The doula path has been a life lesson; it is not what I am, but who I am. It has not been all joy and miracles. I have witnessed the highest of highs and the lowest of lows.

I have been a miscarriage doula, a cone biopsy doula, and a tubal ligation doula, as well as a birth doula. Along my journey, I started teaching prenatal classes and birth doula workshops and, once again, I now find myself at the other end of the life cycle, helping people through their own, or their loved ones' death. Helping people through these life-altering experiences requires working at an emotional, intellectual, and a spiritual level. While people die in much the same way – with or without dignity, with or without loved ones, with or without pain – birth is no longer 'just birth' in North American culture. The variables have shifted.

I have seen outright disrespect – "This little girl just needs an epidural. They all do. You'll see, she'll be begging for it." And I have witnessed the ultimate in respect when a visiting obstetrician sat down on a woman's bed, held her hand, and told her how sorry he was that her birth experience wasn't the way she had wanted it to be, but that he didn't see any other option.

I have seen caregivers treat some mothers with outright disgust and revulsion. And, in contrast, I have witnessed love. My memory is full of scenes of love like that expressed by two midwives

surrounding a woman in transition, stroking her head and face and massaging her back.

I have seen doctors become visibly impatient when their arbitrarily imposed time limits on certain aspects of labor have been exceeded. And I have witnessed the patience of an obstetrician waiting, gloved, for 45 minutes for a placenta.

I have seen a doctor self-anointed as God yelling at a woman about *his* way being the only way. And I have witnessed true faith in the belief that birth is a normal, natural, rite of passage to be honored.

I have seen assembly line births as nurses tidy up a room around my client in preparation for the next woman before the placenta has even passed. And I have witnessed births at home, planned and unplanned, when the world stops spinning for just a moment as the continuum of time is suspended.

I have seen the results of births that did not empower a woman; where she was faceless and voiceless and childbirth just happened *to* her. I have seen trauma that is sometimes insurmountable, met with sadness, grief, and depression. But I can testify to mothers who dare to triumph in the face of adversity by finding their voice and exercising their rights to empower themselves beyond their wildest dreams.

I have seen mothers attempt to justify giving up their power by believing beyond reason or logic that their caregivers know birth better than them. And I have witnessed mothers fighting for what they deserve because they know they are best acquainted with their own body, mind, and spirit.

I have seen women who labeled their birth experience as a train wreck, and women who cried with pride "I did it, I really did it!" in the aftermath of birthing their baby.

I have seen partners take a beat, run out the door, pray or pass out; and have witnessed partners so moved by the work of labor and the safe arrival of their child that all they can do is weep with joy and relief.

I have seen the injustice of a doctor who sedated a woman seven minutes after her vaginal birth in the operating room simply

because he had called an operating room team in for a Cesarean that was ultimately never going to take place. And I have witnessed the justice and righteousness of a woman who reclaimed her womanly self after birthing her baby her way following a past filled with abuse.

I have twice seen the stupidity of hospital staff instructing women in active labor to leave one hospital for another over an hour away, once on a holiday weekend and the other time in a blizzard. I have also found great wisdom in an obstetrician who told his patient "You *can* do this, you know."

I have seen anger, pain, and sorrow. And, I have witnessed quiet calm, joy, and euphoria.

I have been saddened by the regret in the faces of my own children when I miss a special event or celebration in our own home because of my work, yet they will beam with pride at my accomplishments and teach their friends about normal birth.

I have seen a lot as a doula, but the further down the path I go, the more I learn and the greater I realize that there is so much more to come. Working with childbearing women has so far in my journey proved not only to be the fulfilment of my destiny, but also an honor and a privilege.

Choosing Home

Jennifer Elliott

"MY FAVORITE PART OF THE LABOR was at home." I hear this all the time from my birthing clients. As a doula, I love the peace and timelessness at home. I love the normalcy as we move in a familiar environment, enjoying the comforts of home – her choice of food, her own clothes (or none at all), her bath or shower, and even her own bed.

It's an extraordinary blessing to be a witness to a birth. And I have been blessed in abundance over my many years of being a doula, supporting women and their partners in hospitals and homes all over Toronto. But the births that most easily come to mind are those that have a distinctive location, the ones that occurred at home.

I recall the atmosphere most easily in homes. Often there was a sense of peace, and sometimes even fun, as we moved through the rooms of the home, and in warm weather enjoyed the porch and yard as well. I've explored backyard playhouses with older children; I've browsed bookshelves and foraged in cupboards and fridges as I waited and encouraged, moved closer and stepped back; I've

napped on couches and grown to know pets, older children, friends, mothers, and sisters.

I've become intimate not only with the couple, but also with the bathroom floor that I wiped clean of drops of blood, the laundry room where I salted and washed sheets after the birth, the birthing bed that I sat on while pressing on the laboring woman's back. Once with a woman on her hands and knees, I stood on her bed, straddling her to apply strong pressure to her back. That memory is all the more powerful as thunder crashed outside the bedroom window and lightening lit the room. I discovered that one's home is truly a sacred place as I experience the feeling of wonder that permeates it following the birth of a baby. I've even experienced the celebration that comes with a picnic around the birthing bed, sometimes with scotch or champagne to toast the new baby.

I have no favorite home birth. I treasure each one and its many special moments. There was the woman who held off getting into her warm birthing pool until she was ready to step into active labor. In one moment, she immersed herself in both soothing water and the intense waves of active, progressing labor. She found the space she now needed, the relaxation of the water, and the support of her doula and midwife as she birthed her daughter into the welcoming watery warmth of the pool in the middle of her living room.

One woman retreated to the privacy of her small bathroom to find her own way through labor. And another sat for a long time on her toilet, then birthed squatting in her bathtub. The mother is autonomous in her own home. One never knows for certain what room the baby will be born in, or what position the mother will be in – squatting, kneeling, standing, on the birthing stool, leaning into her partner, perhaps birthing on the same bed that they conceived on. There's something organic and spontaneous about birthing at home.

Home birth accommodates families so well. I remember a 6-year-old boy sitting in the hall on a small chair he positioned himself. He faced his mother on her bed. His younger brother had already been tucked back into bed by his dad. Now only the older

one was watching, quietly fascinated, as his youngest brother emerged. All reassuringly normal because it was happening in his own home.

A mother on her bed shushed me through the peak of her contractions, then beckoned me closer to her to whisper encouragement as the sensation faded. She led and I followed. She who was in charge in her own home, and I who was a guest. She who was safe from the entrance of strangers.

There was lunch in a bright kitchen while the boys played and circled their mother, bringing her things, then moving away to play elsewhere. Familiar food, toys, and family surrounding her, normalizing birth even as she moved toward something momentous. And then the moment when she withdrew and moved upstairs, birthing her baby quickly in her own bedroom and inviting her older son to witness his brother soon after.

In another home birth, a woman progressed through labor while moving from floor to floor of her home. She enjoyed every room on the main floor in early labor, paused briefly on the second floor, then reached the third floor for transition. She was the one who stepped in and out of her labor, pausing and greeting her brother who stopped by and chatted from the stairs, then waving him away when she was ready to continue her labor. Later, she almost left the room during that hot summer night when she flung open the window facing the park and seemed to thrust most of her body outside.

One cat, the anxious one, stayed on the second floor at the bottom of the stairs, almost pacing, while the other was quietly present throughout. Eventually this cat curled up on the father's back as he stretched over the bed on his stomach reaching to touch his wife as she sat on the birth stool.

And then there was the birth oasis just on the other side of the construction zone inside their home. I stumbled over renovation materials at the front door, but soon found the calm place this couple had prepared for their baby's birth. The ensuite bathroom was finished, the bedroom a sanctuary where they birthed and retreated from the world after their baby was born. The chaos of construction

was out of site and mind (until I stumbled back outside the room with the laundry I took home to wash, since they didn't yet have a working washing machine).

I attended one birth that seemed an exquisite scene from a movie in its beauty and strong female presence. Two midwives, a friend and two doulas. All women, gathered in the family room. A snowy December night outside and a blazing fire inside. In no time at all, she moved from the couch to the floor. We circled around her on our knees, lit by the fire, like women from ancient times supporting the energy and wonder of birth. So quickly she brought her daughter into the world. And announced immediately, "It was perfect!" I remember thinking of her parents waiting downstairs. I delighted in their astonishment when I came to tell them that the baby was born. They had been fully prepared to take their daughter to the hospital to give birth.

Now as I travel through the city, certain neighborhoods and houses call to me and remind me of those sacred moments. I imagine the families still living there and recalling the treasured memories of their children's births in various rooms of their homes. Perhaps a special feeling catches them sometimes and inhabits the place they birthed, the chosen room.

Roaring Life into the World

Rean Cross

IF I NEVER REALLY CONNECT WITH another client, it'll be okay. I've done what I needed to do. I'm a little awed by having had the chance to be someone's catalyst for change. Just a catalyst – the change was in process. But for the rest of my life I'll hear her voice shouting, "Rean! Women's bodies are strong. *My* body is strong!" I'm so glad I was able to participate in this.

Today she gave me a gift with a tag that read:

> With permission comes choice.
> And making choices based on what I want
> and not what somebody else is telling me,
> feels so empowering. Thank you for
> giving me permission.

A woman hired me for postpartum breastfeeding support with her second child, due in a couple of months. She asked if she could see me for some counselling to process her first birth experience, which sucked from her point of view. She's a woman of strong

moods and opinions, but a lovely person with an engaging personality. She had a doula at her first birth – a friend who was new at it and who froze. We'd been talking for several weeks and her due date was upon us. At the last minute, she finally asked if I would attend her birth. I think she realized that her desire to labor entirely alone came in part from feeling there was no one she could trust to really be there for her. She came to trust me.

Among her issues were problems with breastfeeding her first baby, combined with a birth that was sped up chemically until she could no longer endure the contractions and opted for the epidural she had wanted to avoid. She had a lot of "my body doesn't work" stuff going on. Because she had had uterine surgery a number of years ago to remove a cyst, she was also considered a VBAC (vaginal birth after Cesarean) for both of her births. She experienced postpartum depression after her first birth that went unspoken and untreated. At the root of the broken body stuff was growing up as the fat kid in a family of fashion models. At 11, she was on the swim team, playing soccer, and on her first diet. She is now tall, graceful, with luxuriant hair and gorgeous skin. She is also very overweight. She has no idea she is beautiful.

She knew she wanted to labor at home as long as possible as a way of avoiding hospital interventions. However, she knew she'd only really felt safe planning a hospital birth because she works with special needs kids, some of whom have special needs as result of birth injuries. She felt she needed the reassurance of the hospital, but was very conflicted about that need.

She went past her due date. Her care provider started talking induction. She resisted for a certain amount of time, but agreed to do it at the end of the week following her date. She was prepared to throw away her natural birth desires in the face of this intervention. Happily, she went into labor herself the day before she was scheduled to be induced. It went off and on all day, and we stayed in touch by phone. I ended every conversation by telling her I was ready to come whenever she wanted me there. She finally called in the evening to say it was getting hard and she needed help. I found her in what I judged to be early labor, contracting hard and

fast, with contractions coming every two to three minutes, but only lasting 30 seconds. No bloody show at all, waters intact. She was having a hard time, but talking between contractions. I figured there were many hours to go.

Things started to change after I'd been there for an hour and a half or so, and I thought we were seeing a move into active labor. (Vomiting, then into the shower, then back and tearful. Waters released while sitting on the birth ball, clear, still no show. Contractions finally seemed to be lengthening a bit. I thought we were seeing the 4-cm mini-transition women sometimes experience.) That would mean we likely still had a few hours to go. A bit later she says she thinks it's time to go to the hospital. I've been there for two hours. Her husband gets her clothes; I start getting her up and ready. Then, she makes a funny noise during one contraction, and I look at her when it's done and ask if she was pushing. She says yes, and I'm trying to figure out what to do, whether to dash to the car or stay put. When the next contraction comes, she puts one hand on the wall and yells, "Call 911! The baby's coming!"

The next 10 minutes are a mad dash of activity. I help her get to the living room couch while her husband calls 911. I can see he's being questioned about me by the operator, trying to explain the difference between a midwife and a doula, so I grab the phone and send him for towels, green garbage bags, and a bowl. I get royally yelled at by the 911 operator for having allowed this situation to develop. I keep explaining that I'm a doula not a midwife, that I have no clinical skills, and have not assessed this woman's dilation. I know the baby's coming because the mother says so, and I've seen pushing before. I finally tell her, very firmly, that regardless of whether the birth is imminent there is no way in hell we're transporting this woman and would she just send the damn ambulance!

Meanwhile, my client is roaring. I've rarely heard a woman make such a powerful noise pushing. I'm having no luck encouraging her to pant to slow the birth. At first she would not open her legs and let me see what was going on. (I should add that when she first lay down on the couch and I tried to take her underpants off, she suggested I just cut them off with scissors!) When she finally opens, I

can see a toonie's worth of baby scalp. I look at Dad standing by Mom's head and ask him if his hands are clean. He looks very confused, so I tell him to go wash his hands. With the next push, the baby is born to the eyebrows while Dad stands in the doorway with water dripping from his hands. So I holler at him to come back and get ready to catch his baby. As the head is born, I notice flashing lights through the living room curtains. We try to check for a cord around the neck, but by the time I can figure out what I'm doing, the body is born, sliding into her father's waiting hands. She takes her first breath as a knock comes on the door. I leave the parents and go answer the door to let in the firefighters and paramedics. I then run back to the couch and instinctively pick up the baby and place her on her mother's chest and cover them both.

The paramedics, who walk in to see mother and child together, are fantastic. They never separate mother and child, examining the baby and clamping her cord right where she lies. They administer blow-by oxygen to the baby, not because it was really necessary, I think, but because they felt like they ought to be doing something. They sit and chat while everyone calms down. There's lots of laughter. Meanwhile, I catch the placenta in the bowl Dad brought. Apparently, the paramedics have forgotten about the placenta. They wait for Mom to breastfeed for the first time, and then wait while Mom goes to have a shower. Mother and child are finally transported to the hospital, at Mom's request, to be checked out one hour after the birth. The baby rides in her mother's arms. Baby is 9 pounds 14 ounces! I wish I knew some way of having someone come to check on them at home so that the hospital visit wasn't necessary, but I don't.

The parents are both very excited about what happened. Dad is very proud of catching. I worry that the next day they'll start thinking of what could have gone wrong, and may question why I didn't tell them to go to the hospital earlier. My fears are unfounded, however. They remain absolutely delighted. The mother is convinced that everything wonderful about her child is due to having been born at home. She has become an advocate not only of home birth, but also of unassisted birth, after I told her about the customary

interventions that would have happened had midwives been there. It's a little over the top, perhaps, but this has become a tremendous source of strength to her, and testimony to the transformative power of birth. She shouts "My body is strong!" in the shower 45 minutes after giving birth, after roaring life into the world. Cool.

I'm thinking I should carry a few basic "surprise" supplies in the future: a couple of pairs of gloves would have come in handy, and some cord clamps and scissors might be a good precaution, although perhaps not without some training first. I'm also going to be a little more vigilant with second timers in the future – I'm more accustomed to the pace of first babies.

Twenty four days later, breastfeeding was going well. Although she had a moody week or two during which we talked daily and I visited two or three times a week, Mom was coping well. Her family and friends were even telling her how relieved they were to see how much better she was doing after this birth compared to the last one. She also sought counselling for postpartum depression in the second half of the year. So, a good birth hasn't been a miracle cure, but she's naming problems and facing them head on. And as for me, I think I've found a friend.

Now, a few years later and we're still friends.

A Letter to Anna

Carol Niravong

DEAR ANNA,

It's a lovely autumn afternoon as I sit down to write this. I've just Googled you and see that you're still working as a doula.

Do you remember me at all? It's been almost 6 years since Noah was born. My 8-pounder is now 50 pounds. And I have a second boy, Ronin, who just turned 3 last month.

I know you don't know about Ronin. You weren't my doula at his birth. And this is what I want to write to you about: how it was possible to wholly appreciate what you did for me, and yet not ask you to be my doula a second time.

From the start, you were clear about your philosophy and I agreed with much of what you said. You believed that a doula should not come too early, that it made the mother-to-be anxious, and that it was like watching a pot boil.

When my water broke that cold February night – 4 days past my due date – my husband and I were very excited about our first child. I had plans to "breathe" through the initial pain, maybe even order some sushi. I called you to give you a heads-up and you said to call again when the pain intensified.

Well, the pain came very quickly and it seemed like it was coming every five minutes. I didn't want to be a prima donna and I tried to wait it out, but I must have called you again a couple of hours later. You said that I was fine – I guess because I was still able to talk – and that you thought it would be best to wait a while longer before coming.

It was indeed the most agonizing pain I'd ever felt. My husband couldn't bear to hear my cries – I think he was on the verge of fainting. The bloke had no idea what to do. When he finally called you again (6 hours after my water broke), you agreed it was time to come.

When you finally came into my room, I know my husband and I both felt a wave of relief. I was completely naked and didn't care. You skipped the small talk, stroked my back, and said, "Carol, I want you to breathe into the pain." Your presence was magical; really, it was. I stopped the screaming immediately, and wondered how despite 10 weeks of prenatal yoga, I had completely forgotten about breathing into the pain.

You were able to anticipate all my needs as if we had rehearsed this dance a thousand times before. My midwife came later and it seemed like everything would work out for my planned home birth. You probably don't remember, but it didn't take long for me to get to 9 centimeters. But from 9 to 10, it was an excruciating 3 hours. This was followed by 2 hours of unproductive pushing after which my midwife said we would have to go to the hospital.

I was devastated that it wouldn't be the beautiful home birth that I'd spent months fantasizing about. You knew I didn't want any intervention but you also knew – more so than I did at the time – that it was a posterior baby, and likely difficult to come out. You supported me as best as you could. But after the oxytocin, the electronic fetal monitoring, the epidural, and two more hours of pushing, I submitted to a C-section.

As I lied there in the operating room, just before they would slice me open, I remember saying through my tears, "Anna, this is my worst nightmare." And you looked at me, and stroked my hair,

and told me how strong I've been through all of this, and how hard I worked at bringing this baby out as naturally as possible. But sometimes things don't work out as we plan, and in days gone by, I may have died giving birth. You were teary-eyed, and I thank you for that.

Anna, you were my lifesaver. I loved you for being there with me for so long.

But when I got pregnant again, I didn't call you to be my doula. I still feel guilty about that, but I needed to do things my way.

Have you ever read that children's book called *I Love My Mommy Because...*? It has lovely illustrations of various animals and their young, and goes with something like this: "I love my mommy because she reads me stories. She listens when I talk. She feeds me when I'm hungry." Then on page 13, where the alligator and her young are pictured, it says, "She comes when I call."

In my heart, my mother was never there when I called. And so I quickly grew up never needing her. The self-sufficiency came from a place of resentment rather than independence.

When I needed you, Anna, and called for you, you didn't come. Intellectually, I understood your philosophy and reasoning. But on that February night, I was a baby, and you didn't want to come.

So I hired another doula, Leah, who promised that she would come whenever I needed her. The guilt and feelings that I betrayed you are still with me.

I hope you understand. But mostly I want you to know that you have a place in my heart.

Carol

The Great Letting Go

Amanda Spakowski

WITNESSING CHILDBIRTH IS AN extraordinary and life-changing event. We are very lucky to live in an era that encourages the presence and participation of partners as birth supporters. However, the *experience* of husbands and partners is often left out of the equation when preparing for birth. In addition to learning the 'what to expects' about birth and parenting, it's also essential to consider the special preparation a partner must have to witness childbirth and to develop confidence in themselves as birth supporters.

The first task in this preparation is to evaluate the limiting beliefs we carry about what a 'good birth' looks like. Only when we've taken an inventory of our preconceived ideas of birth are we able to accurately identify what we need for birth and support laboring women from a place of acceptance instead of fear.

When many of us picture women laboring in childbirth, we picture a woman drenched in sweat, screaming in angst or anger. This image evokes feelings of being out of control. We feel that she needs help, that she is not coping and we want to change something for her. We've internalized the idea that coping is limited to

quiet controlled breathing. It's difficult for us to accept that strong vocalizing, rocking, heaving, and vomiting are normal and helpful ways of coping with the intensity of birth. When it comes down to the moment, many of us feel uncomfortable and unprepared for this behavior in birth.

Acknowledging Internal Beliefs

From a very young age, society cultivates the idea that only particular behaviors are acceptable, polite, or appropriate in order for young children to integrate themselves into their greater community. Ascribing to these parameters helps growing children learn to be a functional part of their community and in this sense is very useful.

However, these constraints on social behavior do not have a place in the birth room. As laboring women, our challenge is to let go of the societal norms of good behavior and embrace the instinctual movements, sounds, and bodily urges of childbirth. As birth supporters, we experience the same challenge as we are called to fully accept, support, and encourage the mother to do anything she needs to do to let baby out.

Holding back in birth can hold birth back! Resisting an urge in birth, such as vocalizing, swearing, rocking, crying, etc. often includes some form of physical tension, which impacts our body's ability to open and let labor continue. The real work of labor then is to let go. Let go of wanting to control, let go of preconceived ideals of 'good coping.' Let go of trying to *change* what you are feeling and, instead, welcome the natural responses of the laboring body.

The Great Letting Go

From the early stages of labor (and even in pregnancy!), we are challenged to begin letting go of beliefs or expectations we have about our self and about birth. For example, you may need to deviate from your birth plan and adjust to the next best thing. Or perhaps the doctor or midwife on-call is one you haven't met before and you need to embrace this new person in your support team. For many parents, as labor progresses, the intensity of surges increases and you are challenged to try new ways of coping or sup-

porting. In any case, as the intensity in labor continues to increase, the need to be flexible and open to our experience, instead of resisting it, becomes more important.

There sometimes comes a point in labor when the mother completely opens to the urges of her laboring body and without restraint she moves and heaves, cries and moans, vomits, and leaks. She is completely present in her laboring body, she is completely letting go. I call this point in birth "The Great Letting Go." The Great Letting Go is often a part of birth that partners are not prepared for. It happens when the mother no longer holds back what she is feeling and fully expresses herself as she opens to labor. The Great Letting Go can be overwhelming to witness and is often associated with the most intense part of birth.

By 'intense' I don't necessarily mean the most painful. For many women pain is a part of their experience. For some women it may dominate their experience. For a lot of women, they describe labor as painful to some degree, but more emotionally intense or ecstatic than painful. Their physical and behavioral response is to the *intensity* of birth; whatever that means for their unique experience of childbirth.

By this description, it follows that the way a woman looks in birth is *not* necessarily reflective of the amount of *pain* she is in. This is an important lesson to note when being witness to and supporting a woman during The Great Letting Go. In the documentary *Orgasmic Birth: The Best-Kept Secret*, one woman says about her birth experience, "I needed to scream. It wasn't necessarily pain[ful], but it was all just so overwhelming. I *needed* to just call out…it felt very satisfying to scream. Extremely satisfying."

To an outsider, this woman's response in birth may inaccurately suggest she was in tremendous pain. A person looking in may conclude that she is not coping well and suggest this to her in the way they look at her, touch her, or the support they offer her. But, in fact, she is doing all of this *because* it feels good to do it! Her screaming, crying, moaning, rocking, rolling, swearing, pooping, and complaining is *her way of coping*. She is doing it because it helps.

During The Great Letting Go, it's important that partners check in with themselves and notice what assumptions they're making about the moment. Only after letting go of these assumptions and really tuning into what's needed in the moment can we support the mother in her natural responses to birth. When we offer non-judgmental support in this way, a mother feels accepted and encouraged to continue doing what works for her.

So what does support really look like during the Great Letting Go?

Support During the Great Letting Go
It's very normal to question yourself when you are being so physically and emotionally challenged as you are in labor. Women may feel self-conscious of letting go in birth and need to be reminded again and again that it's OK to do what works for them to cope. As birth supporters, we can create an environment that encourages her to allow her body to do the work of birth and reassure her that she is accepted and loved even in the face of completely letting go.

We are sometimes under the impression that we need to do something tangible or hands-on in order to be helpful. For partners, this is not necessarily the case. Simply being present for her can make her feel supported, even when she's also coping by howling, rocking, or calling out. Support during her most intense moments in birth may be as simple as telling her you love her, giving her the occasional (or many!) kisses and being nearby.

However, there are other things we can do as birth supporters to help her let go. As I said before, women may hold back during birth. They may hold back feelings of sadness, anger, or pleasure for fear of making someone uncomfortable. Or it may be bodily urges like moaning, moving, or dancing. Supporting during The Great Letting Go includes giving her permission to embrace her urges and do whatever her body needs her to do.

You can invite her to fully express herself by directly asking her, "Is there anything you're holding back?" and inviting her to do that thing. If you know what it is she's feeling nervous about doing, do it with her so she's not alone, no matter who comes in the room.

This shows her that it's OK to go on and she doesn't need to

stop. If she sees that you're not dismayed by the change in environment it reassures her that she is not alone and can keep going.

Support for Partners

While sometimes labor support is focused solely on the laboring mother, husbands and partners need to have their own support system in place for birth, too. Becoming a parent is a big transition and witnessing your loved one through birth can be difficult, even when you're well prepared for The Great Letting Go. During pregnancy, before you go in labor, consider what support might be helpful for you as birth partner.

Doulas offer non-medical support during pregnancy, birth and the immediate postpartum and can offer amazing resources for both the mother and partner. Your doula will come to your home in early labor, many times even before you see your healthcare provider so that you're not alone as you navigate your way through the unknown of birth. For partners she can offer suggestions for support, allow partners to take breaks to eat, sleep, use the washroom, or get fresh air, and give partners emotional support throughout the birthing process.

Practice 'letting go' during the prenatal months. This is the time to explore your beliefs about birth, determine what good support looks like, everything from receiving to accepting support for yourself. Notice where you can become more flexible and practice it. If you never allow yourself to be goofy or dance, do it! Have a dance party in your living room or make funny faces in the mirror. Do what you need to do *now* to cultivate a flexible mindset for letting go and accepting birth fully.

You may also want to enroll in a prenatal class or another course that further cultivates this sense of flexibility and offers practical emotional preparation for The Great Letting Go of birth and parenting.

Whatever it is that you need to do to prepare yourself as partner and/or birth support, make sure you do it before birth. In order to be the best support you can be you need to be supported as well.

When you consider the special needs of partners, it not only makes a difference in the partner's experience, but it also makes a

tremendous impact in the way a mother feels supported. Practical preparation of partners for the emotional and mental challenges of supporting birth is *necessary* to develop the confidence and flexibility to navigate the unpredictability of labor.

As practitioners, giving ample time and consideration to the partner's experience can have a tremendous impact on their development as a parent and their relationship with their child. We've allowed partners into the birth room, it is now time to take the next step and include them fully in the preparation for birth.

A Life in Birth

Isabel Perez in Conversation with Crescence Krueger

ISABEL PEREZ HAS BEEN MY FRIEND over the last 16 years. Her life encompasses the ancient and modern, the rural and urban, South and North America. Birth has always been at the center of Isabel's life. She lives within an effortless recognition that the seen is evidence of the unseen, that heaven and earth are one condition.

Isabel was born in Guatemala to Mayan parents. Her great-grandmother was a nodrisa, a traditional midwife. Her father was a shaman. After the devastating earthquake in 1976, Isabel, her husband, and children were brought to the United States by Ina May Gaskin, a pioneering midwife, now world renowned. Isabel trained and worked with Ina May for 4 years on The Farm in Tennessee, a special center where women can have a natural childbirth in a safe home setting. She contributed to a community whose way of handling birth resulted in a Cesarean rate of only 1.4% among 2,028 women from 1970 to 2000. Home was the environment for 95.1% of the births. Isabel then moved to Toronto where she practiced midwifery until it was integrated into the Ontario healthcare system in 1994. Subsequently, Isabel has worked as a doula.

What follows is some of the conversation we had in her kitchen this past May while Isabel cooked and shared a breakfast of rice pudding.

Crescence Krueger *What is the most powerful thing that you bring to a birth?*

Isabel Perez Confidence. Peace. Love. And trust. Those are the words my clients use, eh? So I'm just repeating them. I have a very simple personality. And that works for me almost everywhere. It's very simple the way that I work. Very simple. You have seen.

CK *That's what I love.*

IP Women, especially these days, find information on the Internet, in books, from their doctors. Anything they want to worry about, they can find. And for me, I touch those things if they really want me to touch them. But if they don't need me to, I don't. I keep it as simple as possible. I use my hands and my voice, pretty much.

CK *Keeping it simple allows you to drop into the heart.*

IP Yeah.

CK *To not get caught up in the head…*

IP Oh, yeah!

CK *…and to come down into the body and into the heart. That's where the spiritual work of birth work comes in, right?*

IP I think this is one of my gifts. I have very good intuition and I go to people and work through my heart and through love. I love my clients. I don't use them as my work. I use them to become very close with them.

CK *There's an intimacy.*

IP Yeah. If I use my heart, I listen to my spirit. And I believe that my spirit guides me to better places. Sometimes if I fail, it's because I wasn't listening. Most of the time, I hear [them]. Most of the time, I know. So when I come here to Toronto and get involved in so much, my mind comes to be very busy. Now that I'm getting older, I'm taking myself back again to the place where I was.

CK *To where you began. You said you had an urge to do this work when you were 12. Do you remember what it was that was drawing you?*

IP Oh, because of the work that was happening in my family around birth.

CK *That attracted you?*

IP Oh, yeah, that attracted me. We lived in my parents' house but we spent most of our weekends at my grandparents' farm. My family was very traditional. My grandfather was Mayan from my mom's side. His mother was a nodrisa. She worked for the wealthy people. She lived with pregnant women and took care of them through their pregnancy and she caught the babies and she actually breast-feed the babies herself.

CK *She did everything.*

IP Yeah, she left their homes when the babies stopped nursing, I guess. So my grandfather, he inherited this farm from her. When I was a kid, if we didn't go to the ocean or to the rivers, we went to the farm. You know...our family was so big, my grandfather used to rent a bus. We used to go on a bus...to the lakes and they'd cook and we'd swim and have fun and when we [weren't] there we'd go to the farm. And the farm was beautiful. It was amazing. He had an orchard. He had it for us so we could go and pick and

eat whatever we wanted. And he had a few animals. He built a room for each one of his kids with their kids. It was big enough for all of us to sleep in. And there was a tiny little kitchen that our mom could make breakfast in. For lunch we did it in the big kitchen...almost the size of my house!

CK *How many were in that extended family?*

IP Oh, we [were] 39 grandchildren.

Laughter.

CK *Wow. I remember you telling me a story about...was it the farm that had a room specifically for women to give birth in?*

IP No, that was in the city. My grandparents owned another house in the city. They had this tiny, tiny room. It had one bed and a table and a dresser. This is where all the babies was born. There was kids always being born...and of course we got training. If you was young, if you was of the age, you know, that you could be training, right?

CK *Training by watching and being around?*

IP Yeah, I think so.

CK *You told me once about a birth where your grandmother organized making chocolate to keep all the children busy until the baby was born.*

IP Yeah. My grandmother used to make chocolate for business. She always had a batch ready for when somebody was going to go into labor. She processed the chocolate night and day. So we hang out with her, you know, drinking tea or whatever, or coffee, who knows, and eating. I remember my mother was in labor and

my grandmother was roasting and working on that until the baby was born.

CK *It was a good labor project.*

IP Yeah, because it's a process to make homemade chocolate.

CK *And so your life and birth were integrated, right?*

IP Oh, yeah.

CK *It wasn't something that was hidden away in hospitals.*

IP No, no. My family started going to the hospital when our midwife died. I went to her when I was pregnant with Frederico, my first child. She was still alive but she was blind. Her son was a doctor but she was still taking women. She did the tummy massage and she palpated the babies. She died the year Frederico was born so I gave birth to him in the hospital.

My mother and grandmother always tell me what to do when I was pregnant, what I need and don't need; they was very aware of the pregnancy process. This is how with the earthquake and being pregnant with my twins, I didn't bother to go to the hospital or to a doctor because it was too hard to get to the doctor.

[On Feb. 4, 1976, more than 25,000 people were killed when an earthquake devastated Guatemala City.]

And I thought, "I know how to take care of myself." And I pretty much went to the hospital just to give birth.

Laughter.

I was fully dilated when I got there.

Laughter.

CK *You were fully dilated?*

IP Yeah, yeah.

CK *You were living in a tent then?*

IP Oh yeah, because of the earthquake, we moved to a tent. We moved to a tent with 350 people, families. Yeah. And this is where I was for my pregnancy. And ah, this is where we lived when my twins were born.

CK *When did you know you were pregnant with twins? How did you figure that out?*

IP *Laughter.* I was denying it…but everybody thought I was pregnant with twins. I was huge, bigger than ever, right? But I didn't want to pay attention to that. I didn't want to be overwhelmed with that, so I just carried on until, until the first baby come out.

CK *Oh, you're kidding?!*

IP Yeah! The first baby come out and my doctor said that it was his first delivery. And actually…

CK *Of any baby?*

IP Yeah. He said that it was his first delivery on his own and he wasn't so sure what was going on because I still have a big lump.

Laughter.

IP The big lump. And so he went to get another doctor and they got a midwife who comes and she checks me and she's like, "Oh, Doctor, she has another baby there." So 22 minutes later the second

twin was born. Yeah, they say when you start feeling contractions, just push like you have to push a big cow. Because the other baby, Elmar, was feet first, right, he was breech. And so, I push and he comes out. Yeah, I think we just lucky, you know. I think we was just lucky.

CK *And he was fine?*

IP He was fine, oh yeah. We went home 48 hours after they was born. Yeah, they was nursing; I already had two children. Frederico nursed for 2 1/2 years and Lukie nursed for 2 years so I know my way with that one.

CK *And no bleeding issues?*

IP Not that I remember. It was fine. I don't remember having major issues. I was on my feet pretty quick. We don't have no, there was no ah, no choice, right? You just get up and do what you have to do.

CK *And you were still living in a tent at that point?*

IP We living in a tent. We have to walk almost two blocks to get to an outhouse. We have to walk to go and wash the laundry.

CK *You were doing diapers for twins.*

IP Yeah, my two sisters and my mom, they come and help us out in the beginning. They always helped out for two or three weeks. They cook and do the laundry and help out with the kids.

CK *And so around this time is when you met Ina May?*

IP Ah, well I met Ina May probably when the twins was under a year old. I met Mother Theresa first.

CK *Mother Theresa?*

IP Yeah, yeah. This is how I met Ina May and The Farm. Because Mother Theresa come to build a place for mothers who have babies so we can go and get water; we can get food or do our laundry. And so we did an exchange. I help in the kitchen and with cleaning and they take care of my twins for two or four hours so I can go and organize my day with my other kids. And the people from The Farm, they was working in Mother Theresa's place.

CK *Ah. I never heard that part of the story.*

IP Yeah, so this is why Mother Theresa is one of my spiritual guides. You know that I have her on my altar? Because she's in my work.

CK *And so you met Ina May when you were working there?*

IP Yeah. I was pregnant with Carla, and she said, "Why don't you go to The Farm and have your baby? I could train you to become a midwife." So I say, "Really?" I really wanted to do that since I was a girl. It had been sinking into my head. We got to The Farm when I was eight months pregnant. I have to be on bed rest for almost three weeks. That was the only way that I could keep her inside. It drove me crazy.

CK *And what was the birth like?*

IP Was good. Was long because I had been resting. At seven in the morning on my due date, I got a call from them and they say, "You can get up and do whatever you want." Before, every time that I get up, I was having contractions. She was born by 10 in the night. I was in labor all day.

CK *So you really had kept yourself from giving birth!*

IP Oh, yeah. All my births are a piece of cake.

CK *How long, on average?*

IP Usually my labors start around four in the morning. I used to wake up with my water breaking and then contractions start happening. Frederico was born at 9:15 in the morning.

CK *Five hours.*

IP Yeah and Lukie was born at eleven in the morning.

CK *What about the twins?*

IP The twins, the same. My contractions, they start in the early morning and I always do the same thing: have a nice warm shower; get my house clean; sweeping; making sure everything is done. And Fidel made sure that his work knows that he wasn't going and I went to the hospital about 8 in the morning. Eight? No. It wasn't eight. It was later because I was fully dilated when I got there. And Paula was born at 10 in the morning. And Elmar was born at 10:22. Yeah. Fast, fast, fast, fast. Nice and easy.

CK *And then how did your training begin? That's something that interests me enormously because you were mentored as a midwife. And that form of training no longer happens here, obviously.*

IP Oh, it was very beautiful and I think there's really no comparison, you know. I even learn English through midwifery.

CK *Did you know any English when you came to Tennessee?*

IP No.

IP Ina May knows a little bit of Spanish so she say, "You teach me Spanish and I teach you midwifery." And I say, "Sure! That sounds easy!" And so she invited me to come to the first birth when Carla was one month old. She said, "Are you ready? You can bring your

baby." So Carla was allowed and I started to go to births pretty much to observe. Not doing anything. Just to sit and watch. And slowly I stopped bringing Carla with me because she was starting to move around. Sometimes I'd have someone come and pick her up because the baby was going to be born and at that time I was already helping out. And then I used to attend three days of clinic a week also. The clinic was very simple. We checked the pee and blood pressure and made sure the babies was good [*by listening to fetal heart tones*] and the moms was good. Of course, most of the women, they was in good health. We didn't have to worry. So I worked there, at the clinic, and I was going to every birth, especially if the birth was risky for some reason: twins births, breech babies.

CK *How many births would The Farm midwives deal with a month?*

IP Oh! They used to do a lot. I was on my own one time, being the only midwife with assistant midwives. I think they left me just to see how I handled that. And we had three births in less than 24 hours.

CK *Was that because The Farm was so big at that point? Or was that because so many people came in?*

IP Because a lot of people come. A lot of people on The Farm have babies but also we have people from all over the place: from Germany, from Mexico, from Chile, from all sorts of different places in the States.

CK *I remember you telling me that Ina May wanted you to take responsibility for births a lot sooner than you were willing to.*

IP I attended a hundred births before I caught my first baby. It was only because she keeps saying, "You know…you are ready! You're more ready than you think." And then one day I said, "OK." The woman was my friend and so it was very nice. The baby had the

cord around the neck, but Ina May was right there and she said, "It's OK; you just do this." Very peaceful. No pressure.

CK *No stress?*

IP No stress. No excitement. And I was able to do it and it was like, "Wow!" All the other midwives was very nice, too. I did feel very special to them because they know where I come from and they know my English wasn't big, so they really teach me by showing me...even holding my hands. Ina May and all of them, they used to hold my hands.

CK *So teaching through touch, passing on the skills in such a tangible way.*

IP Very gentle. Very gentle. After, when I moved to Toronto, I realized that I had learned midwifery through energy, through the vibrations of what was happening because the language wasn't my language!

CK *Yes, but even more, because that's how Ina May worked anyway, right?*

IP Yeah.

CK *What did you learn from Ina May about the essence of your job as a midwife? Where was most of the attention put?*

IP On love and compassion. And not... mmm...not to have expectations. Just to go with the flow. I think that was pretty basic.

CK *So you're working with the feeling in the room, the feeling from a woman, the feeling in her partner.*

IP Right, right.

CK *And making sure that that feeling was good and warm and open and loving.*

IP Yeah.

CK *And then from that, I'm guessing, things would then tend to fall into place, right?*

IP Yeah. And also I think I learn...because Ina May is very strong...even if she's very sweet, she have a strength in herself, I think I learn a lot of courage, a lot of strength from her.

CK *That she would go to that place of strength and calm.*

IP Yeah. That was her strength.

CK *One of Mark Whitwell's yoga teachers was T.K.V. Desikachar. His father, Krishnamacharya, was a great and very learned yogi, a healer, and teacher. Desikachar says that you can pass on informa-tion, a ton of information, but true teaching happens through the heart and it's a transmission.*

IP Yeah. Yeah.

CK *What I get from you is that Ina May is a true teacher.*

IP Yeah. Yeah.

CK *And that you were a true student!*

IP I love Ina May. In my heart, I love her. I do love her. I have her in my prayers and in my meditation.

CK *What we get through love and compassion, that's missing when we just pass on information to each other. And in that absence, the truth of the power of this work is missing, I think.*

IP Then I think people use power but they don't know how to use it; they don't understand what real power is. You can be so little but have big strength. That is power, right? But they don't understand. Power in birth comes from being able to accept reality. You deal with things as they truly are. This is what is happening right now. And you have to do that, right?

CK *Right. So it's the greatest spiritual work...*

IP Yeah.

CK *...seeing reality for what it is. And getting out of your own way around that.*

IP Well, that's one thing too. Whenever I have clients who I know are in their head, I just take it. I hold their head and I say, "Take a deep breath and just get out of your way." Yeah so...

CK *Birth demands...*

IP It demands integrity in your own self. As a support person, right?

CK *Yes. Huge. Yes.*

IP Even when your life is falling apart, you don't bring that into the place. You always have to learn to put your life to the side and be there because this is where you are.

CK *Fully present.*

IP I really like my work right now. I don't know if I miss catching babies. The actual catching can be very challenging, holding those babies when they are so slippery, making sure they're not going to drop. You have to be so conscious. To hold them...it's pretty interesting...I think the way we work is very easy.

CK *Well, it's clear and it's focused and no one else is doing what we're doing.*

IP I'm enjoying it. I'm very at peace with myself. I've done midwifery. Maybe I was meant to do it to learn and to have a better understanding. Now, I'm free.

The Art of Giving Birth: The Power of Ritualizing

Heather Mains

PRESENTED HERE IS THE FINAL CHAPTER of Heather Mains' Master's degree thesis "The Art of Giving Birth: The Power of Ritualizing," an ethnography that examines five home births and five hospital births in a large urban area in Canada. The data was collected from the perspective of either a doula or a photographer at these births and included a postpartum interview. In particular, it examines the way women created their own rituals for comfort, coping, and security before and during childbirth.

This detailed ethnographical study of 10 women from a large urban center in Canada demonstrates the relationship between the art of giving birth and the power realized through ritualizing. Ritualizing is the invention and enactment of personalized informal rituals. We have seen that when a woman's self-determined ritualizing for the childbirth is consciously acknowledged and practiced, it leads to a reinterpretation of her well-being before and during birth and an opportunity for her to enact meaningful choices, which maintains birth in the context of her family life. The ritualizing done by the women in this study provided them with an opportunity to take

control over *preparing* their birth environment, tailoring it to meet their emotional, physical, and spiritual needs. The resulting increase in confidence, comfort, and coping empowered them to be leaders at the time of childbirth, enabling them to better select choices that met their needs *during* the unpredictable event of birth. The control of the birth setting gave them two other important advantages in childbirth. First, it allowed each woman to create a place that was safe enough for her to (paradoxically) relinquish control over the birth at essential moments in the process. Second, it created an environment that permitted a change in the way that time was experienced during labor, thereby contributing to the woman's ability to cope with labor and, in turn, enabling the relinquishment of control during birth.

By making personally meaningful choices, the women in this study gained control over their surroundings, thereby stabilizing their world to the point that they could release control and remain flexible in the challenging journey through childbirth. The benefit of the resulting state of awareness was significant: it was apparent (through direct observation and substantiated by reports of the participants in this study) that being in this state of "letting go" was a place where the women labored best, were most able to cope, and even found a sense of joy or peace in the "work" of giving birth.

The ritualizing done by the women in this study was initiated without direction by the researcher. It was documented (in pictures and stories), discussed in interviews with the women and later analyzed using the characteristics of ritual as defined by Grimes (1982). Referring to his categories, we can see how these women intentionally invoked objects, actions, sounds, identities (including foods, smells, attires, and lighting), which contributed to the creation of ritual time and space. When personally meaningful and familiar practices were brought forward by a birthing woman and sustained by her attendants during labor, she became secure enough in her ritualized environment to relinquish active control of the birth and move into an experience of liminal time. During liminal or ritual time, a woman in labor is no longer concerned with the judgements of those around her and is not caught up in judging herself;

she is immersed in the present and is focussed only on the activity of the moment, whether that be contracting, resting, or pushing. When she relinquishes control, she loses concern for planning, organizing, predicting, comparing, and judging herself and others; this is when she does her best work in labor. From my observations in this study and as a doula, when I see women experiencing liminal time, their labor appears to become less of a struggle, their contractions fall into a more established pattern and their labor progress is often (ironically) more rapid than in a "disorganized" labor.

In this state, women are more self-sustained and do not require much external intervention beyond reassurance and encouragement. Feeling secure in the midst of her familiar rituals, the woman becomes unencumbered by the expectations of others and better able to fully participate in the powerful nature of birth as it unfolds. She is alive in the sacred space of giving birth.

Confirming Eliade's (1959) theory of defining and remaking space, the women in this study consecrated sacred or privileged places by reinventing activities and objects from daily life specifically for the purpose of childbirth. The carefully selected people, objects, and actions found useful at other crucial times of their lives formed an environment that permitted a transformation of experience from the mundane to the sacred and lent emotional and spiritual meaning to the women's experience of giving birth.

The change in perception of time during labor that I alluded to above was a surprising discovery for the women and for the researcher. All the women identified its occurrence in hindsight during our interview (many of them volunteering their observations of the phenomenon prior to prompting) and insisted that it benefited them during labor. Their experience of time during birth is remarkably similar to reports of how time is experienced during rituals. When one is immersed in ritual, the experience of time seems to shift (Turner 1977, Ellwood 1983). It was also surprising to find how much women said that this state was of benefit to them during the birth process. In our culture, which places so much emphasis on time and control, I now understand why this experience of

"sustained present" time is overlooked by birth attendants, under-estimated (particularly at most hospital births I have attended), underreported in the birthing literature and therefore not considered worthy of attention. It runs counter to how we normally experience and measure our world.

I have discovered from firsthand experience that liminal or ritual time may be experienced by any or all the members of the birthing team when the experience of "flow" is achieved. As Mihail Csikszentmihalyi (1990) indicates, however, there must be a loss of ego on the part of the attendants and a complete focus (in this case) on the creation of a mutually supportive set of actions that aid the mother. This requires the belief that it is the mother who can create the positive conditions for birth-giving outside and within herself.

As the research summarized by Odent (1999) indicates, the engagement of a woman's intellect (e.g., planning, judging, directing, even talking) during labor is counterproductive to her labor. Accordingly, he agrees that she must reach a point during labor when she no longer uses rational processes to make decisions during the birth. This loss of the woman's "rational, logical verbal left-brain," as England (England & Horowitz, 1998, p. 181) summarizes, occurs in the experience of liminal time in the birth ritual. At first glance, the idea that a woman should not plan or direct during birth may seem to offer her less likelihood of choice and leadership and of maintaining her place at the center of the birth event. However, if her ritualized environment includes people of her own choosing, people who respect her wishes and reflect her birth philosophy, then it will be the woman's own ritualizing for birth that is maintained through the supportive actions of her attendants. In other words, through her established self-defined rituals, the birthing woman can continue to be influential despite her lack of continued direction. It occurs when the woman's needs and support for her solutions remain the focus of the birth.

I believe that I witnessed each woman's individual influence at periods during the labors of Beatrice, Sarah, Nora, Barbara, Muma, Lucy, Mandy, Laurie, Molly and Kathy. In fact, every woman in this

study was honored in this sacred place during, at least part, of their labor. If this position of a woman's strength and influence is the ideal situation, the challenge to caregivers is to learn a new way of seeing women in labor, of trusting their bodies and abilities in birth, and of sustaining a supportive environment.

Whereas Odent (1996) suggests that the doula/midwife should create the required security by protecting and mothering the birthing woman, I suggest that a woman's initial and spontaneous ritualizing during the birth process builds an even more secure environment in which she can be free to give birth. It is the birthing woman's specific and personalized environment that must be maintained by the protective figure(s). The ritual space created by these women was most successfully supported and sustained by the specific individuals *chosen* to do so, rather than those *assigned* to attend the labor and birth. While ritualizing was perhaps more apparent and more easily sustained with fewer interruptions in the home birthing group, it was undeniably observed at the hospital births as well. The data shows evidence that these women successfully ritualized and sustained their rituals both in and out of the hospital setting. By paying special attention to a woman's ritualizing for birth, an *assigned* caregiver could participate with the women in her rituals in order to acknowledge her wisdom and thereby earn her trust. Acknowledging a woman's ritualizing could be a new point of access to build practitioner/clients relations. We have seen that the geographic location is less relevant than the shared practices.

The design of single-room maternity care rooms has fallen short of the ideal. The error has not been in the designers' attempt to hide the machines and to make the birth room "home-like" in decor, but rather in the lack of realization that it must be created, in part at least, by the woman herself. Most labor/birth/recovery/postpartum (LBRP) rooms have been made more accessible and less medical, but they need the sounds/quiet, smells, lighting/darkness, objects, privacy, and people that make each individual woman feel comfortable. Each woman must fill and mold the birth space to make it "like her" as Nora [a woman interviewed for this thesis] said.

It seems apparent from my observations that a woman's ritualizing became full ritual once everyone in the group (the birthing woman and the people in attendance) fell into the same patterned practices with a shared intention and when liminal time was achieved. At this point, the women's own practices were recognized within the sacred space created for that birth. It was then that the practices meet Grimes's (2000) requirements of ritual, since at that point they become recognized by members of the specific group gathered for the birth. If greater value is placed on this ritualizing by both the women and their caregivers, the possibility exists for this kind of ritualizing to become an accepted form of ritual to an even wider audience, i.e., outside of a specific birth event and beyond the home birth or alternative birth movement. In other words, these micro-rituals may become meta-ritual over time. While the possibility of changing our pervasive birth rituals may take time, the concept of individual women's ritualizing becoming accepted rituals is feasible.

In this thesis, I have shown how our dominant birth culture has been ignoring the artistic and creative components of giving birth by ignoring the women's own invention and creation of the birth space. (This is an expression of her emotional and spiritual needs during birth.) We have overlooked the need to care for the emotional and spiritual aspects of mother (and her child) in the context of her life, in favour of a narrow focus on her and her baby's physical condition. This study addresses this need and identifies an avenue for engaging these vital components of childbirth. By paying attention to the ritualizing a woman does during childbirth, we can see how she frames and addresses her understanding of her birth. The choices a woman makes to address these personal needs increase her confidence, comfort, and coping and thus reduce the desire to control or be controlled during the birth process. When her meaningful birth practices are sustained she can relinquish control and begin to labor well.

Birth-giving is about releasing, not about forcing the birth of a baby. When a woman feels comfortable to relinquish control, she can release her baby of her own accord; she is not reliant on oth-

ers to force the birth through the use of drugs, time pressures, mechanics, and surgery. When she is not "delivered" of her baby by someone else's accord, she is an active and essential participant who is encouraging her baby from her body, rather than a passive observer of a procedure done to her. It is when she is *giving* birth that she is at the center of the birth of her child and the birth of herself as a strong and capable new mother.

When we pay attention to the emotional and spiritual needs of the birthing woman we are honoring that part of birth-giving that is the art of creation. When we support a woman's ritualizing for the birth process we are acknowledging her power to care for herself and her baby. The birthing woman moves to a place where she trusts her body, the people around her, and the process of birth precisely because she has created an environment safe enough to do so. This is woman-centered birth.

Further research
This study, which considers the ritualizing women do in childbirth, raises many new questions and comments, some of which are listed below:

1. If women place themselves securely at the center of the birth event through ritualizing, will we see a reduction in medical interventions? Part two of the same question would be, if caregivers place women securely at the center of the birth event through ritualizing, will we see a reduction in medical interventions?
2. Does the self-confidence that results from ritualizing in birth lead to increased confidence in early parenting and less postpartum depression in women? Related to this, how does a self-ritualized birth impact daily life postpartum? Could we measure changes in what she is, or believes she is, capable of?
3. How does the experience of liminal time prepare the mother to live in time shaped by the demands of a baby?
4. What is the relationship between liminal time in the birth experience, trance (as discussed in relation to hypnosis) and mediation or prayer?

5. Is it useful to compare the amount of ritualizing done at home with that done in hospital to determine the preferred setting for women? Or is it useful to generalize and declare a preferred location? How would a birth center accommodate medical, holistic, and ritualistic needs?

6. Would a comparison of personal rituals versus well-established rituals (such as breathing techniques, water birth, husband-coached birth) be helpful to determine the most effective way to produce relinquishment of control in birth?

7. It might be appropriate make an investigation into the extent to which the effectiveness of establishing self-defined rituals may be restricted to a certain race or class and possibly prove or not prove cross-culturally appropriate.

8. What is the experience, emotionally and spiritually, of the unborn/newborn during labor and birth and how could this be accounted for in the experience of the mother? What measures could be invented to pay attention to the needs of the babies?

9. In light of new research that suggests caregivers should not direct women to push during second stage of labor and considering that this study encourages women to be ritual leaders of childbirth with minimal external interference and stresses the importance of release rather than control, how could this be applied to the second stage of labor? In other words, do women really need to push out their babies, or should the emphasis be on releasing, rather than forcing?

10. None of the women in this study had a mechanical or surgical birth. Statistically, between three and four should have given birth by Cesarean section. Although these women were not asked to ritualize for their births, to what extent did enacting their rituals have on this unusual outcome?

11. For some time, childbirth education classes have advocated the clock be removed from the birth room. While this act is symbolic of the need to change the perception of time for the birth event, it has fallen short of having a major impact with our obsession with time at births. What work can be done prenatally with women to help them embody this concept shifting

the perception of time? How can this concept of a technique become embodied practice and belief in advance of birth?

These questions may be useful when considering the future research on the topic of ritualizing in childbirth.

Crossing over with Ritual

I wish to conclude with a short story that illustrates the value of ritualizing for childbirth, as I have learned it from the women in this study. I wrote this story to provide a metaphorical framework for how the conscious establishment of self-defined rituals can allow a woman to be carried through birth. My story is based on an African proverb (Wolf, 2001, p.1). It is a story that tells of a rope set up across a river of rough water by an expectant woman and her attendants. Traversing the river is the journey of birth. The establishment and use of the rope mirrored what I saw expectant women do to build and practice rituals for the experience of labor. The story goes like this:

A group of women stand on the shore of a wide, rushing river. They stand in a row, hand in hand, supporting a single pregnant woman who is in the middle of the line. Her job is to get to the other side of the river. The group wades into the water with her, but the support people find their footing too loose and the water too deep to continue; one by one they relinquish their grasp of the pregnant woman. It is she who must cross and she must do this alone.

There are other women on the far shore who journeyed across when it was their time; they are calling to her, waiting for her. The woman might look down at the water and in fear, lose sight of the far shore. Or she might reach to the rope that is suspended between the shores and maintain herself on this structure that she put in place earlier with the help of her friends. The water is deep – up to her waist or more – and the torrent of moving water jostles her. It is loud and drawing her attention. She thinks that she might slip and lose her ground; she might have to give up. Yet, she

can also hear faint words of encouragement, and she can feel the rhythm of her own breath as she is held between the two worlds. She may not notice the repetition of her plodding as she moves forward hand over hand. She is holding on to what she knows will help her. Even though she cannot hear or see or feel her women friends for the moment, she knows that they hold a sacred space for her even as they let go of her physical being while she makes the crossing. Slowly, the group of women supporters on the other side come into view. They are standing in the water with outstretched hands. They are there to receive her and her baby from the rough water. They reach out and guide her over to the shore. To her own amazement she has finally given birth and the water appears calmer now. Yet the rope-bridge is still suspended like a memory, available for other times of need.

References

Csikszentmihalyi, M. (1990). *Flow: The Psychology of Optimal Experience.* (1st ed.). New York: Harper & Row.

Eliade, M. (1959). *The Sacred and the Profane: The Nature of Religion.* (W.R. Trask, Trans.). New York: Harcourt Brace & World.

Ellwood, R.S.J. (1983). *Introducing Religion: From Inside and Outside.* Englewood Cliffs, N.J.: Prentice-Hall Inc.

England, P., & Horowitz, R. (1998). *Birthing From Within.* Albuquerque, New Mexico: Partera Press.

Grimes, R.L. (1982). *Beginnings in Ritual Studies.* Washington, DC: University Press of America.

Grimes, R.L. (2000). *Deeply into the Bone: Re-Inventing Rites of Passage.* Berkeley: University of California Press.

Odent, M. (1996). Why Women Don't Need Support. *Mothering Magazine*, 80, 46-51.

Odent, M. (1999). *The Scientification of Love.* New York: Free Association Books.

Turner, V. (1977). Variations on a Theme of Liminality. In S. Moore & B. Myerhoff (Eds.), *Secular Ritual.* Assen, The Netherlands: Van Gorcum.

Wolf, N. (2001). *Misconceptions: Truth, Lies and the Unexpected on the Journey to Motherhood.* New York: Random House.

The Best-Kept Secret

Katarina Premovic

DURING MY FIRST PREGNANCY 11 years ago, I had never heard of a doula. Most of my friends had their babies in the hospital, with their husbands for support. No one I knew well enough expressed that they needed any other support.

The fact that both spouses were in uncharted territory, one feeling overwhelmed by what her body was doing and the other feeling overwhelmed by not being able to help, seemed to be ignored when we envisioned the upcoming birth.

I remember when one brave friend, in a rather conspiratorial tone, told me weeks later that she had a doula at the birth of her first child. I was skeptical. What could someone I hardly knew do for me in my hour of need? Wasn't my life partner the one to help at such a time?

Knowing me at the time to be practical in my approach, my friend moved on to detail the practicalities. In the old days, she said, nurses had time to help laboring mothers. Now, she said, you rarely see a nurse and there is no one there to help. Doctors only

come in once every few hours; nurses a bit more often. It is really just you and your spouse trying to muddle through.

It was these practicalities that convinced me initially. I hired a doula. Looking back, I'm not sure how I would have managed without her. To have someone in the room who had helped many other women before me through the birthing process and knew what to expect and what to do was a relief. To have someone who had your best interests at heart, but who wasn't so emotionally involved with you that they were almost paralyzed with fear, was comforting. To have someone who was familiar with the hospital routine but not cowed by it was empowering. To have someone who was totally in your corner and there to support you was a miracle.

At that first birth, our doula helped make what could have been a nightmare into a positive birth experience. She was there to translate what the doctors were saying; she was there for support for both my partner and I while we tried to make the right decisions. She never pushed us, told us what to do, or rushed us. But, rather, provided input, helped us make necessary decisions, and provided us with the time we needed to make those decisions.

Our doula did things I was only aware of after the birth. She prodded the hospital into allowing my husband into the operating room during the surgery, which made a huge difference to both of us, and was something neither of us thought to ask. After my son was delivered, but while the surgery continued, my son started crying and I started to shake. No one in the room made any attempt to help. It was our doula who suggested putting my son next to my face. He stopped crying and I stopped shaking almost immediately. It never would have occurred to me that such a magic formula was available. And we all carried on much calmer. It was our doula who suggested taking pictures of the birth in the operating room and celebrating the event. I can't imagine how it would have been without her.

I have had two other children since then – both home births with midwives and a different doula. During the second pregnancy, I was, naturally, afraid to have to go through another medicalized birth, but our doula provided pre-birth support, positive thoughts

and suggestions about alternatives, including recommended read-
ings about other birthing options. It was our doula who brought
me from a place of fear to one of wonder about the process; who
led me to the point where birth was no longer a medical proce-
dure, but a natural and wonderful part of life. This changed not
only my views on birth, but also my views about so many things
that cannot be briefly described.

I can't imagine what it is like for these marvelous women on the
other end of labor. There must be times when they want to shout,
"Oh for heaven's sake, will you just calm down!" but they don't.
There must be times when they want to laugh inappropriately, but
don't. And there must be times when they are exhausted or unsure,
but they don't show it. Their patience, in my experience, seems
inexhaustible; their support constant; and their joy in what they are
doing enormous. Their ability to bring out the strength in laboring
women is awesome, as is their ability to help them cope with what-
ever birth comes their way.

In some ways, having a doula is like having the mother you
always wished for when you needed her most. Someone wise,
patient, loving, helpful, fiercely protective, and there totally to help
you. It has sadly been one of the best-kept secrets about the
birthing process.

What doulas bring to a birth (in addition to their support, wis-
dom, and experience) is a sense of community about the birthing
process; a circle of mothers you never knew existed before, and
you never want to leave it once you find it.

Mariah Abigail's Birth

Mona Mathews

MARIAH ABIGAIL'S BIRTH: SEPT. 12, 2008

A client had been experiencing Braxton Hicks contractions for 2 weeks. Sometimes, these contractions would be 5 minutes apart and last for several hours. Since this was her third baby, and she delivered a week early with her two other children, she was surprised to reach her due date. On the morning of September 12, she called me at 5 a.m. She had been having contractions between 6 and 8 minutes apart for a few hours. She also had a bloody show this time. She had put in a call to her midwife, who happened to have delivered a baby in her town an hour earlier, and so when I arrived at 6 a.m., the midwife was with her. She was about 3 centimeters dilated, and when the midwife did a stretch and sweep, she was able to stretch her to 5 centimeters. The midwife suggested that M stay in her home, have a warm bath, and something to eat, and try to relax until her contractions were getting closer and increasing in intensity. By 9:30 a.m., the contractions were getting more intense and closer together, and she paged her midwife who suggested that she go to the hospital, where she would meet her.

Her husband and I accompanied her to the hospital and arrived at 10 a.m. We were met by the backup midwife who was covering for her regular midwife (who had gone home to catch a couple of hours of rest since she had been up all night with another client). M was coping very well with her contractions. In her two previous pregnancies, she chose to have an epidural as soon as active labor started.

This time, with my encouragement, she decided to try a natural, unmedicated birth. She attended HypnoBirthing classes a month earlier to help her learn how to get into a deep relaxation during her labor. She also opted to use the tub, and after being examined by the midwife, she promptly got into the tub. She really felt that the jets in the tub, the warm water, and the gentle shower spray, which G directed on her lower back, helped her cope with the contractions. I massaged her arms, kept her hydrated, and whispered words of encouragement. She was doing amazingly well. Around 12:40 p.m., the midwife examined her again. This time she was 7 centimeters, and the bag of waters were bulging. The midwife asked M if it was OK to rupture the membranes – she felt it would allow the baby's head to descend more and, ultimately, put more pressure on her cervix and open more. M agreed, and came back to the labor room. Within a very short time, the contractions increased, and M was feeling a great deal of pressure, and was having the urge to push. Also about this time, her two regular midwives whom she had seen at prenatal visits arrived.

M was not comfortable in a lying down position, and so choose to stand, with her arms around G's neck, gently swaying. Soon the urge to push was overwhelming, and after a quick vaginal examination by the midwife, she was 10 centimeters and ready to push. She was asked in what position she wanted to give birth. She decided that a semi-sitting position was the most comfortable, and within minutes, and very few pushes the baby's head was crowning. Delivering the head was a little difficult as the baby had her hand up by her face. Once the head was delivered, the rest of the baby slid out very easily. Time was 1:30 p.m. Baby girl weighed 8 pounds 13 ounces. They named her Mariah Abigail.

My role as a doula was to encourage both M and G that having this birth, unmedicated and natural, was something that M really wanted and she could do it because she was strong! I also felt that choosing to birth this way, a very different experience than her two previous births, would empower her as a woman. My role was to keep reminding her that she was doing very well, better than she thought. I also wanted to encourage G to comfort M, and that his strong hands – to apply counter pressure – and his kind and loving gestures were something that she needed from him. Even when she sometimes appeared to be short with him because he didn't always anticipate her needs as quickly as she hoped he would, I assured him privately that this was not to be taken personally, but sometimes women in labor do this.

M was elated about her labor and birth. She was so proud of herself. Although she admitted the labor was more intense, it was much quicker than her previous deliveries, and she felt energized and alert after the birth. Her baby latched on almost immediately and was very attentive. M was anxious to go home as soon as possible after the birth, even though she originally planned to stay in hospital for 48 hours. Overall, it was a great experience for her.

What I learned as a doula is that women are much stronger than we sometimes give them credit for. This was the second birth I attended with M, and I saw how frightened she was with her previous labor. She didn't believe she could ever deliver a baby without drugs. When she became pregnant this time, I encouraged her to do more reading of the *right* kind books, and not to listen to what others were telling her about their birth. I also learned more about breastfeeding – because this client was determined to successfully breastfeed this baby, I accompanied her twice to the Dr. Jack Newman clinic. From helping her, I assisted future clients with their breastfeeding needs. Attending her previous birth made me decide to become a doula.

M is my daughter!

♀ Things I Know about Birth
Jennifer Elliott

I know that birth is a natural function of a woman's body.
I know that others think it is a medical event.

I know that a woman needs to birth her way.
I know that mothers, partners, and others often tell her where
and how to birth.

I know that pregnant women need confidence and trust in the
birthing process.
I know that prenatal classes often foster fear and insecurity
instead.

I know that women who believe in their natural ability to birth
experience easier labors.
I know that fear causes tension and leads to poor progress in labor.

I know that birth is the result of the power in a woman's body.
I know that others credit a doctor or midwife, or even a husband.

I know that western women have gained power in many areas of
society.
I know that western society denies the power of a woman's
birthing body.

I know that women turn to experts to guide them in childbirth.
I know that women need to turn inside themselves.

I know that women can be deeply connected to their intuition.
I know that medicine gives no credence to this inner knowing.

I know that birth can be painless.
I know that medical practitioners do not accept this.

I know that positive birth stories build a woman's confidence.
I know that women hear mostly negative stories.

I know that women are entitled to make decisions about their care.
I know that medical staff sometimes fails to ask for consent before doing procedures.

I know that birth may require patience.
I know that we are not a patient society.

I know that birth can be so fast and simple that mothers and babies need no one else.
I know that some call this an emergency.

I know that caregivers have much to learn about birth.
I know that caregivers are often doing too much, and observing too little.

I know that positive encouragement keeps a laboring woman going.
I know that a negative comment can undermine her focus and commitment.

I know that laboring women need support and respect.
I know that some doctors ask them questions in the middle of a contraction.

I know that each labor is unique and has its own timing.
I know that caregivers expect labors to progress at a certain rate.

I know that one person believing in the birthing abilities of another can make all the difference.

I know that too few women experience this support.
I know that women want to believe that birth is normal.
I know that too few caregivers treat birth as normal.

I know that women want more nurturing care.
I know that nurturing is not time-efficient.

I know that women want their birthing experience to be honored.
I know that caregivers forget that each birth is the unique arrival
of a new human being.

I know that birth is sacred – the moment of a new life and new
family.
I know that a focus on pain and procedures in childbirth has dis-
tracted us from the sacredness of birth.

I know that women will experience powerful, perfect births
when they believe that they are powerful and perfect.
I know that as long as we allow ourselves to be viewed as
flawed, our births will also be flawed.

I know that we must visualize the birth we want, commit to it,
and plan for it.
I know that if we do not, others may take our birth in a different
direction.

I know that powerful, wondrous birth is possible: I have experi-
enced it and witnessed it.
And I know that deeply satisfying, empowering birth is possible
for many more women.

I know that women are ready to embrace and manifest miracu-
lous, magical birth.
I know that when childbearing women lead, the rest of us must
follow.

In'shallah

Beth Murch

I'VE BEEN THINKING A LOT LATELY about the blurred lines between The Sacred and The Profane: What is seen as sacred to some is viewed as profane by others – and vice-versa. The Lakota have the Sundance Festival, where young men tear flesh from their chests and backs using poles from the honored cottonwood tree, Hindu devotees to the goddess Karni Mata share their bowls of rice with holy rats, and Roman Catholics partake with wafers and wine transubstantiated into the body and blood of Jesus Christ. Many of my friends have the names of their children inked upon their flesh, or they circumcise their sons, or they find solace in the sometimes rigid protocols of BDSM (bondage, discipline, dominance, submission, sadism and masochism).

Sadly, it is easy to recoil at the actions of others and to declare, "Ugh! I would *never* do that!" without stopping to find value in what those people call "sacred." In Hebrew, the word used to imply holiness is *kadosh*, which means "separate" or "distinct." I think that regardless of our religious un/affiliation, we all perform rituals that are separate and distinct from mundane existence: I have a friend who prefaces each visit to his doctor by visiting a

nearby coffee shop for an apricot Danish and fresh whipped cream, and in my eyes, his rite bears no less meaning than the tasks of Vestal Virgins.

In my work as a doula, I frequently discover that what I consider to be acts of sacred love: holding a Chux pad between a woman's thighs, wiping meconium from a newborn baby's bottom and catching vomit in a basin (or my hands, or on my shoes) are seen as acts of profanity to those around me. When I describe the pleasure I feel engaged in the feral scents and sounds of childbirth, the wholeness I feel in a world filled with blood and milk, and my fascination with the oohs and the ohs, many people react by gagging, stopping up their ears or not inviting me over for tapas ever again. Just as my rabbi does not understand the appeal of drinking the blood of Christ and I often do not understand the freedom in slavery that someone feels in service to their dominant, many people fail to see what is so ethereal about placentas and cervical dilation.

I admit that birth's charms can be an acquired admiration – much as I imagine death, the military and Wal-Mart to be. The first time I ever saw a film where a woman's labia split like the Reed (Red) Sea to reveal a human head, I thought to myself, "Holy shit!" – but I wasn't entirely sure it was holy. As Mikhail Bakhtin suggests, the body is reminded of its death and renewal through the "grotesque": eating, sexual activity and excretion. Parturition could be seen as the ultimate in Bakhtin's sense of the grotesque: after engaging in sexual congress, the female body swells with food and fetus, and eventually ripens and releases a crying, writhing, bowel- and bladder-eliminating child amid a rush of bodily fluids. Horror movies love to seize their audiences by their repulsion of the birthing female body: abjection seems to equal ticket sales, which of course equals financial windfall for (often male) artists who have very little knowledge of female anatomy or autonomy. However, once I began participating in actual births, it was clear to me that I was witnessing something no less hallowed than a Buddhist *sanga* (community) learning from their *Roshi* (elder teacher).

Walking home from the hospital after my sixth birth as a doula, aching in my muscles and throbbing in my heart with excitement,

I pondered heaven's hand in this joyous and blessed event. Mama was from Pakistan, and she was living with her family here in Canada and sponsoring her husband for immigration. When they realized that he would not be present for the birth of their firstborn, Mama decided that she needed a doula. After speaking with several different doulas in the area, she interviewed me and decided that we were a good fit. I feel so lucky that she chose me to help her through this life-altering experience.

Our prenatal visits always lasted a few hours – we couldn't stop ourselves from giggling together about the excitement of a new baby, discussing our personal faiths (she was Muslim, I am converting to Judaism) and planning how we could share this birth with Papa, far away in Pakistan. It was so interesting to meet her mother and sister and to see them interact with each other in a very traditional manner. This family was truly loving.

As often happens with first babies, Mama's due date came and went and the baby stayed curled up where it was warm, wet, and tucked away. Everyone was eager for this child – the first grandchild on either side of the family – to be born. Finally, on a Thursday, Mama began experiencing some contractions. Unfortunately, the only pattern to the whole situation was the timing of Mama's phone calls to me – two hours apart for three days. The poor lady was so uncomfortable – and so full of questions. When would her labor start? Why wouldn't her contractions come closer together? Would she have to be induced? Why was this taking so long? What doulas don't often share with other people is that they often ask these very same questions. Sure, we have schooling that give us 'answers,' but they don't stop us from sitting over a coffee and wondering, "When will her labor start? Why wouldn't her contractions come closer together? Would she have to be induced? Why was this taking so long?"

Two days later, on Saturday morning, I went with Mama to the hospital for a non-stress test (an exam where they monitor the baby's heart, movements and any contractions that the mother may be having). It was an emotional time for Mama – she wanted to be told that she was in labor, she wanted her baby to be born already,

and she was nervous that something was wrong. Fortunately, she was healthy, her baby was healthy, but she just wasn't in active labor. I held her when she cried, stroked her hair, and told her that she would be back here very soon – and this time on her terms.

That evening, around 10:30 p.m., Mama called me (two hours after her last phone call!) to let me know that she thought she was experiencing "true labor" – her contractions were 15 minutes apart and then 10. I reviewed with her what signs we were looking for (if you've taken a prenatal class then you'll know this chant): LONGER. STRONGER. CLOSER TOGETHER. Sure enough, around 12:30 a.m., just as I crawled into bed and turned out the light, my phone rang and it was Mama letting me know that her contractions were now 6 minutes apart and she wanted to go to the hospital. I got dressed, grabbed my bags (and felt like a Sherpa) called a cab, and made my way to the maternity ward.

Not long after I arrived, Mama, her mother and her sister showed up. The latter sat in the waiting room with Qurans and dates and we were put into triage, where Mama underwent some monitoring and a nurse performed a cervical exam. She was 2 centimeters dilated and while she was experiencing regular contractions, she wasn't dilated enough to be admitted. The nurse gave us two options: we could go home or try walking for an hour to see if that got things moving a little bit and then we could have a "re-do" on the cervical exam. We chose the walking.

The hospital is not the most happening place at 2:30 a.m. on a Sunday morning, but we walked the halls anyway, stopping to breathe through contractions and for an exhausted doula to purchase caffeine from the lone source available to her at that moment: a can of Pepsi from an ancient vending machine. When we returned to triage, it was discovered that Mama was now 3 centimeters dilated. They weren't willing to admit us to a room yet, but we were allowed to stay in triage. Mama got a shot of morphine to take the edge off of her contractions, which allowed her to get some sleep. I sat beside her on a very uncomfortable chair, dozing and waking up every time she had a contraction. It was a long night. I kept repeating the mantra that has sustained me through

every birth: *laborare est orare* – to labor is to pray. Not only was my client laboring, but so was I.

Around 7 a.m., Mama was re-examined, and she was found to still be 3 centimeters. The baby's head was nice and low, but the nurses had wanted to see Mama make more progress than she had. So, we were sent out walking again. We visited with family in the waiting room, where we explained that *In'shallah* (if Allah wills), we could have a baby today if we managed to get things moving along. "*In'shallah*," replied the mother and the sister. I was given two strings with writings from the Quran to tie around Mama's thigh and arm by her mother, to be removed only after the birth. They were to ensure a fast and easy labor. I felt so honored to be trusted with this responsibility.

This time, Mama and I strolled not only the hospital corridors, but also outside the hospital for some fresh air. We walked for a long time; I was so tired that I felt that my feet were made of lead – each step caused a thud to reverberate throughout my whole body. We were gone for 2 hours and finally returned to the maternity ward because the contractions were becoming very painful and close together.

After spending an hour or so in bed, Mama was examined again and this time found to be a stretchy 4 centimeters. We were sent out walking again. We sat for a few minutes with Mama's mother and sister, who had since been joined by Mama's grandmother, who fed me sandwiches made of white bread, eggs and spicy chutney, and the best chai I have ever had. The grandmother and mother spoke very little English, but their actions transcended any language: the motions to "eat, eat," the motions of prayer, and the motions of pressing lips together in concern are international. Every time a contraction wracked Mama's body, her mother ran from the waiting room, unable to bear her child's discomfort.

As we stood up to start our walking again, the little old grandmother (who I thought looked delightfully like Yoda of the *Star Wars* franchise) grabbed my hand and said, "*In'shallah, In'shallah*," and I replied back, "*In'shallah*" and squeezed. We meandered the hospital again, this time stopping so that I could get some coffee (finally,

some more caffeine!) and Mama could grab a croissant. We walked for an hour and then returned, where Mama was really starting to struggle with her birth pangs.

Each contraction is like climbing a mountain: you feel the ascent, you journey to the peak of pain, and then slowly, slowly, you start to descend. I cradled Mama in my arms, holding her hands and breathed with her through each contraction. We moaned together and she buried her face into my chest. Mama was amazing: her family had told me that at home she was screaming with contractions, but with me, she kept things low and soft. We had good energy together.

We waited a long time for another examination, but this time, we were told that Mama was 5 to 6 centimeters dilated, and it was time for us to be moved into a birthing room. It took two hours for all the paperwork, blood work, and tests to be conducted before we finally moved into our suite. During this time, Mama made it known that she wanted an epidural...right that very second. Of course, there is only one anesthesiologist for the entire hospital on the weekends, so we had to wait in a long line of people who wanted medication "right this very second." In those last 2 hours before we were admitted and the epidural was administered, Mama's patience was tested. I had to work hard to remind her that she was safe, that relief was on the way, and that she was strong. Finally, Mama was put into a hospital gown, received an epidural, and was tucked into bed.

Since this hospital's policy is that no one other than medical staff are allowed in the room during the placing of the epidural, I went to update the family. I held Mama's own Mama in my arms as she wept with frustration and anxiety, and I gratefully accepted the grandmother's offer of some more tea. I answered the sister's many questions as best that I could. The question that they needed an answer to the most, I could not tell them: How much longer would this last?

When I returned to the room, Mama was much more comfortable. She could no longer feel her contractions and she had a smile on her face. I held her hand while a nurse broke her bag of waters,

and rejoiced when the amniotic fluid came out clear. When Mama was settled and tidied up, I went and got her family and brought them in to visit. The room was filled with the peaceful sounds of Urdu and the sympathetic murmurings of women.

After awhile, Mama got to talk to her husband in Pakistan and then we both decided it was time for a little rest. I dozed for an hour and when I awoke, the nurses were changing shifts and it was being decided that Mama needed some Pitocin to help speed her labor along because now the new nurse was saying she was only 4 to 5 centimeters dilated and not 5 to 6. This broke Mama's heart, of course, because someone was now revoking the progress that she had made through blood, sweat, and tears. I told the nurse that the three nurses that had examined Mama previously had said she was 5 to 6 centimeters. She replied that Mama was only 5 to 6 centimeters "maybe, if I really stretched my fingers." When I responded, "Well, then maybe you should really stretch your fingers," Mama burst into peals of laughter (as I had hoped she would).

For the next couple of hours, Mama rested her eyes and I kept watch, answering her questions and bringing her family updates. Finally, she was 10 centimeters dilated and we just needed to wait for her body to move the head down a little more before we began pushing. Mama's younger sister came in to visit for awhile and her sweetness kept us entertained.

Finally, it was time to push. With each contraction, I supported Mama's head, cheered her on, and reported back to her on the progress between her legs. I had the nurse bring a mirror so that Mama could watch her baby's head appear. It was obvious that the baby had lots of curly black hair. The doctor came in and things began in earnest. Mama was a champion pusher and it wasn't long until her baby's ears and eyes were out, then the nose, then the chin. I filmed the doctor pulling out first the baby's right arm and then the left, and then the whole body slithered out. At 9:13 p.m., Baby Muhammad Hamzah was born, alert and squawking and placed upon his mother's chest. The doctor clamped his umbilical cord, and I got the honor of cutting it. I had never cut an umbilical

cord before, and I was most excited by the privilege. It was tough and spurted a tiny bit of blood when I sawed through it.

I took many pictures of the baby while Mama held him as she delivered the placenta. I wanted to make sure that her husband got the chance to see as much of the birth as we could give him. I followed Hamzah to the newborn warmer, where he was examined by a nurse. I acted as his own personal paparazzo, snapping new pictures with every breath he took and spoke to him, making sure that he knew that someone was with him other than the nurse examining him thoroughly but without tenderness. I held Hamzah's hand and stroked his cheek, and told him, "You have so many people here who love you. We've been waiting a long time for you!" His black curls were so thick that the nurse had to rip out the seams from the newborn cap the hospital gives each baby in order to get it to fit on his head. I marveled over how furry this little boy was: he had hair on his shoulders, on his back, on his thighs and even by his ears. He was weighed in at 7 pounds and 3 ounces, a perfectly delicious little bundle.

The doctor gave Mama a couple of stitches and then left, and the nurse and I placed Hamzah on his Mama's skin and helped her to nurse him. He was more interested in his fingers than her nipple, but he got a couple of good sucks in. Once everyone was tucked comfortably into bed, I went out to make the big announcement to the family. I had asked Mama how to say "congratulations" in Urdu so I was prepared for this special moment.

I walked into the waiting room and everyone was there: Mama's mother, father, sister and grandmother. They were all reading Qurans, and praying very hard. I entered the room, and the sister exclaimed, "In'shallah, good news, only!" I said: "Mubarak ho, everyone! At 9:13 p.m., Baby Hamzah was born!" Immediately, each of them raised their palms to the sky and said, "Allahu akbar!" ("God is great!") The sister and the grandmother grabbed my hand and clutched them strongly as we went into the maternity ward to visit the new arrival.

I know that whatever words I write will fail to capture the perfect joy that these people expressed when they met Hamzah for the

first time. They all took turns holding him, talking to him, praising Allah, and their faces shone. The new grandmother fed Mama muffins from her fingers and the great-grandmother kept exclaiming "Very good! Very good! Yes!" The new auntie sat in the corner of the room, cross-legged, with her beautiful nephew on her lap and fussed over his fingers and toes. Grandpa drilled me on the birth: did I think that the doctor did a good job? Were the nurses kind? Did I think the baby was healthy? Was I pleased with how it all went?

The nurse came in again and suggested we try feeding Hamzah again, so the grandfather went back to the waiting room. Suddenly, with Mama busy with the baby, all of the woman focused their attention on me in a way that I had never experienced at a birth before: they began caressing me, pinching my cheeks, embracing me, kissing me, stroking my hair and exclaiming that I was "Very good! Very good! Yes!" They had tears dazzling their brown eyes and they showed me such admiration and gratitude that I was overcome.

The family wanted to get Mama some home cooking, so they went home to prepare it. During those few quiet minutes, Hamzah discovered the joys of breastfeeding, Mama reviewed the birth in pictures, and I sat down for what felt like the first time in two days. Papa called from Pakistan and spoke to his wife and his new son over the phone. Mama relayed all his exclamations back to me, as her face glowed. She said, "He wants to hear the baby cry! He is so excited that his hair is so long! He wants to know if his penis is okay!"

Mama also took the time to thank me for helping her. She told me that she felt so blessed that she had found me and that she didn't think she could have had this baby without me. She said that she felt very little fear during the whole labor process because my presence brought her so much comfort. No one has ever thanked me so profusely at a birth before, and I couldn't stop blushing.

The new grandmother reappeared bringing bags of food from home. She fussed over her daughter and grandson as they were engaged in breastfeeding and then made it her personal mission to

feed me. Mama translated that her mother thought that I didn't eat enough in the past day, so she fed me more of the egg and chutney sandwiches, as well as some cheese sandwiches. She held each one above me like she was making a presentation to a holy person, and as I chewed, she held my hands and touched my cheeks. She asked me questions in the little English that she knew: "You parents?" Yes, I have parents. "You sister?" "Yes, I have a sister." "You brother?" "No, I have no brother." "You married, yes?" "No, no I am not married." "Not married?!" she exclaimed, and made such a sound of sorrow in her throat that I quickly responded, "Not yet...not yet. But hopefully, someday soon. *In'shallah*." When she heard that last word, she grabbed me and hugged me with every ounce of strength in her body and squealed, "*In'shallah*! Yes! *In'shallah*! Good girl!"

When it was clear that everyone was settled in for the rest of the night, I packed up my things and departed. Every muscle and joint in my body was screaming, but I hummed my entire way home, filled with the joy of a good birth and feeling so special.

Yes, there were bodily fluids. Yes, there were earthy odors. Yes, there were long hours of waiting and of physical exertion. But to me, this was The Sacred, not The Profane.

♀ The Passage
Marcie Macari

The earth shook. The women gathered.
The chanting
 of The Women Of a Thousand Generations began, their
 hands intertwined.
I breathe low, moaning deep through my body to touch the
depth of sound they generate.
 And for a moment I am with them.
 "We're here – with you, you are one of us – you can do it!"
 One of them.
I breathe.
The coals glow – mocking my strength
 Embers flick their tongues tormenting my courage.
I step onto the coals –
The Women Of a Thousand Generations push closer to the
embers –
 their faces glowing from the coals.
I keep my eyes on them, focusing on *their* ability to push
through the pain,
 to keep walking in spite of their fear –
 remembering that they made it to the other side.
I find *my* courage and step again.
 I feel the embers, and wince.
The Women start beating a drum.
 I find their rhythm in my abdomen, and slowly move
 forward:
One step – look at the face.
 Second step – focus on the eyes.
 Third step…

I see the African dancers, rehearsing their steps as I walk my
 last few.
 I see the circle being set – the fire at the center, the food and
 festivities.
This will be the stage for my welcoming into this elite group –
 this *Women Of a Thousand Generations*.
 my heart swells.
I am close to the end now, and my body starts to shake – Spirit
stronger than flesh.
 I want to give up – to step on the cool grass
 And off these coals.
I look for the faces, and my eyes meet theirs.
 One of them smiles.
She who is *With Woman*, reaches out her hand
Her face is the clearest, eyes at my level.
 "Listen to your body and do what it tells you," she says –
 no trace of concern.
 The chanting changes: "Listen to your bo-dy."
 In rhythm, hands are again joined, like an infinite chain.
I realize just how many have gone this way before me.
The one who smiled places her hand on the shoulder
 of the One who is *With Woman* –
 with me,
 and I breathe, stretching out my hand to grasp the out
 stretched.
I am about to cross over –
 Silence comes over the Universe.
I near the end –
 my body aches,
 my mind is empty of everything but that last step.
 Last step.
 Hands grasped.
 Cool grass.
On my toes, cooling my feet –
 my arms reach out to claim my prize –

"Reach down and take your baby."
 I hold him to me tightly, and proudly take my place in the chain.
 I am now a *Woman Of a Thousand Generations.*
 The celebration begins.

(Excerpted from *She Births: A Modern Woman's Guidebook for an Ancient Rite of Passage*)

Start to Finish

Leslie Chandler

IT'S QUIET. MIDDLE-OF-THE-NIGHT quiet. It's difficult to tell if the woman in the bed is sleeping. Machines quietly monitor her while the young man beside her sleeps, sitting in a chair pulled up to the bed, his head resting on his arms, which rest at her side. He holds her fingers, even in his sleep.

A nurse enters quietly, makes notes, and then asks me if we need anything, wonders if I want to take a break. I tell her I'm fine.

The Beginning

I am not out of my element here. I have worked at a Level 3 hospital for more than 20 years. I have attended births, taught prenatal classes, sat on committees, taught in-services for medical, nursing, and midwifery staff and students.

It began shortly after the birth of my son. My firstborn came after six surprisingly easy hours of dilation, followed by 3 hours of messy and exhausting pushing, ending with a Cesarean under a general anesthetic. Even so, I was so profoundly moved by his birth – by pregnancy, labor, birth, breastfeeding, and most of all,

by motherhood – that I knew I wanted to do this; be with women and experience this again and again.

Shortly after my son turned one, I started training to be a labor coach (this was before the word 'doula' was co-opted) with a local midwifery collective. The first birth I attended ended in Cesarean. I took it hard, as though it were a personal failure. I had yet to learn how to keep my personal experiences out of the room when a woman labored.

The second birth I attended was also surgical. For hours we had all thought it was a posterior labor, her back pain was so intense. Her membranes had ruptured, so there were few internal exams done. When the doctor arrived she placed her gloved hand inside the woman and counted... "One, two, three, four...five."

"Five? I'm only 5 centimeters?" cried the woman.

"No. Five toes. I'm holding a foot." A footling breech meant surgery.

The third birth I attended was with friends. I was almost 7 months pregnant with my daughter, my second baby. I had yet to be present at a vaginal birth and was planning on – no, insisting on – one for myself, with midwives, at home. I desperately wanted to witness one now to boost my confidence and prove I wasn't a Cesarean 'magnet.'

When my friend started to push, her husband sat behind her, supporting her tiny frame and seemingly added to her efforts with every muscle in his body. As the baby began to crown I felt a surge of panic. I stood by her feet, alongside the doctor. I could see this blue, grey wrinkled tissue coming down. It didn't look like a baby. It looked like...a brain. My friend was giving birth to a baby without a skull! Why wasn't the doctor panicking? Why hadn't she called for help? How could I witness this, here with my friends? Then out came a beautiful, wrinkled, perfect girl. What I had in my ignorance thought was an exposed brain was, in fact, the normally wrinkled scalp of a crowning infant.

Twenty-two years later that same girl is staying with us, working downtown on a university co-op placement while my own daughter is away at school in England. My daughter who was born vaginally,

a VBAC (vaginal birth after Cesarean); at home; 36 hours of labor; 40 minutes of pushing. Ten pounds of sheer beauty and joy.

After my daughter's birth I found my voice. I became a childbirth educator, hired before I even graduated from the college program by both a well-known women's hospital and a private education agency. I was busy, confident, and not very humble.

The Middle

Because of "birth" I have become the person I am today. I don't know who I would be if I had not had children. I wouldn't know most of the friends that I have today. I didn't have a political bone in my body before I had babies, before I took on the task of inviting women to discover what they are capable of – what their bodies and spirits can manifest – before I took on a medical system that has at times left me exhilarated, at times defeated.

In those middle years, I was a single parent. Attending births was difficult, though not impossible. I had a wonderful network of friends and support. I had found my place as a teacher, a doula, a shit disturber.

At a birth in a new suburban hospital, as the woman was starting to push, the nurses prepared the stirrups to put her legs in.

"What are those for?" I asked.

"Dr. J always uses them."

"Well Mrs. B doesn't," I said.

"But Dr. J ALWAYS uses them," they said in unison.

"Well. Then we have a problem. Mrs. B doesn't."

The doctor came in, fully gowned and masked – already an anachronism in the rapidly changing ways of obstetrics. He looked at the stirrups, then at the nurses. They shrugged and glanced at me. The doctor, who had never met the woman in labor, tossed his stool across the room to the front of the bed. He sat, masked, in front of her naked crotch and said, "Let's go."

I inserted myself between the woman and the doctor and introduced myself.

"Can I suggest," I said, reddening, "that you introduce yourself before you lay a hand on this woman or her baby?"

Another client confided that she had suffered great abuse as a child and as a direct result, her first birth was terrifying. She disassociated and felt parts of herself spinning off. She was incapable of calling for help, screaming silently in her mind. Her partner and midwives thought she was brilliant. Calm. She was so still and quiet throughout the birth, the perfect picture of natural birth. Afterward she struggled to make them all understand her terror, her version – *her* version – of the birth experience and for years no one heard her.

Several years later, pregnant again, she was desperate to find a better way through. I searched and searched for information that might help her. But this was before the Internet, before the awareness we have now of childhood abuse and the effects on childbearing women. With tremendous openness and effort, she got through it and had the birth she wanted and needed. It was a powerful moment for everyone. I'll tell you her real name because she told me I could. Her name was Hope.

During these years I was called out of delivery rooms, confronted by angry nurses and residents. I was even threatened by security guards. I learned to stand my ground. I learned when to speak up and when to keep quiet. I learned to listen. Most of all I learned to listen. First of all I had to find my voice, then I had to learn when to use it. I learned how to sit quietly with myself and with others.

I felt blessed. Being present at a birth is a privilege, an honor I could never take lightly. Yet the responsibility I sought had changed and grown into something different. I have always thought of labor support as 'heart' work. Like mothering, it demands everything of you, in that moment. You must be fully present, focused and tuned in. As my teaching demands grew, I took on fewer births. I became a certified lactation consultant and worked in the hospital's breast-feeding clinic. I also started teaching classes at a community college, edited a national newsletter for childbirth educators and I worked part-time in a bookstore that specialized in parent-related topics. Through all this I was solo-parenting two busy, growing kids. It was like being a new mom again – I never slept and babies/birth filled my waking hours.

Eventually, birth began to slip away from me. I no longer felt the draw to be there, present in the labor room. My focus was shifting to the welfare of babies and children once the parenting journey began. I began turning down doula jobs and started teaching parenting classes.

My personal connection with birth was slipping away, too. I was nearing the end of my own baby-making years and missing the sweetness of the round belly, the nursing baby. So when I found out I was pregnant early one summer I was thrilled. Mostly.

As summer came to an end, the kids and I were out on a small island off the coast of northern British Columbia and I was around 12 weeks pregnant. We were living in a tent, visiting with friends who were back-to-the land, organic farmers and oyster fishermen. I had attended a home birth already on the island. No doctors or midwives for a hundred miles, present in the room that night were family, a few friends, and a feeling of grace.

On the day I started bleeding I knew immediately what was happening. I took a walk down to the water. Sitting on a rock overlooking the bay we had grown to love, I said goodbye to the baby who was leaving my womb. I told him I loved him. I let him go.

Later that same night, as I lay in the tent with my sleeping children I knew I was bleeding too much. I knew in my heart that I had to get help. I believed that if I stayed in the tent that my children would wake up in a pool of blood and that I might not wake up at all. I got up and went into the cabin where my friends were and told them I needed to get to a hospital. In the two hours that followed I was given oxygen from a scuba tank, carried through the woods by a team of local fishermen to the government dock where I was carefully lowered down (the tide was out) to a Canadian Coast Guard cutter. The medics tried to hook me up to an IV, but I had already lost so much blood they couldn't get into a vein.

I was leaving. Drifting in and out of what felt like a gentle sleep. I thought of my babies, who would wake up alone in a tent and find their way to the cabin only to discover I was gone. I thought of sharks, swimming in the ocean I was riding across.

There was so much blood I was sure they could find me, that sharks would follow me to the marina. So much blood, I was sure I would run dry.

Rushed into the emergency room in the small island hospital, the nurses got an IV in me and wrapped me in a Mylar blanket. I drifted off. Then in came the ER doctor who put his hands on my thighs and started to pull my legs apart. In a surge of doula-inspired adrenalin that I thought was lost forever, I sat upright, grabbed his collar and shouted "Introduce yourself! Why can't you people ever introduce yourself first?!"

Then I lay back and passed out. When I woke up I was in the recovery room. I'd had a D&C. The nurse came round and said, "You really aren't from around here, are you? No one here talks to the doctor like that."

"I've been in training," I said.

So I "missed" my first birth, under general anesthetic, by Cesarean. I missed my last birth, under a general, by D&C. Yet it was all fine. In both cases I had been well-cared for. I knew my options. I'd had a labor coach at my son's birth as well as my husband and two friends. I was cradled, loved, cared for. For this last birth, my miscarriage, I was cared for by my own years of doula and birth work. A gift to myself.

The End

And now I sit here. Quiet. Listening. The sum of everything I know, all I have learned in my years of birth work, is here, focused in this quiet room. Listening to the monitors, watching this woman in the bed, I listen and watch all through this long night.

My friend is dying. When she first became sick – alone, without parents, siblings, partner – I knew what she needed. She needed a doula, a cancer doula. So that is what I became. Together we compiled questions for each doctor visit. I took notes. I helped her navigate the system and array of specialists. All the years of doula care came through as we wandered the medical maze of dying together.

Now. Here. She is dying. And I am in this familiar yet unknown

land of the hospital. The soft pad of nurses' feet. Hushed voices. Smells you only smell in a hospital.

Her son is waking now – he looks up at her as soon as his eyes open. He is so young. I am his legal guardian. I love him fiercely, would do anything to ease his pain. It is in my nature to ease pain. It's what I do. It is who I am. I am a doula. I am at ease with my friend's dying, but I ache for her son with a pain not unlike labor.

He reaches up, strokes her face, talks to her in a quiet, not-yet-grown-up voice. Tells her he will be right back and he leaves in search of food. As I watch him walk away, I think of her house, which we will have to sell. The house he was born in. The bedroom he was born in. The only bedroom he has ever known from the moment of conception.

His mother is dying and in dying she is giving birth to an orphan.

I think of birth, of hospitals, of the many stories that unfold here. Just five floors below me, someone is giving birth right now. This moment, for someone, is all beginning. The joy, the pride, the fear, the anxiety, the sore breasts, the laughter, the awe, the sheer wonder of it all.

I think of my son's birth. As I lay in a bed and the nurse prepped me for surgery, my husband and two friends stood around me, reassuring me, calming me. One friend, who was there truly by accident – she had been our driver and once at the hospital I didn't want her to leave – was terrified. I could see it in her eyes. As I lay there having my belly shaved, she stood, bravely, beside me and put her hand on my forearm.

To this day I remember her touch. Above all, that moment is clear. In that touch – her cool hand, barely and nervously stroking my arm – there was so much love. I could *feel* the love in her pouring into me. I have never forgotten that moment.

This woman is dying. I feel honored to be here. The calm and love I feel in this room is profound. We stand now, with our hands on her. I think of the power of that touch on my arm at my son's birth and it is that which I want to give now. It is *that* which I want her to carry with her as she leaves. It's all I have left to give.

Her last breath comes on so slowly. It is nothing like the first breath of a baby, yet is the same in the watching, waiting, holding myself still. As in birth – when you wait for the miracle of that sound, that cry of life – we stand quiet, focused, straining to hear.

Birth Wish

Toby Neal

WOW! BIRTH! I GUESS YOU COULD say I am an addict. I believe in birth. In the body's wisdom. I love everything about birth, that is, what birth is meant to be.

But what is it meant to be? As a doula, this is what I think about most. This is my dilemma.

As a mom, I often hear other moms warning moms-to-be about the labor. "Don't wait, just get the epidural. Ask for it as soon as it starts, it is not worth it to wait." And as a doula I often hear women say, "I have a low pain tolerance. A natural labor would be nice but I am no martyr. I want the epidural at some point."

Pain. That seems to be what many women think birth is all about.

As a doula, my role is to support women, to support them in whatever it is they want for their birth. I don't want them to have *my* ideal birth; I want them to have *theirs*. But, I would be lying if I didn't admit that my heart weeps a little every time I hear these words. So I struggle. How can women get away from the fear? What can I do to open them to the possibilities? Some would say it's their choice and who am I to think they need education on the

matter. I can respect that, but is it a choice? Don't you need to know the other side to really make a choice?

For every birth I attend, there is a part of me that is envious, envious of the laboring mother. I want to be her again. Feel what she is feeling. Have the power of labor wash over me. Feel what amazing things my female body is capable of – birthing life. I have been blessed with having had an orgasmic birth experience, and let me tell you it is addictive. I would labor every other day if I could. Okay, maybe every other week, but really, it is that addictive. Once you have given in to your primal side, once you have felt the strength of labor and let it happen, there is no better feeling in the universe.

So how? How do I remind women of this possibility? How do I communicate that it is worth birthing without intervention or at least worth a shot? I am not ignorant. I know that sometimes there are complications and sometimes intervention is necessary, not nearly as often as it is used. But, yes, there are times it is called for and, yes, I'm grateful for its use.

Just the same, I wish every woman could experience what I have experienced. I know I am blessed. I don't know why I got to be one of the minority in today's North American society that gets to believe in birth, to know its complete joy, but this is what I wish for all women. As a doula I get to try. I get to support my clients and hope that they too will know this feeling, this innate sense of being. That is what each birth I attend brings me, a chance to support a mom, to help her achieve the birth she desires, and maybe, just maybe, a chance for someone else – who may not have otherwise – experience the amazing, addictive, grounded, peaceful, orgasmic, normal occurrence that is birth.

♀ Small Victories
Julei Busch

*THIS POEM CAME AFTER ONE
poignant winter where several clients sought guidance to finding
ways to acknowledge, honor, and make ceremony for their losses.
This poem is for all women who have grieved the loss of a child, at
any time in that child's life.*

For a few brief days each month,
she bleeds you out of her soul.
Such a small sacrifice offered
against enduring pain.
Drawing deeply upon the residues
of your mouth, skin, and scent,
each month is a little death,
where tears flow like blood.
She bleeds you out of her belly
until her breath steadies again.
Alchemy transforming so slowly,
searching for the woman she has become after you.
Searching to fill gaps in the rhythm
where your heartbeat entrained hers.
Searching to hear a solo dance after a doubled beat.
Once a month she bleeds to build tomorrow one breath at a time.
"Goodbye," she whispers, "Goodbye again."

Mother's Day Intuition

By Tracey McCannell

THIS STORY WAS TOLD AT A STORY circle and recorded by Lisa Doran. As you read Tracey's experience as a doula, you can imagine all the laughter and the gasps of awe and wonderment from her listeners as she tells this incredible story.

This is a story about a client I had a few years ago who took my prenatal classes. She and her partner were very lovely people. They asked all the right questions and did all the right things in my opinion. They had refused any sort of prenatal testing such as blood work or ultrasound. This woman held very strong values around natural childbirth. I thought she was amazing.

When I first met her she said, "I am going to have my baby on my due date," and I said, "Well you realize that only 4% of women will go on to have their first babies on their due dates," she said, "No, I am certain I will have my baby on my due date."

Through our prenatal meetings and her continuing to take choice-based prenatal classes (and really researching what she felt was right and because they were a very holistic couple who lived their lives on principle and very carefully made their

decisions), I really felt that they were going to have the birth they wanted.

The evening before Mother's Day, this particular mother called me and said, "I'm in labor!" and I said, "No you are not!" 'cause you know how it is with first-time mothers? You try and talk them down? (laughing) "No, you are not in labor! Don't be so silly! This is your first baby! You have another two days before you are going to give birth," (laughs some more) and that was 11:30 p.m.

Boy was I wrong. At 4 a.m. she called me again; her water had broken. My partner was at work and I thought, "Oh my God, what am I going to do? I have no place to take my children." I drove my kids to my backup birth partner's house in the middle of the night, tucked them in, then drove quickly back to my client's house.

Now, her backyard was literally on a lake and she had been pacing outside. In her birth plan this mother didn't want any vaginal exams at all. She really wanted a low-intervention birth and in her mind that meant refusing all interventions, including vaginal exams. Her midwife was there and told this woman that she should really do a vaginal exam. At that time, there was a nearby practice of midwives who were insisting that women could not stay at home to birth their babies unless they had a vaginal exam during their labor. Our local midwifery practice was really questioning what their protocol should be. This midwife insisted on this day that she had to do a vaginal exam if they were going to stay at home. As a doula, I was standing there and my eyes were rolling into the back of my head and I just could not believe that this was happening.

Upon a vaginal exam, my client was 8 centimeters and we are all so giddy, you have no idea.

The midwife called her backup and began quickly preparing for a home birth when the mother says, "We have to go to the hospital."

I could not believe what she was saying. I kept thinking, "What do you mean you have to go to the hospital?" So now the midwife and I are trying to talk her out of going to the hospital. Maybe she was simply panicking because she was scared. We were trying to convince her stay at home because she was 8 centimeters and the baby was going to be born at any minute and it's a long drive to

the hospital and we wanted to be sure that she understood the impact of the decision she was making. She insisted. We needed to respect what she was saying. I remember the crashing of the waves coming in off the lake and they were rhythmically crashing in. The mom was really enjoying that sound as we were laboring together. I'm thinking, "What a great place to give birth!" The crashing of the waves, it was so amazing! But she says, "No, we need to go to the hospital." So, very simply, we did. Moms call the shots.

So she climbed in the back of her car and we drove as a caravan to the hospital. The midwife in front of their car and me behind their car. I called my backup to tell her we were going to the hospital. I remember as we drove through some country roads thinking *I cannot believe that this is a woman who was going to have a home birth and we're heading to the hospital to have this baby.* I was very, very sad. I wasn't in the car with her, but I could see her looking back at me as I was driving because she was hanging over the headrest and my headlights were hitting their car in front of me and bouncing into her eyes as she was looking back at me. I could see her face and it wasn't fear, yet she knew she had to go to the hospital.

The whole time it took us to drive up through the country roads to the hospital, which was 35 minutes away, all I could do was hope that my least favourite OB was not on call. *Baby Jesus, please don't let this doctor be on call.* Well, the second worst person to be on call was another OB who really thought he was all that and a bag of chips.

When we get to the hospital, there is a great old pre-legislation midwife who is backing up our midwife. She is one of our favourite midwives who I have worked with a few times. She does a vaginal exam, then looks at our midwife and I could sense something is wrong. They don't say anything and walk to the back of the room. Everyone is tense. The mother is upset because she senses that there is now a medical reason why she felt compelled to insist on that dark and bumpy ride to the hospital. Her partner is super freaked-out because we are now at the hospital and things are flying really quickly and now the two midwives are having a consult at the back of the room. When they come back they say,

"We've got a problem. We think you have a footling." I'm thinking, come on now, really? These are two very experienced midwives that were practicing pre-legislation, they really knew what they were doing, so how did you miss this?

The OB on call walks in. His arrogance meets you at the door – it hits you. He does a vaginal exam and turns to the midwives and he's appalled because they've already told him – unbeknownst to us in the room – that this is a footling. He says, "Well your baby is coming down foot first and if we don't do a Cesarean, your baby is going to die and I cannot believe that an ultrasound has not been done to determine this. This is ridiculous!" He turns and chastises the midwives who are very new at this hospital so they bow down to his arrogance and they bow down to him being unfair to them.

Now it's a complete transfer of care to the OB. The midwives have lost all influence over the birth – to advocate, to be present. Our midwife did stand up to the OB and said, "We need to be there" because at that time they didn't want to let the midwives into the operating room. The OB decided that the midwife who had spoken up could come to the OR and attend the Cesarean delivery.

The mother is now very upset, swearing at the OB and telling him that he is being more aggressive than is needed. She keeps repeating that she can't believe this is happening. But she delivers this beautiful baby – Sarah. (The parents had two names for the baby. It was either or Samuel or Sarah. S names.) The parents are now exclaiming how lucky they are and how wonderful she is and how they love baby Sarah.

While the nurses take baby Sarah over to the incubator the OB goes in to scoop out the placenta, but he doesn't pull it out. What he pulls out is another baby, a twin. A healthy beautiful baby girl was born right after her baby sister and he turns to the mother and he says, "You are not going to believe this," and the mother says, "What do you mean?" and the doctor says, "You have another baby."

This is a woman who is very centered, earthy, wonderful, balanced and loves the universe, so completely out of character she turns to the doctor and says, "Fuck off, you are such an asshole!" She really thought that he was trying to play a trick on her. She felt

that he had been trying to punish her for making her choices – for having midwives, for planning a home birth and for having no pre-natal testing or ultrasound.

I remember the midwife coming out into the hallway laughing hysterically and telling us that the mother had told the OB to fuck off. She had never ever heard anything like that in the operating room during a Cesarean birth. I wish I had been there because I personally had wanted to tell that OB that exact same thing on a regular basis myself! (laughs)

This woman had a bicornuate uterus and upon a physical exam-ination, with the absence of any ultrasound testing, there would definitely have been a head down here and a bum up here – they just were not attached to the same baby! The midwives had not misdiagnosed a footling breech.

This mom now had two baby girls, Sarah and Samantha. Beautiful babies! I remember meeting my client in the hallway out-side of the operating room as she came out of her Cesarean and absolute glee was on her face and I was so excited for her. I was really angry when I heard that she was having the Cesarean because they had diagnosed her with a footling breech. I thought, *Oh my God, here is a woman who has had absolutely no interven-tions in her pregnancy, who wanted a quiet and gentle birth at home and now she was going to endure and undergo a surgical delivery,* and it just seemed so unfair.

During her labor, she felt that she had to be someplace where that second baby could get assistance. More assistance than the two midwives could have given her. This mother knew, she trusted, there was something in her – an intuition – because we tried to talk her out of going to the hospital at 8 centimeters.

This is a mother that had trusted all of her instincts all through-out her pregnancy and her birth, and knew what to do for her babies even if it was against what she had hoped and dreamed for during the birth. She was strong enough to trust her intuition and make hard choices.

What wonderful lessons we learn about trust, about intuition, and about the wisdom of our bodies from our clients.

Tracey's story is interesting but not unusual. I've had three home births where moms knew instinctively at 8 centimeters that there was an issue with their babies and they had to get to a hospital in case of an emergency. It seems that at 8 centimeters dilation the body communicates that there is something that needs assistance. As a birth supporter in these situations, I listen to what the mother needs and respect what she wants, while trying to calm her down and reassure her. Every time a mom has insisted we go to the hospital, there has been some kind of unusual circumstance that would have been very difficult to manage during a home birth. The lesson: Listen to your body!

A Mother's Strength

Melissa Harley

BEFORE BECOMING A DOULA, I WAS really not aware of the inner strength that women possess. I often understood that women relied on other women. When growing up, I watched my mother with her sisters, and I knew that my mother was a strong woman, but I just didn't get it. It wasn't until after being a doula that I truly connected with the inner wisdom that each woman holds.

Throughout the last 7 years as I've been attending women in labor, there were a few women who stopped me in my tracks by their ability to cope with not only labor, but also with life's circumstances. Years later, it still gives me pause to think of how they were able to be so strong in the midst of unexpected crisis.

Emma was a client who came to me by chance. During the summer, Emma spent her days preparing for the birth of her first child, due in the fall of that same year. She hired care providers and went to prenatal appointments, she sought out childbirth classes, and registered for them, and she began to do what many mothers do – she began to prepare mind and body for the birth of her baby.

Emma and her partner Ben live in a tropical paradise. Sometimes

though, paradise comes with a downside, the threat of a hurricane that can destroy everything in its wake. One night very close to her due date, Emma and Ben received news that a hurricane was headed straight for their small island. In order to ensure their safety and that of their baby, they evacuated late at night, expecting to be gone from their home for about 5 days. As it turns out, the hurricane hit their home and the damage was quite extensive. Emma and Ben's home was flooded, and there was a long delay before power was restored. She was about 6 months pregnant, and she wouldn't be able to make it home for the birth of her child. She had a new physician, didn't know anyone in the local birthing circles, and wasn't familiar with the local options in our town. Emma was staying with family, and didn't have a "nursery" to bring the baby home to, yet I heard strength in her voice. I heard her speak about the crisis that was going on in her life, but she spoke with a comfort that I hadn't heard before.

Over the next few months, Emma attended classes in my living room. She attended most classes alone, and for just a few of them, we got to meet Ben. We shared laughter and we shared tears. After class, Emma and I would often talk. We discussed the struggles that she had with being away from her love, Ben, as he was working hard to repair their damaged home. We discussed logistics of what she really wanted for her birth. We also discussed her feelings about being in a new birthing environment, with new care providers, in a new country. I watched as Emma certainly mourned the loss of her perfect birth while still demonstrating strength as she prepared for a new ideal. I thought to myself, *Wow, if Emma can deal with this and keep it together, then women are much more spiritually stronger than I knew.*

After several classes and talking sessions, Emma asked me to be her doula. She was not sure if her husband would be able to make it for the birth. I excitedly agreed, and we began our doula-client journey together. Emotionally, I was honored to be by Emma's side as she walked through the end of pregnancy, but I was also apprehensive about supporting her in the possible absence of her husband.

When Emma called late one night in early labor, I remember feeling both excitement for the impending birth and anxiety about Ben making it. It was about 11 p.m. when Emma's water had broken and her sweet husband was stuck on the next plane out at 6 a.m. When I asked Emma what she wanted to do next, she asked that I meet her at the hospital. Over the next several hours, Emma and I walked the halls and rooms of the local hospital. We talked and shared moments about life, and about how her life would change after bringing her baby home. Many hours into her labor, her physician began to suggest Pitocin as he felt that labor hadn't really taken off, but Emma wanted to go another route, a slower route. Emma respectfully declined, and we continued with walking and talking. Although we shared tears in the weeks and months before, there really were no sad moments that I can remember. Emma seemed tough as nails, she knew that she had work to do, and she wanted to do it slowly to give her husband as much time as possible to arrive.

The following morning, Emma agreed to accept some Pitocin as she had been in labor for about 12 hours since her waters had broken. She knew that her husband was on his way. Her labor picked up quickly, and her contractions became quite strong. Emma found comfort through my words, and the use of the bathtub. As she labored, with Pitocin running through her veins, I couldn't help but think about how strong she was. It brought tears to my eyes, not only because she was in pain, but also because she was so strong. Her strength throughout the end of her labor was one of the most transformative experiences I have had as a doula. I learned to trust mothers in a way that I have never trusted before. I was taken aback by her commitment to normal birth, and her ability to cope with contractions, even through her challenges. I was shocked, truly shocked, that she, after experiencing the emotional months leading to this birth, knew that she had the ability to give birth to her sweet daughter. At no time, even with the Pitocin, did Emma even once ask for pain medications, or wish that her birth was different.

Although I can't remember the exact time, Emma's husband, Ben, arrived with just a few moments to spare. Within 2 hours,

Emma gave birth to a beautiful baby girl, Lauren. It was a joyous moment, because of the new life, because of the arrival of a daddy to bear witness to the birth of his daughter, but also because of Emma's sheer strength, power, and commitment as she birthed her baby. It was as if, with all of the struggles that she had gone through, they were all minute compared to birthing her baby.

When I spoke with Emma days after the birth, we both shared joy and tears again. I shared with her how I was still amazed by her strength and her commitment to birth normally. She shared with me her gratitude for the physical and emotional support that she had received during her labor and birth. Years later, the experience I had with Emma remains as one that has shaped me into the doula and childbirth educator that I have become. As I watched her walk through the trials of life that she faced in those last months of pregnancy, I was reminded of the strength of the human spirit, and the strength of the woman. If Emma could handle these trials, with such poise, composure, and determination, then I learned that women, in general, had exactly what they needed deep inside to birth their babies confidently and normally.

Birthing My Self

Michelle J. Cormack

MY EARLIEST MEMORIES WERE OF spiritual quest...longing...yearning for understanding...why am I here? Where did I come from before this life? Where am I going?

By the time I was about 12 (in the late 1970s) I was drawn to a book about meditation and yoga and bought it because I knew I had to investigate further. Silently, secretly, I chanted Om as the book instructed. I planted the seeds to "my self" as a yogini. I also knew that more than anything in the world, I wanted to be a mother and I wanted to have children, especially to bear them and to give birth to them myself. As a child, I would actually visualize and pretend that I was birthing! Spirituality and birthing were my interests from such a young age, I don't ever remember a time when I wasn't interested in them.

Then at 22, I had the most transformative and life-altering experience of my life. I was blessed to co-create with the Divine and bear my first child, Jacqueline. It's as though my entire life purpose was catalyzed in that first spark of pregnancy, just like the ancient tantric wisdom teaches that at the moment of conception, when the sperm and ovum come together, it triggers a spark of bliss that

becomes the heart. So our innate nature is bliss, we are born from bliss, and we literally have bliss at the core of our being, in our heart! My heart as a mother and as a doula was sparked by that bliss of pregnancy, and Jacqueline's subsequent birth. Her birth was a difficult forceps delivery that I felt traumatized by and obsessed over for way too long. Once I found out about doulas (and due to the specific circumstances of Jacqueline's birth) I felt deeply in my bones that if I had been blessed to have a doula assist at Jacqueline's birth, I would not have had such a difficult forceps delivery. However, due to what I felt was 'trauma' at her birth, I became pregnant with 'my self' as a doula at the moment of her birth – the seeds were deeply planted. My connection with all mothers throughout the ages was unmistakable and clear.

I gave birth to 'my self' as a doula on Sept. 1, 1992, as I gave birth to my second child – my premature son (gestational age of 23 weeks) who died at the moment he entered this world. He slipped from one world into this world, and then passed right on to the next world, carried through the portal in a flash of human birth. The transformative power of Shakti was sparked within me at his passing through my body, the passage through the open window to the universe. Shakti is the sacred force of empowerment, the enabling primordial cosmic energy that moves through the universe and is considered to be the divine feminine creative power or energy. Shakti is even considered to be "The Great Divine Mother" and manifests in form (on the earth) as the embodiment of a woman and her fertility! Never before had I experienced the height of ecstasy as I did at the moment of his birth, yet coupled with the height of emotional pain, like a dagger in my heart, brought on by the knowledge that he would not stay with me. Instead, he was merely a passenger passing through me as he moved onto the next world. That magical 'space,' beyond the confines of time, when the passage through that open window takes place – at the moment of birth or death – or in baby Gary's case, the simultaneous moment of *both* birth *and* death.

The birth of baby Gary, as we still refer to him today, was my second personal experience of giving birth, yet it was the first time

I had experienced the loving kindness of a doula 'present' at my birth, truly present as a shimmering gem of luminous light that was priceless beyond words. Being blessed to have the unconditional support of my doula made all the difference in the experience, both in how I coped with the intense pain at the time and also with my memory of the experience. At the moment of baby Gary's birth, I experienced the same peak of bliss that I enjoyed at the moment of all my births (yet it was peaked simultaneously by the horrifying grief that my beloved child would not survive). Later, as a doula, I could feel a similar 'peak experience' palpable at every birth I attended. I clearly remember learning, from the very first doula/labor assistant training that I took, that the word "facilitate" describes with the most clarity what we as doulas do. We facilitate the birth for the women we serve. We facilitate with a deep reverence that we as doulas witness and honor that sacred passage, regardless of how that passage manifests, yet maintain an all-encompassing commitment to doing everything that we can do to provide the most sacred passage.

Although the 'passing' of my baby, whom I so very much wanted in my life, was so unbelievably sad and heart-breaking, I somehow intrinsically knew that it was a significant part of my life purpose. I had no idea how life would unfold from that moment on; I just knew that *this experience* was part of the plan, it was an important piece of the puzzle of 'my self.'

Then, within a month, my doula shared with me some info about a labor assistant workshop that was going to be taught in our city (by Informed Birth & Parenting, now known as ALACE) and I instantly recognized that this was my path, so I signed up immediately. If I had still been pregnant with baby Gary, as I should have been, or if he had survived, I would not have taken that training. At the workshop, I felt immediately that my purpose in life was to do this work, the work of supporting women in pregnancy, labor, and birth. It was one of the most powerful convictions that I had ever felt! Interestingly, the use of the Greek word "doula" to describe the professional labor support person/assistant had at that time only recently been connected.

My personal birthing journey continued to weave in and out of years of attending births as a doula and teaching childbirth education classes. My next four children were all daughters born gloriously at home with the guidance of midwives and a doula. Each one of their births was potent and magnificent. They reaffirmed for me the intense power and glory available to women as they birth from their deep well of resources within. Often times since then, when faced with a fear-inducing or seemingly impossible situation, I would reflect upon my own birth experiences as an inspiration that anything is possible. My desire for all women is that they too can reflect on their birth experiences in this way. A testament to the strength and resolve within us...our inherent Shakti. I also flowed in and out of yoga practice over the years until my last daughter was born in 1999, when I started to take on a regular, consistent yoga practice and the yogini fire was once again lit in such a profound way that I felt the call to teach – then the marriage of my love for pregnancy, birth, and yoga was complete. I was fully born as a yoga teacher, a yogini.

Each birth that I have had the privilege to attend affected me in so many profound ways. I was in awe and wonderment of the primordial awakening that happens in the pregnant woman as she is transformed from a woman into a mother. It is for this reason that I prefer to call them pregnant goddesses. To witness a pregnant goddess giving birth is to humbly transcend all worldliness into a sacred realm of 'other worldliness,' to plunge into the depths of her soul and transcend the limitations of the physical body. To witness the unification of cosmic forces of primordial creation with the given form of reality in this world, the birth of the manifest: the new sacred embodiment entering this world for the very first time.

Having served as a doula in various intensities over the years I have, as a result of 'being in the flow,' observed certain patterns. You could call it a common thread or elements of pregnancy: The 5 Elements of Life (earth, water, fire, air, and ether/space) come alive in pregnancy and birth like at no other time. Just as all of us are created and born into this world with a specific blend of the

primordial elements that we manifest as our bodies come into being, so too the elements are central to the pregnancy and birth experience, especially as pregnant goddesses tap into their inherent nature during pregnancy. I have steeped in these impressions of the 5 elements and how they emerge from pregnancy and birthing for many years. I now see birth as a journey through the elements, and have witnessed the pregnancy and birth experience enhanced greatly as the conscious connection with the elements, especially through yoga practice, allows for transformation in pregnancy and birth. Some may call this transformation the magical 'ah ha,' the moment when they truly feel connected with themselves, their baby, their fellow pregnant goddess, and often, their 'source.' This transformation can be the most absolutely powerful transformation that they have ever experienced. I've witnessed women climb the highest mountains and dive into the deepest depths, often roaring like a lioness protecting her young, navigating their journey of birth with strength and fire that they otherwise didn't realize they possessed. It's like beholding the alchemy of the elements, potent inner forces, manifesting in full splendor in the laboring goddess.

Earth. The grounding element. It anchors women through the intense times of distraction that profound labor pain/intensity can invoke. When pregnant goddesses energetically access the essence of their roots, both metaphorically and physically, they draw strength and stability during a time of destabilizing. Rooting into the earth physically literally improves their center of gravity, potentially relieving some of the back pain so common in pregnancy. Metaphorically, during pregnancy, women often return to their own roots, remembering and connecting with their mothers and even grandmothers and deeper. The energetic quality of rooting also gets women in touch with their root energy center, which represents our primal aspect, our instincts and foundation, the security of 'home base.' Earth energy aligns our bodies and our baby's bodies to the physical path of birth, of passing through the birth canal with optimal alignment. It is the place where the final physical portal is that the baby passes through to fully enter our world.

Water. Powerful, intense waves rising and swelling, then falling and fading, like the tides on the shore. Ebbing and flowing. Rocking and rocking, back and forth, side to side – like a boat adrift on the wild, raging ocean. Undulating and meandering the river of their spine. Such is the ritual many birthing goddesses embrace. The moment rising up from within without any effort, other than to 'let go' and be carried in the flow. Water is the essential nature of all of our bodies. We are all like islands in reverse, like containers of water, held in connection by our skin. Our bodies are usually 70 to 80% water and during pregnancy blood volume increases by 50%, so with the combined extra blood volume the degree of 'wateriness' in pregnancy is formidable. Of all the elements, water is actually the most powerful. Just look at what a hurricane can do. Contractions come in waves, and it's so inspiring to witness a woman literally riding the waves of her contractions, like a surfer on the ocean. Finding the inner balance to ride the wave into shore and not fall off. The fluid motion in the mother's body also helps to align her baby. Women are also juiciest when they are pregnant. And their babies gestate in the watery world of the womb. The seeds that we all came from were in fluid, we were conceived in fluid, gestated in fluid and then slid into this world through fluid – we truly begin life in this world in water. The birthing mother who moves with fluidity can access that joyous, free dancing spirit within her and her own memories of the watery world in which she also evolved from. Incorporating fluid movement, 'flow,' is one of the best ways to tap into our primordial self, which is the key to an empowered birth.

Later is also defined by the container that it is in, so 'going with the flow' means that although circumstances may change during labor, the laboring goddess remains empowered, even when the plan she had for her birth is veering on a different path. She will still be in the flow. Water may also manifest as still and reflective, so it reflects its own changing nature, which is remarkably typical of labor and birth, since it becomes a day to reflect upon for the remainder of most women's lives.

Fire. The burning fire of passion that ignites the creation process within that conceives the new child. Fire is the source of life, just

as the sun is the source of life on this planet. So the fire burning in our bodies and in our hearts ignites as we connect to our babies, the flame of love in our heart. Witnessing the fire element manifesting in the birthing goddess is one of the most exciting things to be privy to. When the goddess transforms from quiet and introspective to the roaring lioness…WOW! Inner fire helps the goddess defend what's best for her and her baby in the face of perceived danger (such as an intrusive caregiver or an unwanted spectator). Nothing can stop her from staying true to her path with the embers of inner fire burning. Fire is the element that transforms – it can transform fear into anger, yet also can transform fear into resolve and action or transform anger into discriminating awareness wisdom. Fire illuminates our inner wisdom to help us know what we need and provides the light we need to have insight ("inner sight"). A mother's burning devotion to her child is like fire in her heart. The inner fire is also what sustains women through the most challenging moments of labor. When she feels that she just can't bear one more contraction, fire ignites and she transforms from docile and submissive to empowered and powerful.

Air. Breath is the linking mechanism between the body and the mind. It is through the conscious, directed movement of air, or conscious breathing, that a laboring goddess has the greatest sense of control and release. The perfect balance between the receptive and the letting go. I've observed over the years that laboring women find the conscious control of the breath (a.k.a. breathing exercises) as the number-one tool that guides them through the difficult moments of labor and birth. A baby's first breath, the breath of life, is the very first element they embody to identify them in this life and to acclimatize to in their new little body. It is the inspiration of air and prana (the mystical life force energy that enters the body with the air in each breath) that initiates and guides their journey from the watery world into our airy world. It is the elixir of life, and through our awareness of it and controlling it in our bodies, we master the key to yoga practice (the practice of connecting with our 'self').

Ether/space. It is the hypothetical medium that fills all space, the space in which the other 4 elements exist and manifest. It is the

space between. The space a pregnant goddess creates in her spine, relieving some of the compression, and potentially transforms some of her pain and discomfort. Cultivating the 5th element also brings a higher attunement that allows the new mother to be more fully connected with herself and her baby. It means she is able to view all the areas of her life with more insight and consciousness. Her intuitive awareness becomes clear and her mothering is guided by this awareness. Jeannine Parvati Baker describes it as "the invisible fabric, the weaving in the weave. It is the egg, sperm (and the cervical mucus), and the attraction that pulls them together. It is the intention of the baby to be. Ether pervades all, is all, heals all." When the pregnant goddess attunes her awareness on the ethereal level, she perceives that anything is possible through visualization, toning (our sense of sound and our voice is ruled by ether), increasing awareness and even by the knowledge of the benefits of incorporating the other 4 elements into her birthing experience!

Ultimately, it's all about the balance between the elements – primarily being in the flow (water), yet remaining grounded and rooted (earth), igniting and sustaining our faith and resolve (fire), and being with the breath (air, which really means to stay connected and conscious with it rather than wasting the life force and letting its power 'leak'). The deep, all-pervading consciousness of being 'awake and alive' and fully aware in every way, the alchemy of all the elements, *that* is the 5th element (ether).

So I come full circle, or as the ancient Tibetan Tantric wisdom teaches: the circle, zero "O", is the *cosmic cervix*, the cervix of the universe. And we are transformed from the unseen to the seen, through the circle of the cervix, the entire 'round.' As doulas, our personal "her story" and experiences inform, guide, and empower our work. Being fully informed about pregnancy, birth, and all the options and physical realities of it is helpful, but it is ultimately our connection with the real, raw emotions and universal feelings of pregnancy and birth that is at the heart of being a doula – our connection with each other. Imagine what a wonderful world this would be if all women transforming into motherhood could do so with the loving guidance of a doula by their side!

♀ A Birth Story

Anne Simmonds

She's came into triage 12 hours ago
Her cervix 4 centimeters, with some bloody show
We hooked her up promptly to the EFM
The baseline was great, so we watched it again!
Then charted it all with a paper and pen.

And once we were certain the labor was 'true'
We admitted her to a brand new birthing room
Which was well equipped with emergency gear
'cause safety is our main concern around here
We thought she'd be comfy – with nothing to fear.

But *this* woman wanted a natural birth
To let things evolve, just like Mother Earth.
But birth's unpredictable – didn't she know?
You can't just let it happen and let yourself go
It has to be measured, observed, and controlled!

After hours of walking, she started to tire
We encouraged some drugs, for relief she required
After some hesitation she finally agreed
So we gathered our gear and began an IV
(and a catheter, too, to make sure she peed!)

Well, once she was comfortably resting in bed
We hooked up the monitor right by her head
It gave us a printout of fetal heart rate
Along with contractions, from which we could state
That the baby was fine and we just had to wait.

But alas, the poor dear, she failed to progress
With incompetent cervix, what can one expect?
We 'pitted' and 'ROM-ed' her, we 'up-ed' her IV
Tried all of the best of our technologies
But nothing would work on this mother-to-be.

We gave Mum the update as she softly wept
She felt somehow to blame, said she was inept
We kindly assured her it wasn't her 'fault'
Her baby was, sadly, too big for her vault.
We suggested we 'section' her just down the hall.

We prepped her for surgery, with partner outside
She said she was scared and she started to cry
We said, "Oh don't worry, you have nothing to fear,
You're the 22nd hundredth section this year!"
She put on a brave face, though the tension was clear.

Once the drapes were in place, she felt disconnected
While we, on the other side, cut and dissected
The clicking of instruments, burning of flesh
She felt farther from birth and closer to death
But she thought of her baby, its precious first breath.

Within minutes she felt a great pull and a tug
"It's our baby," cried Dad, and he gave her a hug.
She heard a first cry but her babe was concealed
She had been whisked away to a radiant field
Where the weight, sex, and APGAR scores would be revealed.

"It's a girl," we called out in our sing-songy voices
"And what will you call her – there's so many choices!"
But the mother, exhausted, relieved, and confused,
Could not answer back – she was not in the mood
She wanted her baby – that's all that she knew.

Once she was sewn up and the linens replaced
She was moved to recovery, a quieter place
And it's there that we 'delivered' the child she had birthed
Like a gift or a present that wasn't from her
And she didn't feel anything like Mother Earth.

What It Takes to be a Doula

Samantha Leeson

Heady
Enlightening
Engaging
Empowering
Challenging
Emboldening
Courageous
Willful
Overwhelming
Devastating
Mystifying
Strengthening
Powerful
Fulfilling

These are some of the many words I would use to describe what it is like to work in the role of labor support. These are the kinds of words I would use to describe the many families I have been invited to work with over the past 10 years. The women I am able

to work with have the gift of being able to bring life into this world. The word that I would use to describe what it means to me to have been bestowed with the honor of working with these women is simple: humbling.

How utterly and completely humbling it is to be invited to share the most intimate of experiences with families I hardly know. I endeavor to get to know them over the weeks and months at the end of their pregnancies. How can I ever know them truly? By witnessing the miracle of their births how can I ever *not* know them truly? I have seen all that they can be and all that they can do.

The most common question I'm asked when sitting down to interview a client (and be interviewed) is: "What made you choose this line of work?" Good question. Tough answer. Ultimately, it's a result of not being respected. Not being encouraged. Not being honored for what my body could do.

When I gave birth to my eldest son in the spring of 1998, I had a chance to discover what it meant to 'feel like a number.' I was treated as though this most blessed and wondrous of events was nothing more than a normal Monday morning for those around me. I was told how my labor would unfold, when contractions should start, at which point the pain medications would be started and then, later, when my son would be pulled into the world.

"Congratulations. You have a beautiful baby boy."

"Are you sure?"

Just how disconnected does a mother have to be to ask a question like that? "Are you sure?"

Never again. Women are designed to have babies and I have enough education, desire, and dedication to make sure that I never hear another woman describe an experience like mine. Fate and I decided my next experience was not to be the same. In fact, it was perfect enough to transform my own personal vision of birth as we welcomed our second son into the world the way we had dreamed of doing.

The transformation and understanding was a long road.

It took me time to realize that some women *do* want the kind of birth I had. Some women are so afraid of the process, often a direct

result of the experiences they have endured in their own lives, that they need to be able to emotionally detach through labor so as to be able to have the energy to invest in connecting with their baby after the birth.

It took me time to be OK with the reality that my ideal experience is not the ideal experience for every woman. My ideal experience has had a chance to evolve into becoming exactly what my clients want.

I have opinions that I give when I am asked. Opinions that are formed from the research I have done, the conferences I have attended, and the discussions I have had with traditional and non-traditional birth attendants over the past decade. It is my private reserve, but I will share it if I am asked for it.

I have learned lessons from each of the births I have been invited to participate in. I have learned something about birth, something about the woman giving birth, something about faith and often, something about myself as well.

Birth is the most incredibly amazing process a body can go through. It is stimulating and invigorating and revitalizing and enlivening. Becoming a parent is a gift beyond measure. Being invited to participate in the event is, as I have said, humbling. It is an honor I will cherish always.

The Power of Birth

Cindy McNeely

BIRTH IS THE CULMINATION OF AN incredible period of growth and development in the life of a woman and her family. Along with the wondrous physical, psychological, and spiritual changes that occur in the pregnancy, the woman then has a transforming event that will fundamentally change her life activities, goals, thoughts, career aspirations, and plans for the future.

As registered massage therapists (RMT), we are both witnesses and participants in the unfolding events of our clients' lives through their lifespan. Nowhere does our contribution become more profound than in the births and deaths of our clients and their families. For many therapists, attending the births of clients may be the highlight of their professional career.

The chances are high that every RMT in practice will at some time in their clinical practice acquire clients who become or are pregnant. The skills of the registered massage therapist working with pregnant clients need to be enhanced beyond a basic understanding of pregnancy anatomy, technique, and treatment application. The variation in pregnancy training in colleges throughout the

world creates a disparate capability among registered massage therapists regarding their skill level in prenatal care. Those skills are also complementary in their role as doulas.

So what exactly does a doula or labor support provider do, and how do we, as registered massage therapists fit into this spectrum of care? By definition doula/labor support providers are people who attend to the birthing process of their clients in a way that provides continuous and supportive care. Clearly this demands a more intensive commitment and therapeutic interchange than that required in a one-hour massage therapy session.

Many Canadian registered massage therapists can be extremely proud that their training includes pregnancy and post-pregnancy knowledge. When trained to understand the holistic process that begins from the moment a woman becomes capable of conceiving, the therapist can understand and approach her or his clients from a state that conjoins the woman in a sharing of the profoundness of the days and months ahead.

The ultimate luxury of our registered massage therapy profession is the factor of time. To spend an hour or an hour and a half with each client at every visit, sometimes weekly, sometimes bimonthly, or in the early stages of pregnancy perhaps once a month, gives the RMT the opportunity to explore each woman's pregnancy with an intimacy that she often does not have with anyone other than her partner, certainly most often with more connection than she has with her primary healthcare provider, whether obstetrician, physician, or midwife.

The confidence and comfort that we bring to each treatment ensures that our clients are able to grow with their changing body in ways that prepare them for their upcoming birth. We hold a great responsibility in our hands to nurture our clients at this time of great strength and vulnerability.

Imagine having a career where one is inspired by the enormous responsibility of helping women and their families succeed in having happy and healthy birthing experiences through the provision of registered massage therapy. This would summarize the role of the registered massage therapist in attending births.

Being asked to attend a birth is an honor bestowed from families who demonstrate a faith, trust, and desire to engage the personal and professional skills of the attendant. It is not for the faint of heart, nor for those who are unable to give themselves to the commitment of long hours, as well as physically and emotionally challenging work.

When I attend the births of my clients, invariably there are moments or hours where I am filled with awe as I witness the courage and spirit of my families, and in particular, the women who are giving birth. There is no mistaking the profound efforts of women who work so painstakingly to bring their babies into the world.

Many RMTs become labor support providers as a result of their intense curiosity and desire to learn about the birthing process, and to assist families in their goals for a holistic and pleasurable outcome to this journey.

Historically, many RMTs/doulas fell into the situation of attending births without formalized training. They may have dared to utter the words out loud: "I would love to attend a birth some day." These words echoed into the thought processes of our clients, who would consult with their partner, return for another prenatal massage visit, and ask the question that resonated into another echo: "Would you attend the birth of our child with us?"

With no other background than the professional hands-on knowledge of registered massage therapists, we might be sufficiently helpful in creating positive birth outcomes. We can all be thankful for the role DONA International has played in providing courses for lay people and professionals alike to improve our understanding and sensitivity to the skills that are needed to provide family-centerd care while working within the multidisciplinary milieu of birth.

Labor support providers need to be prepared to work in an array of settings – in Canada, hospital or home births are the norm. Sadly to date, birthing centers have not taken hold in this country. Labor support providers must be able to work comfortably with midwives, obstetricians, family physicians, and nurses, anesthesiologists,

midwifery and resident students in training, fathers-to-be, same-sex partners, and the endless possible variations of what constitutes family/friends of the birthing family.

Massage therapists acting as labor support providers will have the following inherent traits:

1. Patience.
2. Faith and belief in the potential, strength, and capability of human beings to give birth naturally and without interference.
3. Willingness to connect and share the best aspects of ourselves with our clients and other participants in their birth in order to promote the primary goal – a healthy, happy birth outcome.
4. An endless flexibility to go with the flow, respecting the birth choices of the family, however they influence the birth.
5. An unrelenting demeanour even when we are hardly able to disguise our fatigue.
6. Commitment to our clients in a strong, unwavering way.
7. Joy – in being able to witness power, great strength, and at times, intense pain.

When the family requests labor support care, both parties typically draw up a contract outlining the responsibilities and commitments of the RMT. It might include specific dates that the doula is available to be on call for the birth, the point at which the doula will come to the hospital or home to attend the labor, and her tasks – what they include and what they do not include. Many people mistakenly think that the role of the doula and the midwife are synonymous, but it must be made very clear that the doula does not take part in any of the obstetrical tasks involved in the pregnancy or actual birthing of the baby. Instead, she provides support for the physical and emotional aspects of breathing, relaxation, massage, position changes, and hydrotherapy provision. It will also include phone numbers and outline how long she will remain with the family after the birth occurs. Many doulas go to the client's home or hospital when contractions are consistently 5 minutes apart, and leave the new family approximately 1 to 2 hours after the baby has been born.

In the days leading up to the expected due date, the doula is often in daily contact to check in on any changes in the progress toward labor, and to provide reassuring support at this time of high expectation. The doula will asks for any signs indicating a shift toward labor, such as low-back achiness similar to the onset of a menstrual period, or an increase in the intensity or frequency of the preparatory contractions known as Braxton Hicks. She might also enquire if the expecting mom has an increased desire to perform household tasks, such as cleaning closets and washing floors and walls, also known as the 'nesting urge.' And she'll ask for other physical signs, such as bloody show.

During the early phase of labor, which can last approximately from a few to 20 hours, it's important that the family relax as much as possible and continue their activities as normal. Taking baths, going for walks, watching a movie, and above all, practicing relaxation techniques and strategies that maximize rest are crucial for the journey ahead. Doulas don't typically arrive at this stage unless the family requests it. Fatigue and overexcitement are challenges for the family and care providers at this early stage, and anything that helps maintain a calm and restful atmosphere is the desired goal.

When contractions increase in their frequency, intensity, and duration, a woman is in the active stage of labor, which can last several hours, and it's important for women and their partners to have as much support as possible. The goal of the doula is to provide support in a way that is as unobtrusive and in keeping with the family's wishes.

Many of these have been discussed with the family in advance as a preparation for the birthing experience. Some examples include:

- Using water, whether from a shower or bath (children's swimming pools make excellent birthing tubs!).
- Ensuring the woman (and her partner) stay hydrated and nourished
- Assisting with position changes – the woman may be upright and walking, swaying, slow dancing with her partner, on all fours doing the cat stretch or rocking movements, kneeling over a bed, a banister or a birthing ball, lying on her side, or semi-reclining.

- Providing touch and massage therapy with a goal to help create a reassuring physical contact, to increase comfort and decrease pain, and to remind the woman to release any tension that may accumulate in her body as a result of the contractions.
- Offering reassurance and encouragement. Provide as much comfort as possible and facilitate the woman in reaching an internal/external state of deep trust in her body to birth her baby. This may involve creating the environment for a restful, relaxing experience more than anything else. Dimming the lights, playing music that the woman loves, ensuring there are no distractions (noise, interruptions, questions) that take the woman away from her birthing work.
- Creating a calm environment, similar to the environment registered massage therapists create in their practices. A peaceful birth place creates a peaceful family. If birthing clients reach a state of internal calm, then everyone's work is easier. Research shows that achieving this state allows the body to release natural endorphins and provide an amazingly effective sense of pain relief. It is my belief that if more women were taught prenatally to facilitate the release of these endorphins through visualization, vocalization, and through breathing, women would be much more confident in their capabilities to birth without the need for epidurals or other medications to get them through the process. And it helps everyone around them too. I once had a nurse come into my client's birthing room in the hospital, and as she whisked through the door, she suddenly paused, slowed down her pace, and said, "I feel like the Tasmanian Devil who comes whooshing into this room, which is so beautifully calm and peaceful – such a contrast to what is going on in the unit outside."
- Supporting a laboring mother while pushing, the second stage of labor. The doula might be supporting a leg, massaging the neck in between contractions, vocalizing their support during the pushing, or reminding their client to relax and release tension at times when they are not pushing. In the meantime, doulas also support fathers – some fathers look forward to

watching their baby enter the world with a hope to actually 'catch' the baby, while others are more content to remain at the head of their partner, encouraging them in their efforts to bear down and deliver their baby.

- ✦ Providing emotional support for a less-than-desired outcome. Many woman have high hopes and expectations of their birthing process that they detail in a birth plan. Sometimes events occur either during the pregnancy or birth that result in a change in the desired outcome. For example, they may experience the onset of high blood pressure (also known as pre-eclampsia), preterm labor, the baby at term in a breech position, or induced labor if she has gone past 41 weeks of her pregnancy. During the birthing process, the baby may not descend far enough, or may show indications of fetal distress, or the woman may decide that she wants an epidural because she is physically exhausted from a long labor or can no longer tolerate the pain.

- ✦ Liaising with the family during medical interventions. Having an epidural or a C-section does not preclude the presence of the labor support provider. Some hospital policies or attitudes of care providers can make the continuous presence of the doula more challenging. But continuous consultation with the family and staff, as well as a reassuring attitude, goes a long way during these situations to ensure family members are a valued part of the team.

- ✦ Providing postpartum massage and infant massage instruction. This is a very worthwhile benefit for families – not only because of the obvious physical and emotional aspects of our work, but also because it once again gives the family an opportunity to discuss their experiences, ask questions, and process their experiences with someone who was present at the birth.

There is no greater satisfaction than hearing the words, "We couldn't have done it without you!" "We will always remember you" or "Whenever we celebrate the birth of our baby, the impact of your presence will be a part of it."

I received those gratifying words from one of my clients who contracted me to attend her birth, however, due to the SARS outbreak, no labor support providers were allowed into the hospital at the time. Just the same, I had an ongoing therapeutic relationship with her during pregnancy. She wrote: "Hi Cindy. We just wanted to drop you a line to thank you so much for your support and guidance during our pregnancy. The massages were a lifesaver, but even more than that, it was so wonderful having you in our corner as the big day drew near. It was such a shame you couldn't be with us during labor, but with your help we felt really relaxed and prepared. Thank you for helping to make the whole pregnancy and labor such a positive, enriching experience. Your generosity was amazing."

(Previously published in *Massage Therapy Canada*, Summer 2003.)

The River

Jessica Porter

I AM NOT A BIRTH JUNKIE SO MUCH as a relaxation junkie. As a hypnotherapist, I am regularly awed by the power of profound relaxation, and birth certainly shows it off.

Standing next to a woman, giving her the prompts to go deeper and deeper, to let every muscle, every nerve, every fiber of her being go loose and limp, we all get pulled down, down, down to the river of relaxation. As I repeat and repeat, encouraging her safe and soft fall into the parasympathetic nervous system, fathers, nurses, and even doctors follow suit. Everyone begins to slow down, speaking in half-whispers, stepping more carefully as they enter the room. The energy of the team begins to orbit the mother's mind...where she is calm...and handling the surges...and she is calm again. As we all go deeper and deeper, all that exists is the mother's mind – calm and full of the power of life moving through her.

Relaxation is magic. When she goes down into that place where all tension has slipped away, her physical body works perfectly, the way nature needs it to. From that place of calm, all useless mental chatter slows and finally disappears. Last, when so relaxed,

the woman dips below the level of her emotions, so she can simply be and birth from a place of peace.

I have been with 52 women as they birthed their babies. Every one of them, when confronted with the choice between tensing up and relaxing, chose the latter. It doesn't take long for a woman to decide which route is more pleasant. Whether she's on Pitocin, or laboring in a warm tub, or feeling the pressure of her child's head at her vulva, relaxation makes sense. I feel that reminding her of this, and helping her to achieve it, is nothing less than a sacred privilege. As women, we are the stewards of relaxing, letting go, accepting and receiving; this is woman's work, in the truest sense.

So while others are dazzled by breastfeeding and rebozos, and love to swap stories of transition and positions, I remain obsessed with the river of relaxation, flowing deep below each of our chattering minds – the river that babies come from.

♀ The Baker's Oven

Lesley Da Silva

I

Her name is Doula
She bakes bread
All day

II

She rolls the dough
Flattens it so
That it rises
As such
Up
As much
As it can grow

III

Doula is special
She's one of a kind
For she keeps her
Passion
Always
In mind

IV

She bakes
Extraordinarily
Quite un-ordinary
From her heart
"It's always been about the bread…"
She will start

And never finish
To the end
A tear interrupts
Her thought
And her baking
Seems to mend
Something

V

She dares not say
For the magic
In her bread
(I suppose she thinks)
Will fade away
To taste simply;
"like all the others"

VI

Doula pains over her
Bread
And watches it grow
Like the love of God
She comes to know
When the time
Is right
She rolls the dough
Tight
And clean
Morning to night
And again to morning's sheen

VII

The Baker's Oven
Is ready as well
Smelling heavenly
As babies

And sweating hot
As hell

VIII
It's ready to go
"Yes, it's time"
You know

IX
She'll make muffins too
Quite often it happens
Thirteen times two
Baked with Doula's
"Baker's Bread – A Dizzy Dozen"
They seem to always
Come out right
Perfectly from the oven
Of course they do!
They belong
To you
Somehow

X
Doula
Whose sweet bread
Evenly leavens
Day and night
Unfailing
In the baker's oven

Being There

Nelia DeAmaral

♀

AS A DOULA, SOMETIMES I LEARN things from a client that I did not expect. This was the case for me when I had the opportunity to support a young woman. I received a call from a local agency, asking if I could support her. It was 2 weeks before her due date. It informed me that she was dealing with a challenging mental illness, schizophrenia, and she was alone – no parents, no family, no partner, not even a friend. She was about to give birth with almost no knowledge of labor, and even less information about babies. We sat and talked, numerous times, as she shared her anxieties. At times she was incoherent, and at times, she just wouldn't speak at all. Despite her fears, when we talked about this little baby boy that she would soon be holding, her face would soften. She would say, "I can't believe how much I love him already." I thought to myself, "The love of a mother transcends all!"

Eventually, I got a call from her caseworker, telling me that her labor would be induced to protect the well-being of her and the baby. The nurse on duty arranged to give her an epidural *before* the induction, knowing that her intense fear of pain would be

harmful to her and the baby. I thanked the nurse for acting so compassionately, knowing that she had to advocate strongly on the client's behalf to begin pain medication before labor even started.

I sat with my client throughout the labor. I massaged her and assured her that all was going well. When I noticed she was getting anxious, I helped her ask questions, or asked them with her. I assisted hospital staff in understanding her unique needs. This labor was utterly quiet. There was almost no pain, so everything that I would normally do wasn't needed. She didn't need me to remind her to walk, she didn't need me to remind her to relax during contractions. At times I even wondered if she needed me at all. We read her bible, we talked, and we listened to country music (her favourite *not* mine, but we make sacrifices for our clients). I urged her to sleep. While she slept, I watched the baby monitors along with some decorating shows on TV. It's funny the things we do during labor, certainly not what you see in movies. Every once in a while, she would wake up, anxious, with eyebrows weaved. I would assure her that all was well, and she would drift off to sleep.

Baby arrived after a peaceful 6 hours of labor. In the weeks before his arrival, I never saw much emotion from her, but when that gorgeous baby boy was placed on her chest for the first time, tears poured down her face. It was the first time she had *ever* held a baby, but her instincts to care for and protect him were evident. In the days that followed, she managed to find ways to visit him at the nearby hospital where he was transferred, even though she had no car, wasn't able to travel on her own, and had limited financial resources. No one expected that she would become so resourceful and so powerful. Her determination inspired me.

I learned that every mother, regardless of her age, abilities, and resources deserves a dignified birth, with a caring support team. She thanked me many times for being there. I felt that I hadn't done anything at all. Later on, I realized that 'being there' was the most important thing I could have done. This baby's arrival taught me that the best support sometimes requires less than we think. No heroics, just plain human kindness – a precious and rare resource that we can all offer.

The Rollercoaster of Being a Doula

Autumn Fernandes

PURE JOY AND AMAZEMENT TO ANGER and frustration are all emotions of being a doula. As a doula, I started volunteering at a home for young women who needed support when no one else was there for them. It was an eye-opening experience on how families do not always come together to support each other and how the health-care system sometimes tries to take control over these young women in pregnancy, labor, and postpartum. I felt like these women really needed me there and I was happy to support and comfort them through their pregnancy and birth.

Although it was rewarding to help these young women, it was also a huge disappointment to see how some nurses and doctors treat women in this demographic. They gave them little support, judged them for being so young, and seemed not to care if they were in pain or needed help. At one of the births I attended, the young woman had received an epidural, but she kept saying that she could feel the baby coming out and instead of checking to see what was going on, the nurse ignored her for 15 minutes until she finally gave into my client's cries. The baby's head was fully out

when the nurse did check and instead of delivering the baby in the room she was in, she was transferred to the delivery room and told not to push. The staff strapped her legs into stirrups, all the while the young woman was crying that she needed to push. As her support person, I tried to get her to breathe, but all the while I felt ashamed of what was happening to her and I cried the entire way home. I was overwhelmed with anger at the nurses and doctors who were supposed to be there to help her through what should have been the most beautiful moment of her life.

Unfortunately, this was not the worst experience I encountered. I moved on from volunteering and started working with low-income families, charging only what they could afford. Sometimes my fee was just a dinner or $50 for my services. One couple I cared for was very excited to be expecting their second child since they never would have been able to have two children in the country they lived in before. The mother was hoping for a vaginal birth after her last C-section and had done her research about the risks. When her water broke, we went to the hospital, but after only 4 hours of labor, the OB on call insisted she have a C-section, even though Mom and baby were doing great. My clients did not speak perfect English but understood everything that was said to them. The nurses and OB talked to the mother like she was a child. It seemed like they thought that if they talked louder she could understand them better. The OB finally got her to agree to a C-section and, at the same time she was having her sign the consent form for the C-section, she told her that she should be getting her tubes tied since it might be dangerous for her to have more children. The OB had the form in her hand and gave my client no more than 5 minutes to decide if she wanted to have any more children. My client signed both forms and once the nurse and OB left the room to prep the ER she broke down in tears. I tried to comfort her and let her know that she did not have to get her tubes tied and could ask more questions about the C-section. She decided not to ask questions and everything moved forward. The C-section went smoothly except for excess bleeding, which caused them to close the incision quickly not allowing them to tie her

tubes. Again I drove home from this birth and cried in disappoint-
ment for my client and for the horrible way she was treated. I never
told my clients how I felt after the birth. I reflected on the positive
that both Mom and baby were happy and healthy and how amaz-
ing her and her partner had done during the birth.

I then started working with clients who were under the care of
midwives, either home or hospital births. My first home birth was
very fast. I got there at the same time as the midwife. The mother
had called very late and the baby's head was crowning. The sec-
ond midwife did not have time to arrive, so I helped the midwife
set up. The baby was delivered in less than 15 minutes and was
then wrapped in a blanket that was on the women's bed. At 4:32
p.m., on a Thursday afternoon, I witnessed the most beautiful,
peaceful moment of my life. My eyes opened to the fact that birth
is the most natural, beautiful, and empowering experience we go
through as women and to be a part of that moment was a gift.
Since that day, I have been a part of many wonderful moments
when a little person takes their first breath and Mom and baby
meet for the first time. I have found my place as a doula. I feel
emotionally connected working with midwives and their patients.

I have been lucky to be there with the families who have taken
me on as their doula and am thankful for the experience. I
believe that every woman should experience being a doula
before they have their own children so they can see for them-
selves what they would like to experience when they give birth.
I believe that if a woman has a positive birthing experience, she
will be able to adjust to motherhood easier with a positive mem-
ory of the birth.

Birth is the most primal, natural, beautifully intense achievement
we experience as women. Sometimes our medical-care system tries
to control the outcome of birth, which causes women to lose the
control over her body and birthing experience and feel helpless at
a time when she should feel in control and safe. Having a doula at
your birth and creating a birth plan can help women and their part-
ners take control of their birthing experience and help them have
a say in what goes on throughout the birth.

I have two beautiful children of my own, which were both home births with the help of my husband, midwives and doula. I could not have gotten through the incredible journey without them. It was the most rewarding and powerful experience of my life. I also believe that without my experiences as a doula things may have been different. Being able to witness firsthand what a birth can be like took the fear out of my birthing experience and gave me the confidence to know that my body was made for this. It gave me the strength to allow my body to take control and tell me what I needed to do to birth my children.

Doulas are people who care for the well-being of expecting mothers. We are people who will help pregnant and laboring moms and their partners achieve a positive birthing experience no matter what the perfect birth looks like – at home or hospital, epidural, or natural. To have another person there to support moms and dads throughout birth is something that should not be a question but a must. One day I hope that our healthcare coverage includes doulas as a support system that can be offered to all women without a cost.

♀ Shri Yantra

Julei Busch

Cliff's edge, soft stance,
learning to breathe again.
Allowing, opening, surrendering
to all that is.

Glimpsing communion
with angels and demons
glittering within.

Gazing deep to marvel
at an ocean of breath
stretching horizon to horizon
endlessly.

Bridging the rivers of life
to baptize
that which remains
when the monkeys dance
in the banyan tree.

Blazing sparks
ignite this triangulation
of belly, breath, and bone.

Gone, gone, gone...
merging
emergent in
an endless moment of integrity.

Being pregnant is merging with another being in a way that is inde-scribably profound on so many levels. To speak of that is an act of anarchy in our times as it highlights how much of our lived experience is as disconnected from ourselves and others. Experiencing labor as a process of integration, of transformation, even for a brief moment, shifts a woman's experience of how her mind, body, and heart can interact. Within the power and immensity of labor is the seed of wholeness. Who knows what that might birth?

♀ Top 15 things to do or not to do as a doula in the middle of the night

Janice Preiss

Today, in my doula world, I have learned a lot. Here are my top 15 things to remember for middle-of-the-night births:

1. Remember to sound enthusiastic when a doula client calls at 2 a.m.

2. Don't bother wishing that you could be a cat and see in the dark and try to pack the bag, the bag that you were going to pack this weekend, 2 weeks before the scheduled birth.

3. Never, *ever*, try to put on a sports bra, in the dark, in the middle of the night, with a damaged rotator cuff.

4. Never try to explain to hubby that you really do need to go.

5. Never let out a dog that might not come back in immediately. Instead wake up your sleeping teen and tell him the stupid dog won't come in.

6. Find another route to get there now that you realize your highway toll transponder is not in your car.

7. Pat yourself on the back for having a full tank of gas.

8. Run back inside the house to find the digital camera. Don't wait until the birth to discover the batteries are dead.

9. Gaze at the half-moon and tell it that it's supposed to be a full

moon to have a baby in the middle of the night. (The moon might think this doula is a little crazy.)

10. Follow the blue Hs (hospital signs) to the hospital since you've never been there, especially if you never did a test run on the weekend.

11. Don't drive around the parking lot trying to figure out how to get into the parking lot. I once debated driving through the barricade and apologizing later but decided against it.

12. Rush past the bleeding people awaiting emergency attention and ask how to get to Labor and Delivery. Clue: when they say HURRY! Heed that warning in future.

13. Do not pass the room where you hear a woman in labor to check in with the nurse's station. That sound is likely your client delivering her baby and she'll need you immediately.

14. Do remember, 30 minutes after the birth, that you have a cell-phone that takes pictures. Get the mother who has just had baby to teach you how to use it; it will entertain her.

15. Do not, under any circumstances, tell anyone when you get home that you have been wearing your sports bra backwards.

I Hear a Voice

Kelly Ebbett

Minutes, hours, days go by
I heard her voice
I hear a voice
I was the voice
"I can't do it"

The presence is strong, gentle, real, quiet

Her body was weary
Her body is capable
My body was upright
"I can do it"

Babies, mothers, fathers, families
are born

A moment ingrained
lasting a lifetime

Her doula was there
A doula is here
The doula – I am

The Unsuspecting Doula

Nicola Wolters

WHEN I DECIDED TO BECOME A doula, I don't think I had any misconceptions about what a challenging role I would play. With marathon-length hours, juggling family and work, and managing relationships with birth moms and dads, nurses, midwives, doctors, never mind the emotional ups and downs of birth itself, I knew I was in for some unexpected situations. Just how unexpected quickly became quite evident.

Early on in my doula career I met Janice, a first-time mom-to-be. Feeling quite anxious about her upcoming birth, she hoped that with the help of a doula she and her husband could overcome some of their fears surrounding the birth. Over the next few visits, I discovered (and thought I understood) what Janice meant when she told me that she considered herself to be a "very modest person." I heard what she was saying but thinking back to my doula training (and my own birth experiences), I was quite confident that at some point during labor she would lose at least some modesty. I was sorely mistaken.

On the day Janice was giving birth, I arrived at the hospital happy to learn that she was already in a birthing room. I was surprised to

see that she was fully dressed, in a coat and boots, despite being in active labor. Unusual, I noted, just beginning to understand the depths of her modesty.

As her labor intensified, so did her resolve to remain in her clothes. I did not think this was much of a problem until she said that she was ready for an epidural but was not going to take off her clothes in order to have it. Despite encouragement from her doctor and a nurse, she remained adamant that it somehow had to be done with all her clothes on.

While her doctor and nurse continued to do their best to explain the necessity of removing her clothes, Janice became increasingly agitated and vocal. As her screams began to permeate the walls of the birthing room, I was at a loss on what to do. The effect on her husband was quite devastating. He became increasingly frantic as he witnessed his wife's distress. Turning to me, he grabbed me by the shoulders and started shaking me while yelling, "Do something Nicola! Do something!"

Silence flooded the room as his wife stared at him in shock, her labor momentarily forgotten. We collectively held our breath. As the seconds ticked away, I couldn't think of a single item in my doula bag that would fit this situation – rice bag, cold compress, essential oils, massages tools? No, nothing would do. Finally with an exasperated sigh, Janice removing her shirt simply stating, "I'm ready." The rest of the birth, at least for me, was far less eventful.

Now that time has passed I prefer to see "the humorous side," that is, in the image of me being shaken and yelled at, not the fact that the father was so obviously distressed. Humour is my way of coping with the many surprises that I have encountered working as a doula and it can be a great tool for coping with some challenging situations. Many parents appreciate some humour during birth and it's something that I try to incorporate into my work with parents if they're open to it.

I once worked for a family, first-time parents, who had not initially considered using a doula. After several days of on-and-off labor they were getting to the point of desperation. After several trips to the hospital, Sonia, the mother, was exhausted. She had not

yet been admitted because she had not dilated the magical 3 centimeters. Finally, a nurse suggested they try calling a doula. I received a call from Sonia's husband, Gordon, asking me to meet them at their home.

I was pleased to meet Sonia and Gordon in their home and see how well they were coping despite what Gordon told me on the phone. What amazed me even further was Sonia's up-beat mindset despite several very difficult days. Between contractions she was able to joke and laugh a little.

Sonia was finally admitted to the hospital and immediately got into the tub. She had planned not to use an epidural, but the long hours and exhaustion had taken their toll. Sonia and Gordon had a brief discussion between contractions and agreed that Sonia would have an epidural. I knew this was a hard decision for Sonia and that she was unhappy. I then spoke to Gordon saying to him that I noticed he and his wife had been joking around and laughing a lot before this point. Perhaps, I suggested, we could somehow incorporate that back into the birth. Gordon went to the nurse call and pressed the button. "How can I help you?" asked the nurse. Gordon replied, "I would like to order an epidural, please." Sonia burst out laughing, "Gordon, we're not at the Tim Hortons' drive-thru!"

I have also learned that the unexpected can happen at any time while working with birth families. When I met Lisa and her husband, Michael, I was happy to learn that they were a curious, open-minded couple ready to learn everything they could about birth and doula-ing. However, I was soon going to have my own open-mindedness challenged!

Lisa's first birth experience had not been what she had hoped. It had ended in a Cesarean birth after being induced. She and Michael hired me with the hope that she would have a vaginal birth. One of her concerns and mine was to avoid induction. Lisa's healthcare provider had encouraged her to explore her options for inducing labor at home if she went beyond her due date. The option that she and her husband found most exciting was sex. And

lots of it! What position? How frequently? How well does it work? Should they call me each time they were about to make love?

My initial thought was you've got to be joking. No, apparently not. Michael momentarily left the room returning with a popular men's magazine. *Oh no,* I thought. *I'm going to have to look through pictures and explain why the different positions are going to help!* I don't remember learning anything about this when I was in doula training. Perhaps I had been on a bathroom break when this was being discussed. To my premature relief, Michael referred to the articles in the front of the magazine. "I heard that before a woman goes into labor she can have loose bowel movements. There's an article here that discusses how this woman has diarrhea after making love. Do you think my wife should also swallow?"

Being thrown for a loop, as I had with Lisa and Michael, is something to be expected and accepted when working as a doula. After all, you're welcomed into some of the most intimate and significant events in someone's life. Once I've agreed to work with a couple, I believe it's my responsibility to support the mother and father to the best of my abilities and roll with the unexpected.

Sometimes those surprising situations don't come from the mother or father. Even when a mother is clear about her wishes during birth, she won't always be supported by others and it's up to me to try and safeguard those wishes.

When working with Mary, a single mother, she was adamant about not using any pain medication. She had used none during her first delivery. As soon as we entered the hospital, Mary and I were greeted by a warm and well-intentioned nurse who immediately said, "Hello dear. How are you? Should we get an epidural ready for you?" I was speechless! Perhaps naively so. Mary seemed unperturbed by the question and dismissed the offer with a wave of her hand. I was so impressed. Little did I know that this was just the first time Mary's wishes would be challenged.

As Mary labored I was excited to see how well she was doing. Developing a beautiful rhythm and ritual, she seemed prepared for a birth experience that was to be exactly as she had hoped. I was also mildly surprised at how we were left alone. As labor intensified,

she became quite vocal, which quickly brought in a nurse. "Now are you ready for your epidural?" she asked. Mary shook her head. I smiled and thanked the nurse.

Not too much later a nurse returned to check on Mary's progress. "She's at nine!" she said in shock. "It's too late for an epidural. We have to get her some gas!" *What?!* was all I could think. When did Mary give any indication of wanting gas? Mary was leaning into the bed, groaning but managed to tell me, yet again, that she was fine and needed nothing.

Minutes later, two nurses returned with gas. As they fiddled around with the knobs on the canisters, Mary reached the peak of her labor with a wail. The next sound was the distinct fading spurting sound of an empty canister. "Quick! Get a replacement bottle!" yelled one of the nurses. They returned just as I knelt down beside Mary and did a double-hip squeeze. As Mary sighed in relief, the nurses stood and watched, mask and canister hanging uselessly in their hands.

I felt triumphant! Mary was amazing – unaffected, undeterred by what could have been an undermining of her beliefs and intentions. Her birth was a victory. I was on cloud nine. It was only the third birth I had ever attended, yet I felt that together Mary and I had accomplished so much. These feelings, perhaps, were selfish and even unrealistic because I had not been the one who was giving birth. But as I attended more births, I gradually began to feel a far greater range of emotions than I had initially expected. Almost every birth I attended, I was introduced to a new feeling or emotional reaction to many new situations.

In one instance, I had attended a beautiful and peaceful birth. Soon after, to my great sadness, the mother let me know that she had decided to give her baby away. I felt so let down and deflated. I was shocked and unable to fully comprehend how she could even consider such a terrible option? Was it really my place to feel this way? As a way of coping with such an unexpected conclusion I resolved to try to remain more detached at the next birth. Not uncaring by any means, but better able to accept the decisions that were not mine to make. I truly didn't feel that I had a right to feel

the way I did. After all, I was there to support the mother, not to influence her life choices.

This experience caused me to reflect a lot on my emotional reactions surrounding birth. Somewhere between supporting and being a part of the birth I had to find a middle ground. Finding this elusive middle ground is something I continue to work on. Of course each time I work with a family I tend to care deeply for them. How can I be a good doula if I do not care? And why would I be a doula if I did not care? There are still times when I think I have found my middle ground and it is again challenged.

Pamela was having her first baby and it was a particularly long and difficult labor. Unable to find a good rhythm, she fought every contraction. When it came time to birth her baby she pushed for three hours. Toward the end, she was coached to push harder and harder until her baby's head quickly emerged. Pamela's caregiver then asked her to stop pushing in order to reposition her baby. Pamela was unable to stop the intense pushing and her baby's shoulders jammed. What ensued were some very panicky moments.

Within seconds, a whole team of nurses and doctors sped into the room. They jumped on the bed and started pushing the baby out. Pamela gripped my hand and screamed in my face in pure terror. The image will forever be frozen in my head. As her broad-shouldered baby was born, happy and healthy tears rolled down Pamela's cheeks. I knew she was unaware of what exactly had transpired. For the first time, the tears that regularly well in my eyes when a baby is born rolled down my cheeks, but they were tears of relief. Pamela turned to me and pulled me close to her, saying, "Oh my goodness you're crying too! That's so wonderful!" I was given a gift by a mother who appreciated my tears, and acknowledged that she knew how much I truly cared about her and her baby.

Surprises abound in the world of labor, birth, and babies. By now I should have come to expect the unexpected. But there is no real way to be entirely prepared for it, the greatest skill a doula can possess is the ability to adapt and flow with the ever-surprising, unpredictable world of birth.

Brand-New Doula

Melissa Bone

I'M A BRAND-NEW DOULA. AS BRAND spankin' new as the five (count 'em' – five!) babies that I've been privileged to participate in their birth stories. Of those five births, one was at home and the rest at a local hospital. So even though I can only count on one hand my birth experiences, I still have been affected profoundly by the few I've seen. One family's story must be shared, perhaps because of the long-awaited arrival of this little one.

The story began more than 10 years ago, when the parents (I'll call them Abe and Sadie) set out to try to conceive. Their journey took them through several clinics, many tests, countless trysts in the bedroom, much frustration and many tears. After a decade, they came to the conclusion: "We're not one of the lucky ones. Let's just stop trying and live without children. At least we still have each other." But there was more in store for them than they bargained for!

Shortly after their decision, an unexpected phone call came from Sadie's aunt. She knew about their journey with infertility and told them about two little girls, sisters, who she heard were being put

up for adoption. She thought these girls were destined to be the answer to their prayers. Abe and Sadie were not so sure – they had never filled out the mountains of paperwork for an adoption, never done a home study, and had no clue about the bewildering world of adoption protocol. After a few days of whirlwind thinking, earnest praying, and butterflies in their stomachs, they decided to put their names on the list, even though their chances were slim.

Through a series of what can only be called serendipitous events, and in short order, the girls became their daughters in only a matter of a few months. Suddenly they were parents of two! As sometimes happens after an adoption, as they were making room in their hearts and lives for these tots, the couple conceived a baby.

Several months into the pregnancy, I entered the growing picture. They had heard about me through another client. Sadie was naturally nervous: she had become a mother of two, not by natural means, but by adoption. Now she was pregnant after climbing so many mountains, and the birth was the largest one yet. Could she climb this one, too? She was having a good pregnancy up to this point, but she needed the support – physically, emotionally, and spiritually – that a doula typically provides. We got to know each other over a few prenatal visits, learning from one another.

I began to feel like my life was revolving around her due date. I postponed several events in my own personal life several weeks before the baby to be there for her. I had told Sadie she could call me anytime, day or night, during her last trimester if she had any issues. As it turned out, the baby was overdue by almost a week. During that week we were in touch almost daily by email or phone – she was frustrated that the baby was overdue. The 10 years of waiting was almost up, but it crawled to a close.

When things finally got going, it was three steps forward, two steps back. Everything we tried in labor seemed to have the opposite effect. For example, taking baths and walks at home slowed things down. Finally, heat packs were the magic key to back labor early on. Things really started cooking when we went to the hospital after 12 hours of labor. Sadie was breathing nicely, slow dancing with Abe, and having me do lots of back counter-pressure and

massage. By dinnertime she opted for an epidural – she wanted to rest and get comfortable. But it stalled the labor almost immediately. To speed it up, she received medication and went from 7 to 10 centimeters and began pushing around midnight, a full 24 hours after I had joined her and Abe at home. And push she did, mightily, for a long time. But the baby was stuck in a posterior presentation, and finally the OB/GYN was called in for assessment. They began to talk about 'other interventions' and called the team together to prep for a C-section. We just kept on encouraging and counting, massaging and wiping her forehead during all of the proceedings. Finally, it was time to go up to the OR, and this is when it got really difficult for me.

When you've been with someone in an intense situation for more than 24 hours, and then you're told, "No, you can't go further" (due to hospital protocol of having only one support person in the OR), you feel like the rug has been pulled out from under you. I just looked at Sadie and said, "I'll be praying down here, waiting for you," as she was wheeled away. I found an empty rocking chair at the end of the maternity ward's darkened hallway and settled into it. It was about 4 a.m., and even though I wasn't physically present, I needed to be close at hand. After what seemed like forever (about 45 minutes), Sadie was being wheeled out and, while lying there with her little bundle, looked up at me and said, "His name is Judah. It means 'praise.'" I lost it and became a ball of wet Kleenex. He was born vaginally after all, with the help of a vacuum, and the help of many people, including, humbly, myself. What a gift to be in on this miracle birth after so long. That's the privilege of being a doula, brand new or seasoned!

Oh to be a Doula!

Angela M. Brown

THERE ARE TWO THINGS IN THIS world that have always amazed me. One of them is the concept of giving birth to a human being. I've been a certified doula for 7 years now and have been fortunate enough to take part in 20 birthing experiences. Each of these experiences has touched me in so many different ways.

To me, there is nothing more rewarding then being a doula. I still can't help but feel extremely honored each time someone asks me to accompany them while they give birth. What an amazing privilege to be invited to play a role in such a personal and life-changing moment. I'm thrilled to be able to lend a helping hand in the many different ways we as doulas are trained to do – giving massage therapy, assisting with positioning techniques, being a 'gopher' for ice chips, fetching water or warm towels, sharing a nurturing, encouraging, supportive, and constant voice, or even just sitting on the sidelines to observe and jot down notes to pre-serve a birth story that will be retold years later. Our role can seem to have no end. The more births I attend, the more I learn how helpful we doulas can be.

Sometimes I still can't believe that someone has invited little ol' me into the delivery room. I'm so fortunate to be able to witness the marathon of emotions that a woman and her partner go through during this miraculous event – the anticipation, fear, suffering, strength, bravery, tears, anxiety, laughter, and then, at the finish line, whether she is giving birth vaginally or by Cesarean, with an epidural, general anesthetic, or no intervention at all we witness a mother and a father immediately falling in love with their little bundle of joy. In that moment, *the* moment, something amazing is felt in the room when that baby enters the world. How lucky are we as doulas to have the opportunity to witness something like that? It never gets old, just an amazing experience for each and every birth.

Over the years, as I've been invited to assist, I've learned that my role extends beyond just assisting the mom and as importantly supporting the extended family. I remember a dad telling me that he felt so calm, confident, and in the moment because, while I provided the physical support, he could truly be there emotionally for his wife. He said he felt like he could clearly witness what his wife was going through and offer encouraging words because he wasn't worried about what he should do to help her with pain. Another dad told me I should accompany his wife into the operating room (only one person was allowed) during a Cesarean birth because he felt I could help her more than he could. Of course I told him that I couldn't take that moment away from him, so I patiently waited outside the operating room while Mom and Dad experienced *the moment* together.

At the last birth I attended, I realized how our role also extends into the waiting room where extended family and friends anxiously await baby's arrival. I updated them on how Mom was doing and the delivery was going from time to time. Once the baby arrived, I received so many thankful hugs. The grandfather told me my little updates made the long wait go by worry-free and decreased the anxiety. He said he needed me in that waiting room as much as his daughter needed me in the delivery room. That was enough proof for me to see that our support genuinely affects people both inside and outside the delivery room.

It is quite an achievement for us as doulas to realize we've opened other people's eyes to the good work we do. I find that even hospital staff are taking more notice of our good work. What a delight it was when one nurse said she was happy I was there to give the patient so much support while she could focus on her work. I've also had an obstetrician shaking my hand and telling me what a great job I did coaching the patient throughout the delivery. I could go on and on. But it's not hard to see that I love being a doula – I feel it is what I was meant to do and I feel so fortunate for the wonderful training. I'm happy to say that I took all my birthing experiences into the delivery room with me 3 months ago to give me the strength, courage, and endurance to give birth to my own baby! Oh yeah...the second thing in this world that amazes me is the sky – it is just so enormous!

A Woman Never Forgets

Christy Swift

FOR A SHORT PERIOD, I VOLUNTEERED as a birth companion for teen moms in trouble. I attended five births in total, but one stands out to me more that the rest. The pregnant girl was 18 years old and had lived on the streets before finding a place at a group home. When I met "Monique" she was ready to give birth. She didn't tell me much about herself, and when she went into labor, she did not call family or friends. She was closed up, nervous, and in a rush to get to the hospital. When we got there, her labor stalled, and she was so distraught that the nurses let her stay the night. I slept beside her on one of those terribly uncomfortable little sofas. It was the longest shift I'd ever done as a doula.

She went into labor the next morning. There wasn't a lot for me to do for her because she insisted on getting an epidural right away. But I did take a lot of photos. Looking back at those photos, I'm surprised to see a smiling face on an otherwise troubled teenager. My favorite is the picture of her scratching her oversized belly with a hairbrush because the pain medications made her itch so badly. She has a huge, sheepish grin on her face.

Before noon, she gave birth to a beautiful, tiny baby girl. She wanted to dress her up immediately in the outfit she had brought for her. I remember the tenderness with which she dressed her baby, still covered in vernix. The nurse rolled her eyes, but I thought to myself, *It's her baby. If the first thing she wants to do is dress her up, so be it.*

When I visited her later that day, I was surprised to see she already had a visitor – an old man, stinking in filthy clothes with the biggest, reddest nose I had ever seen. Monique must have met him while she was living on the street. They chatted like best friends. I had never been privy to this world – the world of the homeless. But he was celebrating Monique and her passage into motherhood, and I was happy she had a friend to share the moment with.

Monique did not get to keep her baby. I don't know the details, but I remember having completed her birth story (a little photo album with some details and comments about the birth beneath each photo) and taking it to the group home for her. Monique no longer lived there, but after contacting her, the staff gave me an address where I could drop it off. She did not want to see me, but she was eager to have the birth story. She did not answer the door when I arrived, so I put it in the mailbox and left.

I don't know whatever became of Monique or her baby. I don't know if she ever got her daughter back. I don't know if she even wanted her back. It doesn't really matter to me. My job as her birth companion was to be there for her during the difficult work of birth, to be someone she could count on, someone who was on her side, no matter what. Not as a mother or a sister or even a friend – but as a fellow woman filling a uniquely intimate role during a uniquely intimate moment.

A woman never forgets the birth of her first baby. I hope that when Monique looks back on her experience she will have positive thoughts and a feeling that she was cared for and it was a beautiful event, even if it was preceded (and followed) by pain. I hope that her birth story shows her that she was strong and capable, gentle and loving, and happy – if just for a few moments to bring her daughter into the world.

♀ I Am a Doula

Kristin Peres

I am an intruder.
She and him
And the life within
Whispering ancient words.

I am an assistant.
Need water?
Are you comfortable?
How has it progressed so far?

I am a trainer.
Let's go for a walk.
The air will do you good
And we'll keep your mind occupied.

I am a dancer.
I sway and hum
With your intimate rhythm
I will teach your partner how to move.

I am a watcher.
Silent cues
The tone is changing
The time to move has come.

I am an anchor.
As the waves rock you
Hold tight to my hand
I'll be still.

I am a mother.
I've been down this road
Know uncertainty, the fear
And the thrill.

I am your champion.
You can do it
I'm proud of you
You're almost at the end.
I am in awe.
As new life emerges
I am speechless
And humbled at once.

I am an audience.
Seeing family begin
First moments
and smiles and tears.

I am a doula.
With my sisters in history
I hold a woman's hand
As she brings a baby into the world.

A Defining Moment

Kimberley Fernandez

I STOOD THERE FROZEN IN MY kitchen, my head spinning while I held the phone to my ear. SR was telling me about her latest doctor's appointment. The ultrasound at 34 weeks had shown severe malformation of her baby's brain. She explained that her little girl would have virtually no quality of life.

Her voice was steady, but wrought with anxiety as she told me about the specialists she and her husband were speaking to, both at home and overseas. It was clear they were leaving no stone unturned. Then she told me her pregnancy would likely end in a termination. My heart stopped. She said she knew I would have to think about it and she said she understood if I couldn't, but she and her husband wanted me to be there with them for the delivery.

As soon as the words were spoken, I said without hesitation, "Of course, anything you need, I will be there." I could hear the relief in her voice when she told me she would keep me updated on what was happening.

When I hung up the phone I didn't move. I stood there for what seemed like hours until my own daughter asked me to read her a

story. I scooped her up and hugged her as my tears flowed into her hair.

After a few hours, it really hit me. I wasn't so naïve that I didn't think this could never happen. Birth is unpredictable by nature. But I just did not think it would happen so soon. I had only been a doula a little over a year and this was my 22nd birth.

I knew this was going to be difficult and so I sought the advice of my colleagues. Many of my doula sisters offered me great advice, a shoulder to cry on, and an ear to unload my thoughts and feelings. I garnered lots of comfort and support and I realized then that sometimes a doula needs a doula. For as doulas that is what we do. We offer comfort and support, and we do it uncondition-ally. When a mother or her partner needs us, we are there. No question. And we do it not only because it is our job but also because we know someone needs us, and we do all we can to sat-isfy their needs, sometimes sacrificing ourselves and our families. I knew this birth would change me forever emotionally but I didn't care. She needed me and that was all that counted.

In the coming days, SR and her husband informed me what was going to happen. I met them at the hospital, where she had been induced the night before. I entered the room very early in the morning and they looked drained and worn. I didn't really know what to say but I talked and I asked questions all day long, every-thing possible to keep things calm and light. We all knew what was coming so we did our best to not focus on it until it was necessary.

Later in the afternoon their little girl was finally born, stillborn. The silence in the room hit me like a truck. Not hearing a baby's cry was unnerving. I concentrated on SR's face and told her how proud I was of her. I brushed aside the hair from her damp fore-head and made sure her husband was OK, while the nurses took the baby to clean her up and swaddle her. During that time there were lots of tears and hugs. I did all I could to stay strong and sup-port them.

The baby was then given to her mother. SR cooed and snuggled her and did everything a new mother would. My heart was ripping apart in my chest while she spoke of her little girl and showed me

her precious little face. I took pictures of the three of them for their memory box and wrote down notes for the birth story I would be preparing.

Finally, it was time for me to leave and give them some alone time. SR asked if I wanted to hold her daughter. I was barely hanging on, so I bent down and kissed SR on the forehead and whispered that I couldn't. She gave me an understanding smile, looked into my eyes, and thanked me. I smiled back but could feel myself unravelling. I hugged her and her husband and left.

By the time I got to the car I was completely overwhelmed with emotions. With tears clouding my vision I drove home. I wasn't sure how I made it, but when I did I hugged my family and thanked God for all I had. I knew then that life was more precious than I had ever realized.

This birth was single-handedly the hardest thing I've ever done in my life. But this very special couple needed support through an extremely difficult time that no parent should have to go through. So regardless of my own beliefs and emotions, I would not have been anywhere else that day, except by their side – supporting them, caring for them, and grieving with them. I realized that day that being a doula was not what I do for a living but who I am as a person.

Time to Change the Batteries

Heidi Scarfone

THERE WAS A TIME THAT I LIVED TO be a doula. Not just any doula but a 'Penny Simkin' doula. A doula who had the voice, the knowledge, the hands and, most of all, the commitment and passion that Penny, the Queen Doula, has always displayed. As every doula knows, being a doula is a privilege. It goes beyond being a job to being a mission – the mission to provide continuous and unselfish support to a laboring woman and her partner at a vulnerable, sometimes scary and yet exciting, time in an expectant couple's lives.

There was a time when I lived and breathed doula. I couldn't pass a pregnant woman without stopping her in my mind or in body and sharing the doula word with her. There was an excitement in knowing that I could help to empower a woman with the knowledge and confidence she needed to have the best birth experience possible. There was a time that my bedside table was piled high with books on the art of being a doula. Penny Simkin became my God. I remember long ago sharing with Penny that doula-ing was on my mind even during the most intimate times with my husband. A little obsessive, yes, but I was impassioned by what I did.

I realized very early that being a totally accessible doula gave me a feeling of importance, hey, I got to wear a pager and when it went off, I was needed. I will never forget the time when I was standing in the kitchenette at my other job and the microwave buzzer went off. The adrenaline rushed through my heart and feeling very important as I reached for my pager. I felt a wave of disappointment and embarrassment when a fellow tech told me it wasn't my pager but her lunch that was ready!

As the doula years passed, the sound of that pager started to become a wedge between my family commitments and special moments that I would never get back. During the night of my daughter's first prom my pager went off and I didn't get to help her with her corsage. On the day of my other daughter's 13th birthday, I missed part of the party. Slowly, I realized that being a doula was as much about giving up as it was about giving. Don't get me wrong – I truly loved the excitement and feelings of fulfillment of being a doula but it comes with a price.

I got older and along with losing those Cooper's ligaments and finding better support bras I also began to find that I just didn't have the stamina to breathe, rub backs, and slow dance through the long days and nights. Thoughts of *please get some drugs so that I can sleep* began to creep into my head, where at one time I would do anything to help a laboring mom labor without drugs if that's what she passionately wanted. Despite those thoughts, I continued to support women in their choices for childbirth, trying even more passionately to rekindle the fires of my early doula years. While I may have had those 'take the drugs' thoughts I remained a constant support for my moms and never acted on those thoughts. But I knew that my doula days were dying. I knew that the passion that I held so closely to my heart and soul was changing. I grieved. I was a doula, and from all client and hospital staff accounts, a good one.

But something was missing.

Maybe it was age, perhaps it was the depression that I had suffered during my later doula years, perhaps it was just my time to hand over the birth bag to someone whose desire to doula was

now a burning spot in her soul. Whatever it was, I knew that the time had come to disconnect my pager and start a new chapter in my life.

It has been a good choice. I finally learned that I could not give what I did not have.

Perhaps one of the most important ways that we can provide support to moms is to know when it is time to hang up the birth bag, deflate the birth ball, and support the new doulas – the ones whose voices run over with words of labor support and commitment. The ones whose energy allows them to do a double-hip squeeze for hours and then run off to another birth to do the same.

I'm still overwhelmed by the miracle of birth, the inner strength of a laboring woman, the love of a partner, and I am thankful for the incredible memories that I will store in my heart forever having once been a doula.

That pager has now been replaced by another passion that pours from my doula experience. When the doula door closed, another door opened, and now I use my artwork to put my passion to paper.

Anyone need a pager? It just needs new batteries.

(Previously published in *The Ovarian Connection Magazine* and in *International Doula*.)

Email to a Friend

Crescence Krueger

I GOT HOME FROM THE HOSPITAL 6 hours ago. The mother was cut open. "I'm not here," she said. "I'm very far away."

Drugs up her. Drugs in her. Womb in spasm. Seven wires snaking from her flesh. No food. No sleep. She began to run a fever. A baby's heart began to race.

I'm not allowed into the operating room. I'm not allowed into recovery. "Father or you. Only one at a time. It's hospital policy." The nurse points to the sign.

So I wait.

The mother is incapable of doing anything but tremble. There is only a floating feeling and her fear. "You are here," I say and touch her. But she is right. Body and mind have split in the disintegration of this birth that has shattered her.

Ten feet away, the baby lies speechless. Two nurses sit, thigh to thigh, eye to eye. They sort through dosages and fetal heart rates with the focussed ease of children arranging candy on a tray. The baby roots on his fingers. I pick him up, unwrap him, and place

him on his mother's breast. Skin to skin, his lips blind to her dry nipple. Everyone is numb.

I find her mother. "I am impotent," I say. Yesterday I had tasted her breath, she stood so near. "Why is my healthy daughter here?" "I don't know." She liked my answer. It meant her rage wasn't just that of the old.

When it had become clear that a Cesarean was inevitable and the mother had stopped her weeping, the father said he had to admit he was feeling much more secure. The thought of her giving birth through her vagina had really frightened him. "I'm not here," she said.

Fear of the feminine is embedded in us. It digs deeper. Terror accepted as the legitimate reaction to life and technology the appropriate tool in response. Disconnection nurtures disconnection. Pain has no source.

I didn't come home exhausted and my anger is very cool. It's been a couple of years since I walked away aflame. You wrote of being burned-out. I feel burned away.

♀ Unable to Stop

Lenka Pedwell

"This is my last one," I say to him.
"Are you sure?" he replies.
"Yes – I can't do it anymore."

It's 2:13 a.m., what am I doing here?
I should be home.
What is it that makes me keep doing this?

I need you…I can't do this without you…You have to be there.
These words I hear over and over.
I remember all their pained faces.

I say I'm done – no more,
Family is more important,
But I keep coming back…

* * * *

The phone rings, it is 1:52 a.m.
"She's asking for you," he says.
I get up, shower, and quickly pack.
Some snacks, I might never get a chance to eat.
"I'll call when I can," I say as I leave the house.

I drive in the damp, dark night.
I see them in the ER waiting room looking lost.
Her face tells me she is in pain and she is tired.
I tell her she is doing great.
Breathe it out and let it go.

No one will make eye contact with us.
I wait for an opening to the ER doors and guide them to Labor and Delivery.

She tells me she can't do this.
I look at her and say you can and we will get you through this.
We check into triage. It is full tonight.
It takes forever for a nurse to come.
Only 5 centimeters and baby's still quite high.
She begins to cry. She says she can't do this.
I tell her she can, and she will.

Nurse says she has to be monitored 30 minutes lying down.
She weeps quietly and says she can't. She needs to stand.
She breathes. She squeezes my hand. She let's go.
Lying down is unbearable for her.
Nurse says we can now walk around.
Come back to be monitored again in 30, we are told.

We walk, and walk, and walk.
The green walls are not welcoming.
She pauses every 3 minutes.
She has found her rhythm; moaning and dancing.
Sometimes she wants my touch, sometimes she doesn't.
I watch to know when.

She tells her husband to stop talking.
She needs silence.
She asks why this is taking so long.
The first one was fast.
I tell her they are all different.

Another strong contraction. The strongest.
I reach around her and massage her belly.
That feels goods, she tells me.
We go back, nurses are swamped.

No one comes to check us.
We walk again.
She is so tired. Her legs give out.
I show him how to hold her dancing.

* * * *

A room – a tiny room – is available.
She is monitored.
She is checked. 7 centimeters and baby has dropped.
Nurse asks the husband if she wants an epidural.
He says no.
"It might make her more relaxed."
"I don't think she wants that," I hear him say.

She wants to walk.
OK, says the nurse.
We walk again.
She is tired.
Yet she is coping.
My hands are pushing on her sacrum.
She does not want me to stop.

She is being monitored again.
She hates to be in the bed.
She wants to go the bathroom.
She wants to sit on the toilet.
She does not want to move from there.

Nurse urges her to go back into the bed.
She pleads just one more minute.
I gently guide her to the bed.
Contractions are coming fast.

She is checked.
The baby's head is felt and now she is 9.5 centimeters.

I smile at her. You are doing it I tell her.
She sighs with relief.

She wants to go back to the bathroom.
Nurse is reluctant to let her go.
She says she feels pressure.
She says she can't do this.
I look at her and say you are doing it.
I get excited. Her partner looks relieved.
This could be it.

Yes, she wants to push.
OB held up in surgery.
Nurse presses the yellow button.
Chaos.
I look at her and tell her everything will be okay.

Nurse delivers the baby.
She looks at me and says thank you.
For what, I reply, you did all the work.
She gives me a tired smile.

* * * *

It has been 8 hours.
This was one of the good ones.
Many are much longer.
Yet, I am exhausted.
My feet hurt.
Want to go home, to sleep, to hug my kids.
I wait until the room is silent.
I say goodbye.
My job with this family is not yet done,
But for today it is.

In the 10 years I have been doing this, I have learned many things.

For one, a birth can often be very different from what a client imagines, or plans, but if her experience was a positive one, regardless of what happened, then I have done my job as a doula.

Birth in the Trenches

Diane Tinker

THREE BIRTHS IN 1 WEEK IS A LOT for me as a doula. I normally don't do this to myself or my clients. Since I work a full-time job, it can be challenging to attend as many births as I would like. However, birth is unpredictable and babies will come when they are ready, which is what happened this week. I write about these three births because they demonstrate the typical challenges women face in today's modern obstetrical system to birth their babies the way they want. These births reveal, through my eyes as a doula, the fight that often occurs and the lack of respect given to women while they are pregnant and giving birth.

I took on the first of these three births at the last minute. I think the mom called me 10 days before her due date since her and her partner had just decided they wanted a doula again. I remember thinking that it would probably be a fast birth and would not tie me up for too long, so I took them on. This birth occurred mid-month and Mom was planning for her second vaginal birth after a C-section birth (VBAC). Since she had already had a successful vaginal birth with her second child, the couple's plan was pretty

simple – have another successful VBAC without intervention. They used a doula with the first VBAC so they wanted doula support for this birth, too, because it helped her avoid pain medication the last time. It was pretty uneventful other than the fact that she was dilated to 4 centimeters on her due date. This apparently made the doctors very nervous – if she spontaneously ruptured her bag of water, they thought she might not make it to the hospital in time to deliver her baby. (Typically, having a baby quickly is good for the mom even though it's worrisome for the docs. So, in an attempt to avoid that situation, the doctor suggested that the mom come to the hospital two days later (although I'm not sure why the timing) and have her water broken. This apparently worked exceptionally well the last time with the woman's first VBAC – she had the baby in less than 3 hours.

On that day, the doc broke her water at about 10 a.m. and by 2 p.m., she still wasn't contracting regularly so Pitocin was started. No big surprise there – a typical procedure and the couple was not opposed. The Pitocin kicked in quickly and mom delivered an 8-plus-pound boy within 2.5 hours. I would have not chosen to write about this birth other than the fact that a third-year resident following the OB on rotation coyly asked after the birth what a doula was. I did not want to be the first to speak up and was so tickled when the dad spoke first and said, "What, you're a doctor and you don't even know what a doula is?" Now that was the best one I have heard in a long time. I piped in and said that it would be unusual for doctors to learn that in their training. They should, but they don't. Heck, they don't even see natural births in medical school anymore. The resident replied, "So, is it like a birth coach?" and we all agreed to a certain extent. Then what really impressed me was that the OB doing the catch spoke up and said that "there are studies that have been published that show the benefits of doulas – they shorten the length of labor and reduce the need for Cesareans." WOW, that is impressive! An OB who actually knows a thing or two about doulas. She just scored a big one with me. Too bad she isn't more open-minded about natural birth and letting women go into labor on their own.

The second of the three births occurred 3 days later. This couple was attempting their first VBAC. Their son was born three years before by a C-section. She told me that at the time she was very close to giving birth – she got through labor and pushed, but the doctor told them that the baby was stuck and wasn't coming out even though they could see a good amount of his head. When I hear that I just cringe. So close to a vaginal birth, but it seems like the OB had a time limit on the delivery. No one suggested mom try to change her position to help open up mom's pelvis and help the baby rotate in an attempt to avoid a C-section, a disservice to women. As a doula, I have to wonder when I hear birth stories like that if the medical staff and the OB really know about the benefits of mom changing positions or are they merely in a rush to get the birth over with. They don't learn these kinds of things in medical or nursing school. If they know they've likely learned it from a doula.

So the second-time-around, Mom does her research and is determined to have a VBAC. She gets her docs on board, joins ICAN, and hires me as her doula. I loved her spunk. She had done her research and was willing to push the boundaries set by the OB group, the biggest one being that she was not going to follow the OB's protocol and schedule a C-section at 41 weeks if she still had not delivered baby. Nearing the end of the pregnancy, this very courageous woman told the doc that she knew the risks but was perfectly comfortable going to 42 weeks. She wanted the extra week to give her body the chance to do it on its own. To our delight, the doc agreed and did not give her the lecture we had anticipated.

In the last few weeks before delivery, she began a regimen of walking every day and getting chiropractic and acupuncture treatments. And to our delight, just a day past her due date, she went into labor late that morning. After she realized that this was the real deal, she asked me about preparing a castor oil cocktail to help labor along. By 4 p.m., she was in active labor and coping well. I arrived and spent a little time observing her as she worked through wham-bam contractions, leaning over the birth ball for each one. I quickly realized that we needed to get to the hospital. When I called

to advise the hospital we were coming, I learned to my delight that the nurse on-duty is a friend of mine who used to be a doula. I knew that she would be totally on our side for this VBAC.

At the hospital, the mom does a fabulous job working through hard contractions. When the nurse checks her she is complete and starting to feel pushy. A resident is told to stand by in case the baby decides to arrive before the OB gets there. Mom continues to do well and Dad is a great support to her. I keep whispering to Mom to listen to her body even though she is being told not to push. I hate, actually detest, advising moms of this. Anyone who's been in this situation knows it's extremely difficult to not bear down when your body is telling you to push. Think of trying to stop a freight train. So when this happens I get close to Mom and whisper in her ear to listen to her body: do what your body is telling you to do – if you have to push then go with it; if there isn't a strong urge to push then save your energy. This was working for the short time it took for the OB to get there.

This was a great birth, aside from the cocky resident who came into the room and asked, "Why is she VBACing?" *What the hell?* I thought. I was silent and so was the great nurse, but only for a moment until she replied, "Uh, cause she wants too!" *Good job nurse! You rock!* I thought. Thankfully, the mom did not hear it but she was aware that the resident had her arms crossed while in the room and never introduced herself. So between a contraction I heard the mom say to her, "Who are you?" I loved her spunk and her determination not to let anyone foil her attempt for a great birth.

When the doctor arrived, the mom did some typical bearing down, holding-the-breath pushes. Mom experimented with a number of positions, including squatting over the squat bar and lying down on her a side. In no time, the baby was crowning and the OB came in and did her thing. Mom was so proud and empowered by the experience, repeating "We did it!" I love those words right after a birth. Yes, as a team we got it done, but it was really the mom who did it!

The third birth happened just 3 days later. The young teen mom initially had another doula but she had a family emergency and I

stepped in as her backup. The young mom was in my childbirth education classes, but because she was on bed rest from contracting frequently, she missed a couple of classes. The day before she gave birth, I went to her home and did some one-on-one teaching. She did not understand the significance of being 3 centimeters dilated, 75% effaced, and having lots of bloody show. She was not due for 3 weeks, but I predicted she would be having the baby very soon.

At her next prenatal appointment, the OB told her that she did not have to be on bed rest any longer since she had reached 37 weeks. The young woman was planning to come to childbirth ed class the next night when I got a call in the early afternoon of the next day. She was having contractions every 5 to 7 minutes. Although I told her she could be in early labor, she still wanted to come to class. When she arrived, I could definitely tell she was in early labor – as I was teaching, her face would get red every time she was having a contraction. I occasionally would encourage her to breathe and relax. Some of the other young women in the class also began comforting her and one suggested that she sit on the ball. I was really impressed with the young women – the one in labor and the others observing. It was a good learning experience for everyone. By the end of class, she was in active labor so I suggested we head straight to the hospital.

The neat part was that the young mom invited my intern that had been working with me this semester to come to the birth as well. Both parties benefited – my intern would see a birth for the first time and the young woman would have more support since her parents lived 3 hours away.

When we arrived at the hospital, the mom was already dilated to 5 centimeters. Mom really wanted to get into the tub, but she was delayed by the typical bedside admitting procedures. In the meantime, I encouraged her do some positions while the nurse monitored the baby. The OB, who didn't introduce himself, enters the room as we were headed to the tub. The nurse hands him an amni-hook after he gets his gloves on and says, "This is Dr. X. He is going to check you and break your water." All I could think is, *Gee, now the nurses speak on the doc's behalf*. Mom questions the

procedure of breaking her water but the nurse tells her that is what they do at this point in labor, to speed things up. *Speed things up? For what reason?* I tell her she can decline but she says it's fine.

Mom's goal was to not have an epidural. Many teen moms don't usually make forego pain medication so I was particularly proud of her decision. But the doctor questions her judgement: "And why don't you have an epidural?" The mom answered, "Because I don't want one." The doctor then proceeds with the exam, but he makes it very uncomfortable for the mom, who is now telling him to stop. Finally, he seems to think he has the water broken even though barely any fluid came out – it was mostly bloody show (this will be important a little later). Once he is done, he has the audacity to say, "If you think my hand hurts, your baby's head is gonna be bigger than my hand and it's gonna hurt a lot more. You really need to get the epidural now," and walks out. Complete disrespect for this woman's wishes and what I consider to be verbal abuse.

The good thing is that we don't see this doctor again until he catches the baby and he almost didn't make it because he was sleeping. Mom does eventually get into the tub, but her labor did not progress for the next couple of hours. Gee, I wonder why? The nurse then advises us that the doc will want to administer some Pit since he broke her water, but I'm still not convinced her water is broken, and she holds off for another hour while we work through various positions during stronger contractions.

When the nurse returns with the Pitocin, she also inserts an internal fetal monitor and just as she does this – you guessed it – out rushes a big gush of water! Even though the nurse is questioning whether the water had been broken, I knew the answer three hours ago. So now that the water is *really* broken, the contractions intensify and Mom seems to make a quick transition even though the nurse says she is a stretchy 5 centimeters. In a matter of minutes, Mom literally jumps out of bed from leaning over the back of the bed and starts yelling she can't do it, that it's too hard. This is what I like to hear – it's usually a sign that the birth is close. When the nurse walks into the room and the mom starts yelling the baby is coming, she can't believe it and practically pushes her back into

bed. But when she checks her, sure enough, the baby is right there, dilation complete. The nurse says, "I barely got the Pit started." *That's because she probably did not need the Pit!*

So all craziness breaks loose – nurses come flying in the room frantically, the doc is called, and the young mom has to push. After the OB assesses the crowning head and Mom's perineum, he turns to pick up the scissors and does nothing to manually stretch the perineum. As he is picking up the scissors, I tell mom that she is about to get an episiotomy. She doesn't especially mind at that point, she just wants the baby out. And that is what happened. She went from 5 centimeters dilation to birth in less than 30 minutes, a very intense experience for mom, both physically and mentally. I encourage the intern who has been there all along to take pictures of baby.

Of course, the doctor is in a rush about getting the placenta out, sticking his hand inside her, tugging on the cord, and putting in stitches to repair her bottom. She barely gives an ouch, when he says, "This is why you should have gotten the epidural. If you had, you would not be feeling this now." One last effort to control the situation. I told her she was doing a great job and that he would soon be done.

It breaks my heart to see women treated this way. This woman had an overall good labor – less than 12 hours – she felt well supported and safe because she had a doula, yet she still remembers the abusive doctor when we talk about it. In my eyes, she's a champion and is focused on being a good mom who is successfully breastfeeding her baby 4 weeks later.

These births leave me feeling proud of the work I do empowering women and supporting them through the good and the bad of hospital births. Since these three hospital births, I'm delighted to say that I have since attended 10 home births and only two more hospital births. Each month, I have more and more requests to attend home births and I prefer them. I love the experience of home birth – it's so calm, peaceful, and respectful of women. That is what birth should be.

Overcoming the Three-Year Itch

Stefanie Antunes

I BECAME A DOULA QUITE BY accident. Although, I have yet to meet a doula who decided as a young girl to become one. Most doulas have similar stories – "I had a wonderful birth experience and want to help others do the same" or "I had a horrible birth experience and want to *save* others from that same fate" – my story follows the latter statement. Interestingly, it wasn't that my childbirth experience was bad, but it certainly wasn't good. That was part of what made it so difficult to understand at the time. Looking back at the experience, more than a decade ago now, my baby and I were healthy and happy. Wasn't that all we ever want as parents? No. I realized over the years that there should be more. There had to be a way to come away from childbirth feeling more empowered and excited than I had. But how? But what?

Four years after my first birth I was pregnant again. I knew this time had to be different. I took Lamaze classes, something I hadn't done with my first child. I made specific choices about my care provider and had a phenomenal experience. I could finally put into words what I had known in my heart, that birth had the potential

to be completely transformative for a woman, easing her into motherhood with blissful feelings of strength and courage.

I immediately decided to become a Lamaze educator. I thought of it as a hobby at first, since my days were filled with my corporate work, but it didn't take long for it to take hold of my heart.

I remember attending my first birth as a doula during my training as an educator. It was for a mother going through a tough time with her partner and she didn't know if he would be helping her through her childbirth experience. I volunteered to help her, as her doula. I had attended several other births as an observer, but not as a doula. I had also attended one other birth with a doula present to observe her. I still questioned my experience. But in the end, supporting a woman with nonmedical comfort measures just came naturally to me. Her labor wasn't easy, but I focused on involving her partner and helping her to the best of my abilities. A few months later when we got together, she told me that she thought she was together with her husband because of me, because of how I had helped him feel supportive as a husband and father during her labor. That was it, I was hooked. I had never felt like that in the corporate world.

I continued working my full-time corporate job, teaching childbirth education to groups of parents and taking on the occasional doula client. As the years went on, I noticed I began to dread the reunions. I hated hearing the birth stories, filled with intervention, medication, and disappointment. All I could think was how unnecessary most of these interventions were (according to research), how horrible they made the women feel, and how much time I had spent trying to educate them about how to avoid these interventions. We had discussed how to dialogue with their care providers and ask the right questions. But it didn't seem to make any difference.

I remember I considered quitting the field at this point. I fought with myself to continue, and I still wonder if the lineup of booked classes isn't what kept me going. I probably skipped a few reunions during this time. Eventually the feelings passed. I couldn't figure out why or how, but accepted its dismissal with contentment.

As the years continued to pass, I began to notice that people in the field seemed to be hitting that same wall I had experienced – that feeling of unease, frustration with the medical system, (skyrocketing intervention rates, unnecessarily high rates of infant and maternal mortality), that 'itch' that made people reconsider their place in the field. I began to notice that I could tell someone was in their '3-year itch' just by listening to them speak. I would encourage people to stay in the field. Sometimes they did, sometimes they didn't.

As the years passed, I did some research on my theory. I discovered that there was a term for it: Vicarious Trauma (VT). Vicarious trauma happens when we continually empathize with our clients' traumatic experiences. It was first used in psychologist/psychiatrist settings, but it is a BIG problem for childbirth workers as well.

Even though I had done research on VT, identified the concern, and tried to put plans in place to prevent it, I still managed to have another encounter with the 3-year itch, at year 6 no less. The 'itch' seems to reappear about every 3 years in most individuals.

I remember meeting with Jessica (not her real name). She spent time telling me how much she wanted an unmedicated birth, which is very common for a doula client. Many of the clients who hire doulas realize their bodies are perfectly designed to birth a baby, and their inner strength will guide them through the process.

Jessica's labor began and progressed slowly. I spent countless hours helping her through her contractions. I did everything I knew to do and more to support this strong woman. She endured intervention after intervention as I continued to support her throughout her labor, which tallied well over 24 hours. When I heard from her after her birth it was via an email, telling me how disappointed she was with my services. The dozens and dozens of thankful letters and cards from other happy clients seemed nonexistent in that moment. I could hardly believe it after the family time, personal time, emotional energy, and physical effort I had expended. I could do nothing but think about it for days on end. I questioned my ability, my profession, my roles, my mission,

because of one unhappy client. That began my spiral into my second 3-year itch.

The next birth I attended had me feeling very anxious. I worried if she'd be disappointed with me too. In the couples of months that followed, the births I attended seemed just dreadful. At one birth, my client began feeling her Cesarean in the middle of the operation. Her doctor told the nurse in the operating room to quiet her down as she demanded general anesthesia (which she never got). The births almost all seemed to end horribly. Even the good ones didn't make me feel good anymore. They just barely kept me in the field. I left the good ones thinking "Wow, she got off easy. Luck, I guess."

I would leave the bad ones and cry in my car. I was frustrated with the system. I was angry with our local providers. I was angry at women for not standing up for themselves. And I was always questioning what I could do to change anything. It felt like an insurmountable mountain. One I couldn't even see the top of.

There seemed to be nothing I could do to want to stay in the field after seeing these atrocious acts and experiencing such disappointment. But a voice inside wouldn't let me give up. There were two things I knew without any shadow of a doubt: 1) These feelings will pass if I worked at it; 2) This mission needs every one of us. Like the transition phase of labor, where mothers sometimes feel overwhelmed at its intensity, this too would pass to reveal something much greater, steering me toward a fulfilling and rewarding career.

I had a turning point when I heard a wonderful speaker discuss the story of William Wilburforce, who spearheaded the creation of the Slave Trade Act in the United Kingdom, and was instrumental in eventually abolishing the slave trade completely. He began working on this mission in his 20s. He worked on it his entire life. Sometimes it was very difficult for him and he suffered personally and professionally at times. At 74, he finally learned that the Slavery Abolition Act had passed (1833) and he died three days later. He had spent his entire life working toward one main goal, working with one cause on his mind. And I was thinking of giving up after 6 years!?

The most instrumental awakening for me came at the realization that I do not need to change the world in one day. Perhaps in my lifetime women will reclaim their strength, their bodies, their ability to birth their babies. Perhaps not. But I will continue to change the world one family at a time, because that's what I can commit to. It will take many shapes and forms over the years. It will change as I will. Some years I will do more than others. But I will always challenge myself and those around me to keep trying.

I know what is needed to do to move past the 3-year itch:

- Creating realistic expectations of myself
- Finding a great support network
- Creating a plan for local advocacy
- Rejuvenation: making time for myself and my family
- Taking time off if necessary

Our medical system is complex. Its primary goal is not to empower women and support them through labor. That's our goal. That's a doula's mission. I will continue to do my part at empowering women and new doulas to continue this very important task. I hope you will join me!

Weathering the Storm

Jill Ritchie

IT BEGINS...

Contractions 3 to 4 minutes apart, 45 seconds long. Walking up and down stairs, marching in one spot, rocking on hands and knees, birth ball bouncing, laughter in between. We rest, we eat, and we keep busy. Finally a rhythm begins, and a pattern emerges. The setting is serene, peaceful, and full of hope for a new little life about to enter the world. She is glowing in her motherhood.

Then it changes...

Admitted to hospital, 6 centimeters and behind the white curtain darkness awaits. With tool in hand the darkness forces the water of life to break and the storm strengthens. Motherhood is stricken with intense, fierce pain and pressure to conform to the darkness.

Light finds its way through the crack in the door and comforts Mom with a soft breeze of music, whispers encouragement, and offers nourishment for inner strength. The light continues to illuminate, allowing motherhood to unfold and open to the changing contractions.

But then the black storm strikes again. Without warning. This time blackness is a rough sea with sharp, pointed rocks. The storm can't escape her prison so she threatens motherhood with bolts of lightening that strike fear into her soul for her unborn child.

Motherhood succumbs to the storm, she lies still on the rocks, her veins invaded by multiple IVs and epidurals piercing her skin, her legs apart as cold steel pulls her newborn out. The universe watches as the swirl of darkness envelops the sacredness of motherhood.

The light anguishes with frustration over her limitations, her inadequacies. Were their turning points where she could have shone brighter and pushed the darkness away? Darkness holds tight to the light, always waiting for her chance to storm again.

With Woman –
Three Sad Stories

Hilary Monk

IN THE 1970S AND 1980S, BEING "with woman," or midwifery ("mydwyf" is the Saxon word meaning "with woman"), developed within Canadian communities as a woman-centered, physiologically-based method of care, less reliant upon technology and more supportive of women's choices. By necessity, much of this care took place outside hospitals, where, for the most part, birth had become highly routinized, medicalized, and unresponsive to women's choices. When this activity was threatened with legal sanctions, there arose a coordinated political movement to 'legalize' midwifery, ostensibly so that woman-centered care could persist. Ontario was the first Canadian province to institutionalize midwifery under the state healthcare system (Irwin, 1993).

Notwithstanding official rhetoric concerning the autonomy of professional midwifery, it has been my experience that most Ontario midwives must work constrained by physicians' standards of care. Therefore more and more over time *in practice* midwifery is becoming indistinguishable from obstetrics. Some have claimed that the new recognition of midwives as autonomous medical professionals would avoid the exhaustion, the low pay, the constant

fear of being criminally charged, the lack of prestige, and the conflicts characteristic of independent midwifery (Benoit, 1997). From what I have seen, the fear, the burnout, the susceptibility to litigation and, most importantly, the eradication of women's choices in birth – regulation prevented none of these. Our supposed "autonomy" is illusory, a sham.

Originally, I had been completely and ecstatically absorbed by birth – delivering three of my four children at home, publishing an alternative childbirth newspaper (*Re: Birth*, 1984-1986), teaching childbirth education and pre- and postpartum fitness, and attending close to a thousand births as a doula, independent community midwife and regulated midwife. I have lectured and taught 'new' low-tech models of care locally and internationally (in Warsaw, Poland, and Alexandria, Egypt) at conferences, university seminars, and workshops.

Originally, the joy in service of attending births far outweighed the difficulties – political, legal, and physical. However, with the eradication of community midwifery as an alternative to medical hegemony in this country, there came a point of such profound disorientation that my spirit could no longer withstand the immoral, degrading, and cruel situations that I had to witness and in which I had, through the immobility of powerlessness, become complicit.

For decades, I have listened to and deeply identified with the hopes and anguish of birthing women and the women caring for them. Regardless of ethnicity, nationality, age or parity, we all have expressed our anxiety about the same things – that our wishes for dignity and privacy during birth be respected and carried out by our caregivers, and that our babies emerge into an atmosphere of skilled gentleness so that all of us benefit from the birth process physically and psychically. I've heard many midwives struggle to satisfy these concerns, resisting the tensions of medical politics and the pressures of their own professional and family lives. And I've witnessed many midwives cave in to these pressures, their resistance collapsed by exhaustion or persecution.

Georgia's Story

Why Georgia chose to birth in hospital was beyond me! She labored beautifully at home, bouncing around on a giant blue ball and laughing while trying not to get amniotic fluid everywhere. Just judging by her progress and wonderful noises, she was for sure fully dilated. When the ambulance arrived, the attendant blocked our way with his six-foot bulk on the doorstep, holding up his gloved right hand to examine her internally. Trying to get past him, we kept telling him she was already pushing and needed to get to the hospital right quick, but he had to "assess" the situation. (Could he not simply *listen*?) She actually had to say out loud that she refused to be touched by him, but he insisted on asking her whether she was having contractions, how far apart they were? Who cared how far apart they were? If he'd just look, he could see she was pushing, leaning on us and groaning deep, deep in that special unmistakable way. Lack of experience does not explain his blindness. Once I saw a roomful of women screaming with laughter at an obstetrician in a video whose wife was in labor outdoors in a hot tub. All the women could see she was already pushing, but he had to ask, while her midwife was hurriedly hauling her out of the tub to give birth any second in a warmer place, "Are you pushing?" He couldn't see what was in front of his face. He didn't understand what he was seeing. He didn't ask the important questions: Was she full term? Had her pregnancy been healthy? Was this her first baby? How long had she been feeling the urge to push? We finally pleaded our way on board and arrived at the hospital within a few minutes. Georgia was rushed to a birthing room; the doctor got there just in time to catch a lovely little girl.

A few minutes post-birth, the babe was a blue and a bit limp, but the nurse didn't notice. Scribbling away on a formidable pile of forms, she had taken no action beyond waving the baby around in front of the mother, bundling it up and dumping it into the warmer until the mother delivered the placenta. If she'd been paying attention to the baby – rather than her charts – she would have given the baby a bit of free flow. So I suggested it and held out the oxygen tube to the nurse. She glared at me, but left her paperwork

and, stating that she was now "visualizing" the baby (Oh, by all means "visualize" this baby!), gave the babe some free flow and stimulation. Surprise! The baby began to pink up and wiggle around quite vigorously.

Meanwhile, the doctor was tugging at the cord protruding out of the woman's vagina, and Georgia was calling out loudly for her to stop, that it hurt. She looked at me breathlessly and said, "Get her to stop that!" I said clearly and pointedly to the doctor, "Please stop pulling on that. She's asking you to stop." That doctor, by repute supposedly one of the 'good' ones, looked me right in the face and pulled sharply on the cord. Ah, Christ! It broke. At this, the doctor paled, and began poking about trying to see past the copious bleeding. I suggested what was common sense at this point – a shot of Pitocin to help expel the placenta and control bleeding. The doctor immediately 'ordered' the nurse to do that. The placenta did not come out 'fast enough,' even though the bleeding slowed right down, so the doctor left the room to fetch the in-house obstetrician. He came in, gently examined the woman for a second or two, clamped the edge of the placenta, which was just barely inside her vagina, with a ring forceps and, with the mother pushing, applied controlled cord traction to deliver the placenta. The mother and the doctor seemed fine after that, but the nurse wasn't. She called me 'outside' to berate me, saying I had no right to say anything to the doctor, that the doctor was an excellent doctor, in fact she would trust her own birth to this doctor (more fool she!), and so on.

Here was a case where three 'trained professionals' could not see what was in front of their own faces, and apparently Georgia and I were at fault for pointing this out to them! That was the very last time I acted in the capacity of labor coach – I could not bear to stand by again and watch another 'pro' botch something so simple so completely. However, becoming a regulated midwife didn't help much. Prior to regulation, I saw many birthing women have their express choices – their rational, well-referenced, responsible choices – dismissed. I often witnessed this when working as a labor coach for women receiving physician care in Toronto hospitals. And after the Ontario regulation of midwifery in 1994 (College of

Midwives, 2000), still I saw women's choices being discarded, sometimes dangerously, now by midwives as well as physicians and nurses.

Faith's Story

The first time we worked together in 1999 was so good. Faith was so spunky, young, and healthy and happy to be pregnant. She definitely wanted a home birth, no questions. We had a good time at that birth – very straightforward. In fact few births are as simple as this one was. Under 5 hours, on the floor at her mother's house. Faith was a Jehovah's Witness and could not accept transfused blood products, so, as a result of her own research, we discussed with our backup obstetrician stocking the hospital unit with Pentaspan – a synthetic blood volume expander – in case of an emergency. The doctor urged Faith to deliver in hospital, but home was her choice, Pentaspan her reasonable fail-safe. Now, this doctor believed a caregiver could convince any patient to follow recommendations, so long as the 'facts' were presented in the 'right' way. I had come to see that this usually entailed outright manipulation of the truth in order to support routine protocols. He couldn't understand why my clients so often had their own belief about things, their own desires and plans that did not match standard medical wisdom – for many physicians, an unusual and uncomfortable prospect that often conjured up frightening visions of litigation for them.

Eighteen months later Faith was pregnant again. We looked forward to another great birth, but, nearing term, it became clear that the baby was unstable, flipping, and flopping all over the place as if Faith's womb was a gymnasium and the babe a gymnast in training. I used to do versions in my office, turning babies head-down, but with all the hysteria around breech babies at the time, this was no longer an option. Between 1999 and 2005, most physicians were afraid to deliver breeches vaginally, because *one* study (Hannah, 2000) had concluded that vaginal delivery was slightly riskier than Cesarean. The Society of Obstetricians and Gynaecologists of Canada said that doctors were supposed to present information and let mothers choose, but that is not what I saw.

Much of this changed when a French study (Goffinet, 2006) was published refuting the Breech Trial.

The head midwife's reasoning said that since most obstetricians were afraid of versions, they *must* be very risky procedures, and therefore midwives should not do them anymore. (According to most obstetricians, all home births are also too risky, but this is not a reason for midwives not to attend). "The fact that there is a low rate of unforeseeable risk in any birth does not morally justify approaching all births as if they involved the highest degree of risk" (Overall, 2002). It had become midwifery practice protocol, to be followed by all midwives *regardless of what the woman wanted.*

My favorite obstetrician turned the baby on two separate occasions after a down-to-earth risk-benefit chat, and he did it without fuss on a normal bed in the hospital, instead of per protocol in the OR 'in case' an immediate section became necessary. The OB refused to do it a third time – although prior to regulation, many midwives would have tried as the baby moved so very easily.

I did not see that this situation was any different than any other; Faith should be given information, make her choice, and get support for it. She and I talked about breech and I shared what I'd been taught, seen, and done. In Texas, I'd caught a number of breeches myself, including a footling breech, and witnessed breech births both at home and in hospital. The midwife-conducted births had been, admittedly, dramatic, but successfully, safely and calmly done. One of the hospital breeches was a footling managed by one very reluctant obstetrician. This doctor had tried to convince my coaching client to be delivered at 38 weeks by Cesarean to avoid a vaginal breech delivery, but the client had refused, wanting to "see how things went" first, after having viewed a video of normal breech deliveries on my suggestion. At the birth, the OB had come flying in frantically at the last minute as the baby's hips were emerging. The woman had pushed excellently to this point without any pain relief, despite being flat on her back. The OB demanded angrily, out of breath, and glaring at me – "Who let it get to this point?" The doctor in charge during the OB's absence had not had the chance to set up an epidural catheter as hospital

protocols required, because she'd progressed in under an hour from barely being in labor to pushing. During this intense part of her birth, I had been trying to get out of the tiny room in which we'd been deposited at the back of the labor ward to let nurses know she was moving fast, but the woman had kept calling me to help with another and yet another whopping huge contraction. The OB picked up an enormous syringe full of local anesthetic and waved it about, futilely looking for somewhere to stick it before the baby was 'helped' out with forceps placed on its head by the understandably nervous and inexperienced resident. Once we could all see that the little six-pounder was pink and healthy, I turned to the OB and said, "How wonderful that everything went so well!" Her response was to growl under her breath, "It did not go well at all." When I talked about the birth in a postpartum visit with the mother, her happiness had dissolved. Instead she expressed a feeling of guilt about her "irresponsibility" in having "forced" the doctor to do a "risky" delivery! She said she should not have watched the video, because then she would have chosen more "professional management" – a cold section at 38 weeks, despite this management being harder on the baby (Gamble, 2002). The mother experienced no joy at her accomplishment, nor relief at having avoided unnecessary surgery and all the very real risks to her and her baby that the operation would have entailed.

Faith and I talked a lot about all these experiences, viewed the breech video, looked at a midwives emergency skills manual section on breech delivery. Her present OB expressed confidence that a vaginal breech birth would be fine for her. The baby's antics did not unnerve him. In Texas I'd seen the birth of a big baby to a large woman where the baby kept floating all over the place in her enormous pelvis. The babe had emerged easily, along with so much amniotic fluid that it poured off the bed, out the door and into the hall! She did not hemorrhage; the baby did not have tracheoesophageal fistula. These were risks associated with polyhydramnios, which she did have, and which in Ontario would have required multiple ultrasounds and obstetrician delivery, per regulatory requirements (CMO, 2000).

Faith, being a reasonable and calm young woman not given to dramatization, prepared for hospital delivery. If she'd been rigid-minded, and therefore not a good candidate for home birth, she might have chosen to insist on staying home; ironically, because she was exactly the kind of woman who made an excellent candidate for home delivery, she chose to go to hospital to keep everyone happy.

Her labor started with the waters breaking. We had already arranged for her to go immediately to hospital rather than me coming to her home to assess her labor as is the norm, because there was a good chance she might birth too quickly and we would not be able to get to hospital. I had seen the doctor on call solicit women's opinions softly and sweetly, then ignore what they asked unless it was already strictly within his normal routine. He was perfectly agreeable unless crossed. When I let him know the arrangement Faith had made with her OB, he became incensed, appearing increasingly red-faced during the entire episode. A few minutes later I shared with Faith his exact words: "If she makes me do a vaginal birth, I'll call Children's Aid, because she obviously doesn't care about her baby!" It made me feel sick, asking her to make such a decision now that she was well into her labor. Trustingly and confidently, she had arrived in hospital to give birth joyfully, and instead was thrown onto a battlefield with no weapons but her honor. Her dignity in the face of personal disaster compelled her, like many mothers, to rise to the occasion with tremendous courage and reason, nor did she consider anything other than the welfare of the child in her belly. With the doctor so furious, what choice did Faith really have? She told me that she was afraid unless she did as he commanded, he might very well injure her or her child in his fear and anger. She told me that since he was obviously incompetent to deliver her normally, she would agree to the section. She had to 'choose' to let him cut her. She had a choice, but it was no choice. Faith's 'choices' were analogous to those described by the feminist lawyer MacKinnon's work on rape law (1989), where informed consent is no consent if a woman is in a position of no power where her only option is no options (MacKinnnon, 1989).

But there was more. She had to endure him screaming in her face that since she refused to sign the permission for blood transfusion on the operative consent form, it was apparent to him that she did not understand it. "Don't you understand? If you bleed and you don't sign this, you could die?" I will never forget this scene, him hissing at her, his blotchy face twisted in rage only three inches from hers, as she lay strapped as if crucified on the delivery table, unable to respond or escape or defend herself. And I felt shamed that I could not act when every bone in my body was yelling at me to free her, to tell him to get out and we would have a fine birth without him on my responsibility.

It gets worse. In the next story, Margaret almost died from incompetent nursing and insufficiently individualized care. Nursing staff said I had not tried hard enough to talk the woman into doing things their way. She did it their way, and it almost finished her.

Margaret's Story

Margaret became seriously hypertensive at the end of her pregnancy. On the day slated for her induction, she stalled arriving at the hospital – I was already pacing back and forth in the hall wondering where the hell she was – until she was well into labor. During her birth I could only provide support as she was ill, way outside the realm of normal – she knew it and I knew it. The staff was to provide all clinical care in consultation with her directly. I helped her with humour, eye-to-eye focus, and breath coaching, and by bringing to the nurse's attention that the baby's heart rate would drop abnormally when Margaret lay on her left side, but did just fine when she lay on her right. Hydrallazine, which lowers blood pressure, worked well for her. Whenever she asked me a technical question I passed it on to the nurse or doctor. She did really, really well for most of the labor. But then, protocol and dangerous narrow-sightedness kicked in. All hypertensive patients received epidural anesthesia to prevent cardiac compromise when pushing. But both times Margaret had gotten a spinal at about 3 centimetres of dilation with her previous babies, they'd gone into fetal distress and she'd had to have emergency sections. She didn't

want a spinal this time. This time she got to full dilation and was beginning to push. She was so excited about the prospect of birthing vaginally, and was amazingly calm and well-controlled with her breathing since she well knew this was the key to keeping her blood pressure down and giving herself the chance she so badly wanted. Every now and then, she'd swear at the pain of a contraction, and immediately laugh about it, saying, "Oh God, it hurts…but it's so great!"

Sadly, protocol prevailed, and the doctor, *in absentia*, ordered the epidural for her. She never really had the chance to object nor to agree; what woman can cope well with heavy duty labor while arguing convincingly on her own behalf for a stay of routine procedures?

For more than half an hour the resident tried to get the epidural in, but couldn't insert the needle between her vertebrae because of exaggerated lordosis, not something unusual for a woman of her race. The head anesthetist stepped in, and opted to do the easier spinal. All this time I was flipping out and asking them to let her turn over because the baby's heartbeat had been so bad on that side. No one listened; no one checked the baby's heart; no one asked about any alternative considering this patient's particular history – how about a touch more hydrallazine? There was no one to ask – anesthetists only give anesthesia, and the obstetrician was nowhere in sight. They just did what they always did, and it was business as usual, never mind the individual.

The second the spinal took effect, she crashed. It was panic everywhere, rushing to the section room, people all over the place trying to get equipment set up, calling out harshly and clanging about, barking codes on the P.A., thrusting arms into gloves and gowns, banging doors, beeping machines. While helping push her bed down the hall to the OR, I tried to tell her husband what was happening. I recall bending over her beautiful face watching her washing in and out of consciousness, in and out of life, calling her name, telling her to stay with us, to stay with the baby. I recall thinking, this couldn't be happening, she was a friend, a former colleague! Within a few interminable minutes, the staff had cer-

tainly risen well to the crisis once they'd created it! The baby was delivered alive, thank God, and Margaret began her slow trip back to health.

After I had taken care of the new baby with the dad, once again I was called 'outside' by the nurse. She claimed it was my fault that Margaret had put off getting the epidural, my fault she'd crashed. I very quietly told her that I had only provided support, and had referred questions and deferred judgment to nurses and physicians at all times. Later, I figured out that this same nurse had administered IV fluids too quickly, which could explain the entire scenario. No wonder she had been so fast to try and blame me. I never got the chance to discuss this in depth with anyone, nor to express my belief that Margaret could have pushed this baby out pretty easily just given the go-ahead. To top it off, I was told the nursing staff had been accusing me of incompetence behind my back, until I was forced to threaten them with slander charges if they did not stop.

I have come home time and again from a birth and wept at the cruelty of it, the gratuitousness of it. I have wondered where on earth did this mistraining, this miseducation come from? Whose obscenely warped idea of what birth is and should be is responsible for these charnel scenes? How has such a view come to be orthodoxy for so many blind, insensitive caregivers, to be passed on year after year in 'professional' rituals that flout evident reality and common sense so often? Why do they seem to have such contempt for the birthing mothers? Where did the freedom that so many of us sought and fought for go? From experiences like those above, and many others, it seems to me this freedom is drying up, despite all professed good intentions to the contrary.

(Excerpted and abridged from Monk, J. (2007). *Divided Loyalties: Locating Freedom of Choice in Regulated Midwifery*. Unpublished Master's thesis. York University, Toronto.)

References

Benoit, C. (1997). Professionalizing Canadian Midwifery: sociological perspectives. In F. Shroff (ed). *The New Midwifery: Reflections of Renaissance and Regulation*. Toronto: Women's Free Press.

College of Midwives of Ontario (2000). *Indications for Mandatory Discussion, Consultation and Transfer of Care.*

College of Midwives of Ontario (2006a). *Registrant's Binder*. Retrieved Oct. 5, 2006 from www.cmo.on.ca/ commbinder.asp

College of Midwives of Ontario (2006b). *Mandate*. Retrieved Oct. 5, 2006 from www.cmo.on.ca/ aboutMandate.asp

Gamble, J. (June 2002). Abstract written for *Midwifery Digest* 12;2:258-59 of research report by van den Berg, A., van Elburg, R., van Geijn, H., et al. (September, 2001). Neonatal respiratory morbidity following elective caesarean section in term infants: a 5-year retrospective study and review of the literature. *European Journal of Obstetrics and Gynecology and Reproductive Biology*. 98(1):9-13.

Goffinet, F. et al. (2006). Is planned vaginal delivery for breech presentation at term still an option? Results of an observational prospective survey in France and Belgium. *American Journal of Obstetrics and Gynecology*. 194:1002-11.

Hannah, M. et al. (2000). Planned caesarean section versus planned vaginal birth for breech presentation at term: a randomised multi-centre trial. Term Breech Trial Collaborative Group. *Lancet*. 356:1375-83.

Irwin, L. (August 1993). Implementing Registered Midwifery in Ontario. *Growth Spurts*. Brampton, ON.

MacKinnon, C. (1989). Rape or Coercion and Consent? Chapter 9 in *Toward a Feminist Theory of the State*. Cambridge, MA: Harvard University Press.

Mason, J. (1988) in Kitzinger, S. (ed.) (1988). *The Midwife Challenge*. U.K.: Pandora Press.

Monk, H. (1994). *Ontario Midwifery in Western Historical Perspective: From Radicals to Reactionaries in Ten Short Years*. Unpublished paper. Toronto.

Monk, H. (2007). *Divided Loyalties: Locating Freedom of Choice in Regulated Midwifery*. Unpublished Master's thesis for York University. Toronto, ON.

Overall, C. (1987) *Ethics and Human Reproduction*. Boston: Unwin Hyman.

Baby Born of Earth, Sky, and Water

Marcie Macari

Baby born of earth, sky, and water spirit of all elements combined...
I wish for you:
to feel your connection to all living things deeply and unshakably
To experience compassion
as though every living creature were your friend.
And may this same compassion return to you when you
need it most.
May you always know the warmth
Of your feet in the sand,
your hands in the ocean,
your spirit in the sky...
May you feel, no matter where you travel, that you have returned
home.

Baby born of fire and fashioned from clay
Teacher of truth and purity
I wish for you a brightly burning soul-fire
A flame that will not be extinguished with words, disappointment,
or grief.
May you never live a day without PASSION – for life, for truth,
for love.
When you look in the mirror, may you always be amazed.
Precious light-bringer,
May you never forget,
no matter how real the human challenges that you are,
and always have been SPIRIT.
May the lessons you have chosen to learn in this lifetime,
be well-worth your trip.
May you rejoice in your heritage,

and may every traveler who meets you,
and every being who loves you,
look into your eyes
and remember who they are.

Renewed

Maurning Mayzes

WHEN IMMERSED IN BIRTH WORK
long enough, one is likely to feel that natural high that follows
some births. One is also likely to feel the intense anger, frustration,
or sheer exhaustion as a result of an emotional experience. To
effectively support a woman's autonomy, one finds a strategy to
renew their spirit whether this is through dialogue, meditation,
journaling, physical activity, or time away from birth.

What about renewal of body and mind through birth itself? This
is my drug of choice.

Birth of unassisted twins.
Birth of unassisted breech.
Instinctual birth.
Birth without fear.
Birth in the snow.

No, this is not an alternative birth center that I visit once a year, it
is a farm. Not The Farm but a sheep farm where approximately 400
pregnant sheep give birth over a 2- to 3-week period.

How does one happen upon this experience? One blissfully sunny winter afternoon while unloading hay from a farmer up the road, I learn that he raises sheep. Intrigued, I mention I would love to spend a day helping at the farm when they are in lambing season. Sensing this isn't just a passing fancy I have with birth but a real addiction, the farmer offers me, a birth junkie, a job to attend lambing. He raises a brow in disbelief when I accept the offer, both eyebrows raise when I happily volunteer for the night shift. It's February, and the snow is flying. I'm bundled head to toe standing among nearly 400 expectant moms. The windchill has dropped the temperature to a bone-chilling −30° Celsius. Despite these conditions I am beyond thrilled.

The task before me *sounds* simple enough. Help those in distress, move mother and lamb to one of the jugs (small stall) to bond and ensure good nursing, and milk some mothers for colostrum, which is to be fed to the orphaned lambs and the ones that are chilling down too fast.

Within the first hour I witness six births. I'm addicted. The simplicity of birth is reaffirmed to me, an amazing unfolding of birth stories that lifts the spirit and brings a lightness to even the weariest of steps.

Labor and birth is a solitary affair for sheep. They do not seem to actively hide, they just find a quiet spot, perhaps surrounded by napping sheep or in a corner by themselves. The most spectacular moments are when I find myself a spot nestled among them and simply be present. I do not know before she births if she is having twins, triplets, singleton, breech or vertex. She shows me, I just have to be patient.

A mom has tucked herself into a dark corner where only one other is sleeping. She makes soft breathy noises as the contractions become pushes. Two little feet and a nose peek out. The next push moves the lamb out to the point of its ears. In a moment she pushes again and her lamb is born. She licks her lamb, encouraging it to stand and nurse. This little one looks unusually like a dalmatian. As casually as she birthed the first she lies down on her

side and begins to birth her second. I decide to get the flashlight since I think I am looking at *one* little upside down foot, this means breech, which would be fine if I saw *two* feet. I am back in less than a minute and I crouch back down a little closer to her, two little feet showing now. A smile spreads across my face as in one push she births her lamb to the naval. Swiftly she stands and births the rest of her lamb. Decidedly this one does *not* look like a dalmatian, but rather more like a sumo wrestler. She talks to her lambs as they experience their legs and voices for the first time. I tuck the mom and lambs into a jug, and they eagerly nurse. My body does not seem to know that it is 4 a.m. and subzero temperatures, I feel warm and refreshed. Another mom on the other side of the pen has started to push. What wonderment awaits me there?

When I look back at the births I have been present for, both in the human and sheep world, the parallels are striking. Lack of bonding, difficulty nursing, shock, and sometimes complete rejection of the lamb is common among those that have *help* too soon or seemingly without consent. Innately, they know when they need help and calmly allow your assistance, almost drawing you in; you learn to wait for that sense. These moments of connectivity solidify for me how important it is to follow the mother's instinctual cues. When I'm *invited* to help, the mother-baby dyad remains strong.

I never grow tired of lambing. It's very intense therapy. The beauty of unhindered or instinctual birth renews the spirit and reinforces for me the need to simply *bear witness* as a woman gives birth. Softly become part of the rhythm she discovers, and if she *invites* you to dance, let her lead.

The birthing high awaits.

Bearing Witness

Lisa Doran

I SLIP OUT OF THE BACK DOORS OF the hospital. It's 3:45 a.m. on a cold and dark February night. It's been a long, long night and I have that kind of foggy fatigue that causes my body to move slower, the world to seem a bit unfocused, and the stars to feel closer. I carry with me that glorious feeling of bearing witness to the birth of a new soul. A baby boy, all pink and wrinkly and covered in his mama's juices was born today. I feel open, vulnerable, happy, and in awe. I close my eyes and try to hold onto the vision of that little man. Of his mom's ecstatic face at her first glimpse, of his father's gentle eyes and loving touch as he strokes his head.

It's snowing and it's cold, the ground is slushy, and I forgot to wear boots. The falling snow in the streetlights is lovely, the snow muffling the sounds on city streets. Time feels like it has slowed as I watch the snowflakes fall gently to the ground. I stand in a stream of light on the sidewalk, let the snow fall on my hair, my upturned face, while slipping into my sweater. I shiver.

I smell like birth and slowly become aware of that. It's in my hair, my sweater, on my skin. Sweat, blood, amniotic fluid. Those

earthy, almost indescribable, smells that come from a birthing room. From holding laboring mom and newborn babe. From massaging mom's back, from supporting her as she squats, from dancing with her as she moans, from holding her as she powerfully pushes her babe into the world. I breathe deeply. These smells make me feel connected to something larger than myself. The incredible power that I am honored to bear witness to, honored to put my hands and heart to work to support and assist. They remind me of this work I love, this work that I have been doing for almost 20 years. This work that I leave my family for, leave dinner half uncooked, chores undone, laundry unfolded. I am called to this work. It fills my heart. It connects me to the divine.

I begin to walk, a slow and meditative walk around the hospital while breathing deeply. This is my ritual and has been my ritual after every single birth I have attended. It gives mom and dad some time to connect to their babe and it gives me time to process a little of what I've seen, of what unfolded during the birth before I go back up to the room to help with breastfeeding, admire the beautiful babe and gather my birth bag. This particular birth was a tough one. Mom worked so very hard. Dad was lovely and present and supportive. But an obstetrical resident instructed this mom to push when she had no urge to on a cervix that was not fully dilated. Nursing staff were tired and curt. And the attending obstetrician had already performed eight C-sections as we pushed on a cervix that grew puffy. Then there was an intervention with an epidural with all the textbook side effects of low blood pressure, of babe sliding into distress. No C-section, though, not for this mama. Somehow the mother's cervix opened up and babe was helped out with high forceps to hurry things along. Mom now feels incredible with her new baby. Endorphins and adrenaline and joy are mixing to allow her to overcome her other feelings that she will need to process and be supported through later. Her anger at mistakes, her grief for the natural birth she had wanted, and her pain and complications in her recovery. These things she will keep private and quiet like secrets.

My heart is heavy with the traumatic journey this mom has had and still has ahead of her. I feel sad for her because I know how

difficult it will be for her to process this experience. I carry this sadness with me. After years of working in birth, I know and understand that this is *her* journey and that my role is simply to be a supportive and loving bystander. I am not there to rescue or save women from their experience. Each woman will make the journey and face a possible struggle in her own way until her time to give birth. Until she gazes into the eyes of the little soul she carries within her. We wait and watch. We bear witness as women make their choices and as their individual experience unfolds before them.

I had worked with this couple for 12 months as their naturopathic doctor when they came into my care wishing for a pregnancy. They had always thought that they wanted to be childless and then they both turned 40, felt their mortality I believe and decided that they wanted to have a baby. We worked on improving their health and fertility and mom conceived within 3 months. We celebrated their excitement and talked about their fears. We worked through the nausea and the minor anemia. Mom was healthy and fit and strong. Babe grew healthy and well, exactly as we had all expected. I saw them every month during their pregnancy and then more often as we worked together with prenatal classes, home visits, coaching around a birth plan. This couple welcomed me into their homes and their lives. They served me tea and carrot cake. I helped them prepare for the arrival of their babe. We worked well together and came to trust each other. We liked and appreciated each other. Fostering that relationship is very much a part of working with a couple around their pregnancy, their birth, and their postpartum. The journey and the evolution of the relationship is a powerful one.

Not all births leave me with a heavy heart. Many more births are joyful, peaceful, fulfilling, and inspiring. The births that I find most truly profound are the births that take place quietly at night with midwives squatting in the corners watching, partners focused on each other and on their process, mom moaning deeply into her surges and moving freely as her instincts tell her. Babes born to singing moms, smiling moms, laughing moms, ecstatic moms. Babes finding the breast immediately and nestle skin to skin as

placenta is born and caregivers speak in hushed whispers. These births are miraculous in their sheer power. I am always inspired when I see women give themselves up to that wild and uncontrollable primal part of themselves that remembers that their body has a rhythm and they must put their trust in it when giving birth. Witnessing this primacy is something so rare and private in our culture today that it's shocking when we first experience it. It grounds us in the memory that women's bodies were meant to do this, that labor is a physiological process that almost always goes right. The grounding in that knowledge and collective memory that our body has this wonderful inner wisdom feels so very right once we process what we have experienced, and we never want to experience or be a part of anything different.

My early doula work helped to inform me about my own labors and births. I had witnessed about 30 births as a doula before I gave birth to my first child at age 24. When I became pregnant and was working with mothers on the hospital floor, I decided there were many things I didn't want as part of my birthing experience. Midwifery had just become legislated in Ontario. So, I took a leap of faith and I made the decision to put my care into the hands of a very lovely and experienced midwife. I chose home birth because I had confidence that my body would birth the way it needed to. I had no fear around the idea of a home birth. It felt right. I had a doula, I had a loving partner, I had midwives I trusted and the support of my family. I was in a state of grace. I birthed Jacob gently onto the same bed in which he was conceived. It was a powerful and a life-changing experience.

Having now the ability to look back over hundreds of births, three of which were my own, of caring in my naturopathic practice for literally hundreds of more women who are pregnant and birthing and newly postpartum, I now understand what an incredibly wonderful and valuable thing it is to be a part of birth. To witness it, to know it, to be comfortable and familiar with it. To not fear the process. To trust women's bodies as wise and well designed. To understand that labor is hard sometimes, that women will be pushed to their limits and sometimes challenged more than

even they can believe. To then know that when women face that wall and understand that they have reached their limits that they can take a big breath, focus inwards, face their fear and exhaustion, and find a well of strength that was unknown even to them. Somehow, that wall of challenges dissolves and women become powerful and unstoppable when delivering their babies. Pushing/moaning/panting, their babes enter safely onto earth. Witnessing that trust and that power during labor and birth is an empowering experience for a young woman, especially one not yet a mother herself. Experiencing firsthand the sounds, smells, and joys of a natural birth, a home birth, a gentle birth dissolves fear, creates wonder and allows young women to discover that their bodies can do miraculous things, without fear, with their own rhythm, with their own power and strength.

I have often invited and challenged clients of mine to invite their younger sisters, teenaged nieces, or female cousins to attend their labor and birth as a doula-in-training. I encourage them to be a part of the event, understand the process, wait patiently in the dark, learn to master their fears, learn to observe, and react with gentle touch. These women, in turn, can offer the birthing mom a cold cloth, a drink of water, a herbal tea, or a light snack. I tell my clients that by allowing their involvement they are influencing directly how these young women will view the normalcy of birth. These young women also bring the gift of intimately knowing their sister or aunt or cousin in ways her caregivers simply can't. They understand her on an almost cellular level. They will recognize the way she moves and often be the first ones to know in their gut that labor has changed or that the mom needs more support just from a subtle change in her voice or movement.

I learned quickly in medical school the adage, "See one, do one, teach one." I appreciate deeply the learning that one does by absorbing herself in the subject – of seeing it, hearing it, touching it and smelling it. As a woman who attends birth in a supportive role, there is nothing that can match the experience of attending birth like when a woman defines what she believes will happen during birth and makes decisions for her own care. I'm always learning

from what I experience – sometimes I learn something new about myself. Sometimes the experience opens up questions for me about human nature, about the definition of strength and perseverance, about values we hold onto and about our own bodies as a society. Around the choices we make every day to stay healthy and around the value of institutionalized processes and systems that dehumanize the experience and disconnect us from our bodies.

I attended a birth last summer that has stayed with me for a while. Dad kept in touch with me all day by phone and text. Just little check-ins. Mom was doing great. They didn't need me yet – she was eating, sleeping, walking, and doing fine. I came over late afternoon just to see them and she was in good, heavy labor. Her sister and her partner were there, too. She was safe and happy. Between contractions she was playing Scrabble with them. Her sister made a light dinner and we all ate and the expectant mom went to have a shower. In the shower, her contractions changed suddenly. Her sister recognized that her moans had become deeper. I recognized them quickly after she pointed them out as possibly transition moans. I gently suggested we get ready for our very short drive to the hospital. We were lucky that we had a very experienced nurse who marched this mom right past triage into a room where she began squatting to push immediately. The OB on-call arrived just in time to suggest mom jump up on the bed because the head was crowning. She delivered a beautiful baby girl. To her sister, it seemed effortless, almost easy, although she had seen her sister in labor all day and working hard to push out her baby spontaneously. Several days later, when I listened to her sister tell the story of the birth to their brother, I knew that the birthing mom had inspired her sister beyond any of the other life experiences she had had to date. I also know that when the time came, the younger sister was going to be ready to face her own pregnancy and birth in a healthy way, without fear of the unknown, and make informed decisions for a positive birth experience.

Today, I come to a birth empty-handed as a doula and usually chat with mom for a bit, then I squat in the corner and watch mom, ask her if she feels she needs anything and I wait until I can see

where she needs help and support. Mostly, it's my hands and my voice that I use as tools. My role is to comfort, to help guide her back to her center, to support her physically if she is squatting or leaning, to be sure everyone has eaten and has had enough to drink and has been to the toilet frequently. I reassure, I encourage, I massage, I hold, I brush hair, and I wait patiently. I help to hold the space and keep the energy calm and gentle. Most women of any age could do all of these things, could offer love and strength. In my eyes we can all be doulas, we can all be present. We can all bear witness.

I love what I do. It's 4:30 a.m. I've been awake for 36 hours and I've stepped outside for some fresh air. A baby boy was born this morning and heaven touched the earth.

List of Contributors

Stefanie Antunes is an author, speaker, and adventurer on life's great voyage. After 10 years of corporate experience in strategy and intelligence, she chose to focus on her true passion of being a Lamaze childbirth educator and doula. Stefanie, a mother of three, is an advocate in the childbirth movement. She helps doulas and childbirth educators to run their businesses effectively by having them join her growing team for business support. She speaks on the topics of avoiding the 'Mack-Truck' life lessons, learning from them when we are hit, and staying motivated when working in helping fields. www.discoverbirth.com; Stefanie@discoverbirth.com; www.powerofwomenunited.com (contributing author of *Power of Women United*)

Melissa Bone is a CAPPA certified labor doula. She lives in the Niagara Region with her husband, Terry, with whom she travels and teaches seminars on family wellness and spirituality. She has co-written two books with Terry: *The Power of Blessing* and *The Blessing Handbook*. She has three grown children, a son-in-law and one beautiful granddaughter. To find out more about Melissa's work, check out her websites, www.powerofblessing.com and www.blessingbirths.com. Or email her at melissa@powerofblessing.com

Angela M. Brown is a registered massage therapist and a Trimesters Certified doula and infant massage instructor. She lives in Fredericton, New Brunswick, where she is owner of Advanced Therapeutic Treatment Center and also is a clinic supervisor at The Atlantic College of Therapeutic Massage. angelabrown30@hotmail.com

Julei Busch has a passionate, enduring interest in women's health sparked while exploring the diversity of beliefs about birthing and sexuality around the world. Drawing from skills developed in academic and clinical research, holistic health apprenticeships, and front-line community service, Julei's work in all settings puts two powerful converging beliefs into practice: Women's health is the foundation of healthy communities, and it takes a village to raise a child. Since 1999, the collective BirthPassages: Services for the Childbearing Year provides counselling and support for fertility awareness, conscious parenting preparation, prenatal, birth, and early postpartum support. Julei has found a middle way grounded in informed choice, critical analysis, and compassionate, non-judgemental care. She is currently on leave from doula work while pursuing other aspects of community health work. lifepassages@gmail.com

Lisa Caron is co-editor of *Bearing Witness* and a certified birth and postnatal doula in Toronto. After 20 years in the corporate world, Lisa found her calling while volunteering with pregnant teens in 1996 and has since attended close to 300 births in homes and hospitals. Lisa is passionate about baby-led birthing and followed traditional and lay midwives in Guatemala and Mexico in 2003. This restored her faith that birth works well most often without the interventions of urban teaching hospitals. Lisa brings a calm, patient, and intuitive ear, as well as extensive breastfeeding support experience to mothers and babies. In 2001, she worked for INFACT Canada and volunteered many training hours from 1999 to 2007 in Dr. Jack Newman's breastfeeding clinics. To complement her passion and commitment to foster healthy confident families, Lisa is a childbirth educator and a certified hypnotist. Lisa enjoys urban exploration and she and her partner are avid salsa dancers. www.lisacaron.ca

Leslie Chandler began work as a doula in 1984. She has been a Certified Childbirth Educator since 1988 and became an IBCLC in 1993. She has been an instructor at Sunnybrook Health Sciences Centre/Women's College Hospital in Toronto for more than 20

years. Leslie has also worked at Parentbooks in Toronto since 1990 as a specialist in books for families and professionals. From 1997 until 2003, she was the chief facilitator of the Childbirth Educator Certification Program at Humber College. Currently, she specializes in prenatal education for midwifery clients. Leslie is hopelessly optimistic, disturbingly happy, and has been told she is pathologically patient. She says she owes it all to her children, Zachary and Kendall. BirthSpirit Pre and Postnatal Education and Support for Midwifery Clients birthspirit@rogers.com

Michelle J. Cormack took her first labor assistant training in 1992 with Informed Birth and Parenting (ALACE) and then became a certified childbirth educator (ALACE) and served as their eastern Canada regional director for many years. She is an experienced registered yoga teacher (E-RYT500, Yoga Alliance) and shares her wisdom of pregnancy, birth, and parenting at her studio she founded in 2003 in Brampton, Ontario. (5 Elements Yoga & Pilates), and in training yoga teachers from all over the world, both at her studio and at international conferences. She is also a reflexologist and Thai yoga massage practitioner and co-wrote (with Kam Thye Chow) *The Pre Natal Manual* for the internationally acclaimed Lotus Palm School of Thai Yoga Massage. She is blessed to be the mother of five amazing daughters. www.5elementsyoga.com; michelle@5elementsyoga.com

Melissa Cowl, CD (DONA), CCE, is a certified doula and doula trainer with DONA International. Melissa brings a wealth of personal experience combined with a professional background to all of her classes and clients. Melissa's commitment and dedication to serving women are apparent through her community work. Melissa spent two years working with all levels of hospital staff, members of the community, and Ministry of Health officials to reopen the birthing unit in her area. Her experience collaborating on a university-led research group looking into the crisis in sustaining primary maternity care workers in Ontario has been an asset to the reopening project in Alliston, Ontario. Melissa was the recipient of the

Heather Mains Memorial Award for her activism and advocacy for the rights of birthing women. Melissa enjoys her family life with her husband and six home-educated children on their farm in Central Ontario. doula@live.ca and www.birthandbeyondontario.ca

Rean Cross is a birth and postpartum doula and childbirth educator in the east end of Toronto. She has been involved in birth work and women's health since 1989. After being home with her children for 10 years, she returned to school and majored in psychology with minors in women's studies and bioethics. This turned out to be terrific doula training. She has attended births in homes and hospitals in Vancouver, Ottawa, and Toronto. She has spoken and presented at several conferences, including the Guelph Sexuality Conference in 2007. She was a reviewer for the book *Postpartum Depression: A Guide For Front-Line Health and Social Service Providers* (CAMH 2005). She is the mother of three young adults. www.lucina.ca

Lesley Da Silva is a published poet and artist who has dedicated her life to reminding people to *play*. Her passion for children inspires her work, which captures our innate innocence and love for life. She is the best friend of a doula, and "bears witness" daily to her friend's work. She was inspired to write her poem as a gift to her friend, when she was struggling with her decision to become a doula. www.birthwithcare.com

Nelia DeAmaral supports expectant and new mothers as a doula, counselor, and yoga teacher. Her work focuses on the whole person, helping women integrate this life-changing experience in a healthy way. Nelia holds a degree in psychology, along with additional training in counseling during pregnancy and early postpartum. As a labor doula she trained with CAPPA Canada. She also brings her passion for women's health and wellness to the corporate sector, where she spent 7 years working with organizations, developing programs to support employees and their families as they move through their lifecycle. Her philosophy is that a happy

and well-supported mother is the best mother a baby can have. She is also a proud mother of two beautiful girls. www.birthwithcare.com

Lisa Doran, ND, is the co-editor of *Bearing Witness* and is the mother of three beautiful and growing young men who were all birthed at home, her third child unassisted into her own hands. She is a midwifery, homebirth, and breastfeeding advocate. She took her doula training with ALACE in 1991 and has been working as a doula since. She is also a naturopathic doctor with a specialty in fertility, pregnancy, and birth. She offers unique services to her patients with the combination of her naturopathic skills and her doula experience. She is specially trained in acupuncture for fertility and acupuncture in pregnancy. Her clinic, Barefoot Health Naturopathic Clinic, is a busy integrated care clinic in Ajax, Ontario. She co-developed and teaches the third year Maternal Newborn Care course at the Canadian College of Naturopathic Medicine and founded the Association of Perinatal Naturopathic Doctors. Lisa has been published in *Midwifery Today, Naturopathic Doctors News and Reviews*, and gives lectures and seminars all over Canada on topics related to birth and naturopathic medicine. Lisa is also an urban farmer, a fiber artist, and a blooming celtic fiddler. www.barefoothealth.ca

Kelly Ebbett graduated nursing from the University of New Brunswick 1997. She has lived in the Maritimes, Montreal, Toronto, and Bermuda. She is certified with DONA International and the International Childbirth Educators Association in 1999. She has been attending births since that time and is known for being a 'doula-on-the-go.' She has attended births in Ottawa, Toronto, Montreal, New Brunswick, and Bermuda. She taught and coordinated the prenatal classes at Mount Sinai Hospital in Toronto for 4 years. Kelly relocated to Fredericton, New Brunswick, in 2006 where she presently works as a doula, nurse, childbirth educator, and clinical nursing instructor at the Univeristy of New Brunswick. In 2008, she became an approved doula trainer with DONA International. She provides doula services, mentorship to new doulas and is the state/province area representative for DONA

International for New Brunswick and Prince Edward Island. Kelly is married and mother to two wonderful boys. kelly@luit.ca

Jennifer Elliott, B.Ed, is a doula, childbirth educator, writer, and hypnotist. She specializes in HypnoBirthing and both trains new HypnoBirthing practitioners and teaches HypnoBirthing prenatal classes. Jennifer is an engaging speaker at conferences and workshops. She is passionate about the importance of the birth experience for mothers, partners, and babies and is dedicated to making the transition to parenting a little easier. Her commitment to birthing and parenting led her to create these two CDs: *Birth with Calm and Confidence* and *Calm and Confidence for the New Mother*. She has supported hundreds of new families in Toronto. www.lifesjourney.ca

Autumn Fernandes, RMT, has been a birth doula for 6 years. She has had the privilege of being there for women and their partners at both hospital and home births. Autumn has two beautiful children, both born at home with the help of midwives. She draws not only on her own experience of childbirth, but also from every woman she has had the chance to support during this transforming time. Autumn is also a registered massage therapist and uses massage techniques along with other comfort measures to help women achieve a natural childbirth. Autumn feels so grateful to the families that choose her as their doula, to allow her to share the most treasured moment, the moment when a woman transforms, the moment when they become mothers. www.fernandesfamily-naturalhealth.com

Kimberley Fernandez has been a doula since June 2006 and has attended more than 50 births. She is also trained as a HypnoBirthing Doula, a childbirth educator, and soon to be a HypnoBirthing practioner. She lives in Toronto with her husband of 13 years and they have three amazing children – William, 10, Thomas, 8, and Ally, 5. She is also co-founder of the Toronto Doula Group, with her business partner Stephanie Alouche. The birth of Kimberley's daughter

showed her that birthing should be more than a medical procedure and is what started her on this journey that has been and continues to be amazing for her. kim@torontodoulagroup.com; www.torontodoula-group.com

Shawn Gallagher, BA, BCH, is a board certified hypnotist in private practice in Toronto. As a childbirth educator since 1986, she created and teaches the *ChildbirthJoy Prenatal Hypnosis Series*, training hundreds of expecting parents in self-hypnosis for birth preparation. She also provides advanced training to hypnotists, doulas, midwives, and other healthcare practitioners in the use of hypnosis during birth. As a HypnoFertility practitioner, she uses a combination of hypnosis, Neuro-Linguistic Programming (NLP) and Emotional Freedom Technique (EFT) to help improve outcomes. While providing services as a doula and a midwife, Shawn had two children (now teenagers), both born at home with midwives. www.childbirthjoy.com

Melissa Harley, CD (DONA), DONA approved doula trainer, LCCE, has been working with birthing women since bearing witness to the vaginal birth of her twin nieces in January of 2002. In her time as a doula, Melissa has had the pleasure to support 68 women and their families during labor. Melissa also works as a Lamaze certified childbirth educator, empowering women to listen to their inner voice and acknowledge their own strength to birth. Melissa is a newly approved doula trainer with DONA International, and is excited to begin the new chapter in her life, training new women to become doulas. Melissa and her husband, Ken, were married in 1998, and have two children. They live in Tallahassee, Florida. capitalcitydoula@comcast.net; www.tallychildbirthclass.com

Crescence Krueger teaches yoga and works as a doula. Giving birth to her daughter at home in 1991 started it all. Two years later, she began attending births. Being with women in the intense intimacy of birth informs her understanding of life. Both are yoga, a spontaneous union with the creative force. Her writing comes from

the same source. She has a BA in drama and English from the University of Toronto. www.heartofbirth.org; www.heartofbirth.word-press.com

Samantha Leeson has been working as a doula and childbirth educator since 1998. She has had the honor of having been invited to the births of more than 200 babies. She has also been blessed to have had more than 5000 couples pass through her prenatal and breastfeeding classes. She and he husband, Doug, are the proud parents of two beautiful, conscientiously birthed breastfed boys. She boasts that her children inspire her to reach out and help others have wonderful birth and parenting experiences. She is also a retired leader with La Leche League Canada. sam@babyREADY.ca; www.babyREADY.ca

Marcie Macari is the author of *She Births: A Modern Woman's Guidebook for an Ancient Rite of Passage,* and creator of Bloomin' Belly Soaps-anatomically true pregnant torso soaps for expectant moms and those who serve them. She is a writer, natural birth advocate, speaker, and workshop facilitator – and lover of all things creative. She shares her life with her husband, three children, a 90-pound German shepherd and a 5-pound yorkie who each think they are the size of the other. Marcie is available for consult and speaking engagements. www.shebirths.com; www.bloom-inbellysoaps.com; shebirths@gmail.com

Tara MacLean-Grand is a singer, songwriter, wife, doula, and mother of three amazing, spirited girls. She was born on Prince Edward Island, and has lived and performed all over the world. The first birth she attended at the request of her close friend was a low-risk/high-intervention hospital birth that inspired her to learn everything she could about the process so she could better support her friends in the future. She had the honor and opportunity of supporting that same mother again, this time in a magical home birth setting. This moved Tara to write this piece about that night. Two of Tara's three babies were born at home. She studied to be

a doula and plans to volunteer with teenage mothers who have no support system. She continues to sing when the spirit moves her. www.taramaclean.com

Heather Mains, BFA, MA, attended births as a doula for 11 years. She advocated on behalf of improved maternity services for more than a decade. Her Master's thesis "The Art of Giving Birth: The Power of Ritualizing" (York University, 2002) was an anthropologically based study on how women create rituals for comfort and security in childbirth both at home and in hospital. As an entrepreneur, she created Duegood (www.duegood.com) to provide social marketing and communication design to non-profit and for-profit business concerned with socially conscious endeavours. Heather's ground-breaking work in maternal care and her passion for promoting social causes in health, the environment, and the workplace has positively impacted family, friends, and colleagues. Heather departed this world following a kayaking accident in 2007.

Mona Mathews, CD (DONA), principal of The Comfort Zone Doula Services, is a mother and grandmother who loves all things relating to birth and empowering women. She lives in East Gwillimbury, Ontario, with her husband of 35 years and a very spoiled mutt named Rodney. m.mathews@sympatico.ca

Maurning Mayzes is a practicing doula and midwifery second attendant. She passionately supports mothers in their right to choose how, where, and with whom they give birth. Country living has proven to be a great adventure for this former city girl and her family. mmayzes@sympatico.ca

Tracey McCannell has considerable experience in areas related to women's and girl's issues, parenting, and education. She is currently the program coordinator for the pre- and post-natal nutrition for Girls Inc. of Durham. She is also a certified childbirth educator, doula and doula trainer, and has offered hundreds of families support and guidance through the birth and parenting process. Tracey

is the proud mother of two boys, aged 15 and 18 and has shared her life with her wonderful man for the past 25 years. Her passions include gardening, drumming, dancing, nature, and animals.

Cindy McNeely, RMT, doula/labor support provider has been in clinical practice in Ontario since graduating from Sutherland-Chan in 1985. She works with adults, babies, and children. Trimesters: Massage Therapy Education was co-created by Cindy in 1995 to raise the standards of perinatal massage therapy. Cindy created the first Canadian Level III Perinatal Hospital Massage Therapy program training RMTs and students. This program works within the High Risk Pregnancy Units, Labor & Delivery, Postpartum, and Transitional Care Unit (with infants in the hospital). She collaborated with the Atlantic College of Massage Therapy to create a 125-hour program devoted entirely to massage therapy for all aspects of the perinatal realm. Cindy also provides in-service trainings for other perinatal healthcare professionals and is devoted and passionate in her work. www.trimesters.on.ca

Hilary Monk (*aka* Sha'alah in the dance and art world) gave birth to her first baby in a highly medicalized hospital setting; then three babies at home prior to Ontario's midwifery regulation. For 20 years, she has been a birth activist, a publisher of a childbirth newspaper, a doula, a childbirth educator, and fitness instructor, and a self- and apprentice-taught community and 'professional' midwife, in high- and low-tech settings, in Ontario and Texas. She has guest lectured in Poland (keynote speaker at the national annual obstetrical conference), Egypt, Nepal, and York University. She has been published in the *Journal of Pre- and Perinatal Psychology*, completed a master's thesis examining choice in professional midwifery rhetoric versus reality, and most recently, lectured at Brock University's Business Faculty on medical professionalism and ethics. shaalah@yahoo.com

Beth Murch has a Master of Arts degree from Wilfrid Laurier University, where she studied the spiritual experiences of woman

during pregnancy, childbirth, and breastfeeding. She is an antenatal, labor, postpartum and bedtime doula in Kitchener, Ontario, where she lives with her two furbabies. When she's not doula-ing or painting pictures of fertility goddesses, Beth can be found with a latte in hand, writing about the world around her. beth.murch@gmail.com; www.freewebs.com/bethmurch

Toby Neal, R.C.S.Hom.Med., has been a doula since 1998. She is also a mother of two, and a classical homeopath with a general family practice but a special affinity for women's issues, pregnancy, and birth. She is also currently a surrogate mother. www.tobyneal.com

Carol Niravong lives in Toronto with her husband and two sons. Over the past several years, she has been active in the "elimination communication" community, promoting a "diaper-free" option. Most recently, she appeared in a documentary called *My Toxic Baby*. carol.niravong@gmail.com

Lenka Pedwell is a RMT and doula in Waterloo, Ontario. She has been a massage therapist for 10 years and has been a doula for 9 of those years. She is a mom to two boys aged 5 and 1. She first became a doula because she was in awe of the birthing process, but after a few births realized there is a genuine need for women to feel supported, comforted, and empowered by other knowledgeable women during birth.

Kristin Peres is a woman of many passions. A wife, mother, doula, and cake artist, her interests aren't easy to prioritize. Kristin has been a doula for about 3 years and a cake artist for 6. A co-founder of babyREADY with Sam Leeson, she has recently stepped away from babyREADY to launch her cake business, Cake or Death. www.cakeordeath.ca

Isabel Perez has helped women give birth over the last 31 years. She trained as a midwife with Ina May Gaskin and worked with her for 4 years on The Farm in Tennessee. She then moved to Toronto

and continued to practice midwifery for another 11 years until 1993. Since then, she has served women as a doula. Isabel has six children. Her last child, Pablo, was born in Toronto, at home, 12 years after her fifth. Worried that her mind was too full of information by that point to surrender to the birth process, she ended up with a "nice and easy" three hours of active labor, confirmation that the body's wisdom runs deep. lucrecia@rogers.com

Jessica Porter has taught HypnoBirthing skills to hundreds of couples and has trained doulas, nurses, and doctors to become HypnoBirthing practitioners worldwide. She is also a macrobiotic chef and teacher, author of *The Hip Chick's Guide to Macrobiotics* and co-writer of Alicia Silverstone's *Kind Diet*. She lives in Santa Monica, California, and at the writing of this bio, is waiting to help a new niece or nephew enter the world. www.hipchicksmacrobiotics.com

Janice Preiss is a full-time mom and dog groomer in Beeton, Ontario. Janice's advanced sense of humour helped her to raise her two wonderful, creative children and not drive them too crazy. She enjoys her saluki dogs, judging field trials, volunteering, and hiking. Janice decided that when her children were grown and the time was right, she would become a doula and indeed she did. She enjoyed a couple of good years in the doula world, doing births for friends and social services. She very much enjoyed the experience but found that health and age were becoming an issue. Janice will always be a doula cheerleader, but has stepped aside for now.

Katarina Premovic is the mother of three children. She is a lawyer by training who developed an interest in birth, doulas, and midwives when surrounded by marvelous women during the course of three very different births. kpremovic@yahoo.com

Jill Ritchie, CD (ALACE), CPD (CAPPA), Lamaze childbirth educator (LCCE), is the founder of Babeeze In Arms Doula Center, a mother of five children, the daughter of an amazing 83-year-old

mother and sister to seven siblings. The person she is today is the accumulation of all of these roles she has experienced so far in her life. Her life as she knew it was forever changed the day she attended her first birth as a doula. Babeeze In Arms Doula Center is committed to creating the change we wish to see for all women of the childbearing years. www.babeezeinarms.com

Heidi Scarfone spends her time living between Hamilton, Ontario, and Fairbanks, Newfoundland. She is happily married and the mother of four grown children. Over the years, Heidi has had the privilege of teaching childbirth classes and attending births as a doula. When she was a doula, she marveled at the perfection of each baby's small fingers and toes and the relationship between the new mom and her newborn child. Most recently as an artist, she has put pencil to paper and has captured these fleeting moments. Heidi has since retired from being a doula but recently provided labor support for a friend in Gander, Newfoundland, and now spends her time writing, drawing, traveling, and looking for new adventures. heidiscarfone@hotmail.com; www.heidiscarfone.com

Anne Simmonds has been a maternity nurse, doula, and educator for more than 25 years. She is passionate about the care women receive during childbirth and has led numerous labor support training for doulas, nurses, and nursing students in Canada and the United States. Anne is completing her doctoral thesis, which explores the moral nature of relationships between nurses and women in childbirth. She has written on ethics in maternity care and is also actively involved in inter-professional projects with other nurses, midwives, and physicians in order to improve care provided to birthing women. Anne is presently assistant professor at the School of Nursing, Dalhousie University in Halifax. anne.simmonds@dal.ca

Amanda Spakowski is the founder of The Nesting Place: Prenatal Classes & Doula Care. She is a birth doula and Toronto's only Birthing From Within educator. Her background in human biology, peer counseling, crisis intervention, and assisting in home daycares

has allowed her to bring an experienced and unique perspective to her classes and care. Amanda's passion for supporting each person's unique transition to parenthood is evident as she brings a thoughtful and compassionate facilitating style to all of her classes. Additionally, her commitment to inclusive space creates a safe and nurturing environment for parents to learn more about themselves as they prepare for childbirth. www.TheNestingPlace.ca; TheNestingPlace.blog.com; amanda@thenestingplace.ca

Lara Stewart-Panko is passionate about birth, family and women's issues, and she finds the powers of the mind-body-spirit a fascinating subject. Lara attended her first birth at age 15 and she was hooked. After attending more births, she obtained her birth doula training in 2001 and Lara had the joy of birthing her own child in 2002. In 2007, she certified as a HypnoBirthing childbirth educator and this has revolutionized her understanding of birth. Lara also holds a degree in social work and has continuing education in supporting survivors of sexual trauma during the childbearing year. It is her deep joy and privilege to walk alongside families as they discover and grow. info@hypnobirthinghamilton.com; www.hypnobirthinghamilton.com

Christy Swift is a freelance writer and stay-at-home mom of two. She is an advocate of midwifery care, homebirth, and extended breastfeeding, and currently lives in South Central Florida. Christy@christyswift.com; www.christyswift.com

Catherine Tammaro created the digital illustration on the front cover of *Bearing Witness*. Catherine's artistic output is well known in the Toronto art scene and internationally through Internet exposure. Her achievements include fine art and design, music composition and singing, photographic and written journalism, and extensive digital graphic design. Her works have been exhibited in both traditional and alternative gallery spaces and her written and visual work has been published in various journals and publications in Toronto and elsewhere. She has been involved in a wide array of interdisciplinary collaborations, ongoing special projects, and

themed exhibitions, both as a curator and an exhibitor. Born in Toronto and raised in Toronto and the U.S., Catherine has a 40-year history of making art. www.catherinetammaro.com

Diane Tinker, ICCE, CD (DONA), is the owner of Birth Companions Doula Service (www.birthcompanionsdoulaservice.com) and has been a birth doula and childbirth educator in Central Iowa since 1996 and has attended hundreds of births as a private practice doula. She is certified with DONA International and International Childbirth Education Association (ICEA). She is also the perinatal services specialist with the Young Women's Resource Center (www.ywrc.org) in Des Moines, Iowa, where she works primarily with pregnant and parenting teens. Diane and her husband reside in Des Moines, Iowa, and have three children, who were born in the 1990s when birth was a much different climate. All three were vaginal, hospital births that were satisfying, but because of a near C-section with her first birth she was empowered to research why, which led her to becoming a doula. queendoula@aol.com

Sofie Weber's placenta print inspired the cover art and can be seen on the frontispiece of *Bearing Witness*. Sofie wears many hats as a birth and postpartum doula, certified infant massage instructor, childbirth educator, vice-president of Doula C.A.R.E. Inc. and a clinical aromatherapist specializing in aromatherapy for childbirth. Sofie respects the childbearing and birth experience as a whole and creates an empowering, positive environment for the birthing family. She carries this respect forward into her postpartum work, where she strives to make her clients feel comfortable and successful as parents. She is honored to be a part of this amazing world where the journey is different every time. Sofie lives in Orangeville with her husband, their two boys and two fire belly toads. www.mothersjourney.ca

Nicola Wolters is a birth and post-partum doula in the Ottawa area. She specializes in soothing babies but loves every aspect of birth, babies, and motherhood, including the fact that she has her own three children, Thomas, Michael, and Darian. nicoladoula@gmail.com

Acknowledgments

"We have a secret in our culture…it's not that birth is painful, it's that women are strong."
– Laura Stavoe Harm

Lisa Caron would like to thank…

This anthology has been a labor of love, and like its conception and birth, it has been collaborative. This book is Lisa Doran's child and as she and I shared her vision with the doula and birth community, it blossomed in front of our eyes.

Foremost, we would like to thank each and every one of our contributors. In their enthusiasm for our project, the experiences of each of these special women have blessed the pages of this book. We have the honor and privilege of sharing a little slice of their lives.

I would like to thank Lisa Doran for choosing to share her dream with me, and working tirelessly to find us a publisher. She has maintained the image of the forest while I was submerged in the trees. It has been a life-changing journey and I am so very thankful that Lisa invited me along. In any role, calm and thoughtful co-editor, patient and loving mother, experienced doula or insightful naturopathic doctor, Lisa's clarity into holistic wellness is inspirational.

I would also like to thank my "book doulas," Lindsay Benjamin, Daniel Hernandez Monroy, Jennifer Elliott, Leslie Chandler, Julei Busch, and Jessica Cherniak, for their endless patience and guidance during my precipitous book labor. And to the memory of Heather Mains as she has been with me throughout the project. She was a dear friend and an inspirational writer and doula who went to great lengths to help the world trust birth again.

Our special thanks go out to Bob Hilderley, who will never know how happy he made us on that special day in September 2009 when he offered Quarry Press as our publisher.

Lisa Doran would like to thank...

My many teachers in the doula world who held and inspired me as I was a fledgling doula and still learning the art of this practice. Dr. Dawn Cormier-Hazen, ND, Sharon Zores at St. Joseph's Hospital doula program in Toronto, and the circle of women involved with Choices Childbirth in the late 1990s who mentored and supported me in my learning; notably Tracy McCannell and Kim Etherington who were the dynamic duo providing such amazing leadership and support.

I would also like to thank my partner, Tim, and our three boys, Jacob, Alden and Eli, who have been incredibly supportive, flexible, and understanding of this calling of mine. Thank you from the bottom of my heart for understanding that this isn't so much of a career as it is a life's work that brings me great joy and fulfillment.

We both wish to thank all of the incredible authors, thinkers, teachers, and world experts in the field of birth who read this book, generously gifted their time in editing, offering advice and their names and wonderful quotes. Penny Simkin, Ina May Gaskin, Ricki Lake, Murray Enkin, Barbara Harper, Barbara Katz Rothman, Gayle Peterson, Michael C. Klein – thank you all so very much.

And, finally, to my co-editor, Lisa Caron. This book took 18 months to birth, 6 months of ruminating, an afternoon where I pitched the grand and crazy idea and my inspiration to Lisa, and a year where we worked hard to pull it together and bring these wonderful 50 voices into this book. Lisa is a gentle, eternally positive, organized, and thoughtful co-worker. She worked quietly to keep us on track, she opened her heart to my vision and reached out across North America to bring us all together. I feel like the two of us were dancing – one working with their strengths and the other looking for ways that they can help and hold the project up and then we switch roles and the other leads. Lisa has really been a joy to work with. She was my doula for this book. Thank you, Lisa.